A SONG FOR ONE OR TWO

Music and the Concept of Art in Early China

by
Kenneth J. DeWoskin

Ann Arbor

Center for Chinese Studies
The University of Michigan

1982

Library of Congress Cataloging in Publication Data

DeWoskin, Kenneth J.
 A song for one or two.

 (Michigan papers in Chinese studies; 42)
 Bibliography: p.
 Includes index.
 1. Music—China—History and criticism. 2. Music—
Philosophy and aesthetics. I. Title. II. Series.
ML336.2.D48 781.731 81-19519
ISBN 0-89264-042-1 AACR2

The illustration on the cover is a detail from a silk
painting that dates to the Western Han dynasty.
The painting was excavated from Chin-ch'üeh
Mountain tomb no. 9, Lin-yi County, Shantung.
Wenwu, no. 11 (1977), p. 30.

Printed in the United States of America

For Judith

CONTENTS

PREFACE

Work on this book was begun with a paper entitled *Music and the Ch'in: A Song for One or Two,* prepared for presentation to the Conference on Theories of the Arts in China, sponsored by the American Council of Learned Societies, held in York, Maine, in June of 1978. I owe a debt of gratitude to the Council for the opportunity to participate in the conference, surely one of the best of its type in recent years, and to the participants for their patient and thoughtful criticisms of my paper. Even though this book only makes reference to an earlier article on music and aesthetic terminology that is to be included in the conference volume, the editors of that volume, Susan Bush and Christian Murck, worked through the entire body of the conference paper and made innumerable corrections, suggestions, and observations. Donald Munro, discussant at the conference, has been a continuing source of inspiration and suggestions in the revision of the work.

I have benefited from the criticisms and suggestions of Rulan Chao Pian, Judith Becker, and Arnold Perris, musicologists who patiently taught me the essentials of their field, into which I had ventured with a vast amount to learn. Over the years I have been occupied with early Chinese music theory and lore, I have gained immeasurably from the knowledge and insights of many others, including A. L. Becker, Jonathon Chaves, James Crump, Stephen Addiss, and Leonard Pack. Anne Behnke's readings and research in early music-theory texts helped bring numerous important ideas into my field of reference.

I want to express my appreciation to Barbara Congelosi. The care and effort she put into the editing and composition of this book were so far beyond any reasonable expectation that I lost track of what was indeed reasonable to expect. It is a pleasure to share in the excellence that she has brought to the publications program of the Center for Chinese Studies. Professor Luo Rongqu was kind enough to take time from his own busy schedule to do the calligraphy for the book.

In clarity and brightness, it is the image of heaven; in breadth and scope, the image of earth. Having movement in time, it is the image of the four seasons. The five colors, fitted in ordered pattern, do not clash. The eight winds, channeled through pitchpipes, create no discord. The hundred measures achieve regularity and are [reliably] constant. All together, the short and long pipes bring completion and in each are engendered beginnings and endings. Melody and harmony, high tones and low, alternate to weave the thread.

Therefore, when music goes forth:

Orderly relations are clear,
The ears are sharp, the eyes bright,
Hsüeh is in harmony, and the ch'i is balanced.
Transforming ways and refining customs,
Music brings peace to all in the world.

"Yüeh chi," pp. 13a-b.

CHAPTER I
The Study of Music

There was a great wealth of musical activity and ideas about music in early China. Voluminous materials for the study of early Chinese music are preserved in the received textual tradition.[1] New materials, differing in nature and quality, are becoming available each year with the accelerating pace of archaeological field work and steady improvement of archaeological methodology and reporting in China. I have framed this inquiry into music and aesthetics broadly, hoping to provide readers with a sense of the diversity of musical activities and ideas that were important in China from the classical period to the early Six Dynasties and to describe the patterns of evolution.

Ancient music has long been a popular subject for study, with the particular interests of scholars shifting often. Early scholarship focused on classical views of music as a social institution and the cataloguing of musical instruments. More recently, there has been analysis of and conjecture about the role of music in archaic ritual and the musical dimension of archaic poetry. Most recently, research has been published about early theories of music in the context of cosmology, aesthetics, and acoustical physics. In the last two decades, the study of pre-Han instruments recovered from the earth has revealed fascinating details about the instruments themselves, especially stone and metal percussion instruments, the technology of instrument manufacture, and the pitch systems. This has, in turn, helped to refine our understanding of musical performance in early ritual

[1] The received textual tradition refers to the canon of written materials that has been continuously transmitted, known to the scholarly world in China since the time the materials took shape. Outside the received textual tradition, there are materials rediscovered in archaeological finds and in Japanese and Korean archives that were not continuously available in China.

3

and the relationship between theories of sound and music and the actual use and investigation of sound and music.

The main point of a broad and interpretative inquiry is to embrace music for discussion in a way that mirrors its discussion by early Chinese thinkers. A germinal utterance, first recorded in the *Hsün-tzu* 荀子 and repeated frequently thereafter, was "music unites" (*yüeh-t'ung* 樂同). Experiments, theories, and speculations about music and sound were central to a variety of the interests evidenced in early historical and philosophical texts, and performances of music and dance were central to much early ritual and public activity. Sound as a natural phenomenon was perceived to be central to many natural processes, especially those that involved remote interaction or influence between entities. Accurate aural perception was of paramount importance in man's perception of the world around him. The ability to distinguish and analyze sound was tantamount to the ability to distinguish and analyze all that was recurrent and intelligible in nature. In speculation and argument about man and nature, propositions and assertions about sound and music were often primary. Understanding sound and music was the key to understanding numerous other aspects of man and nature.

Most of the important texts, textual fragments, and other kinds of evidence that I will consider have been studied fruitfully in their own right. But, by and large, the diversity of these materials and their inherent difficulty have irresistibly drawn scholars' attention toward and into them as isolated texts and objects. This has been at the expense of attention paid to the same evidence as it bears on the hub of archaic theory and practice, the central and normal theory and practice against which the individual bits of evidence need to be measured. Hence, we are likely to know that Mo-tzu 墨子 faults music before we clearly understand what "music" meant to him. Similarly, we know that Hsün-tzu sees in music a communicative link between man and external influences before we know what "music" meant to him. And we know that Tung Chung-shu 董仲舒 sees the pitches as a tangible and demonstrable realization of his cosmic numerology before we know what "pitches" meant to him. To understand what the central ideas were is to build a picture of the whole wheel, the hub, the spokes, and the spaces that are described by the circle of texts, bronze bells, carvings and paintings, and other evidence from early China.

Building such a picture would have been impossible without the substantial research efforts of many modern scholars of music over the last several decades. Nearly fifteen hundred publications are listed in Fredric

Lieberman's bibliography of studies on Chinese music in Western languages. The majority of the works listed either are brief notices or focus on contemporary performance. Still, Lieberman's list contains numerous publications that made major contributions to our understanding of early music. Among these are several writings each by Robinson, Picken, Kuttner, van Gulik, Kishibe, and Levis, as well as signal works by Granet, Courant, Needham, and Pian.[2] In non-Western sources, there have been important works by Mizuhara Ikō, Chu Ch'ien-chih, Jao Tsung-i, Tung-fang Ming, Yang Yin-liu, and Wang Kuang-ch'i. Since the publication of Lieberman's bibliography, Walter Kaufmann has published a collection of selected translations on music from the better-known classics, including the "Book of Music" ("Yüeh chi"). Kaufmann's work is a thoughtful and well-organized collection that consolidates much of the important classical and Han materials in convenient form.[3]

Reading and explanation of the source material by these scholars have naturally followed the dictates of their disciplines—history of science, ethnomusicology, and history of culture—with the result that the wholeness of the early written record has not been well represented. With the exception of van Gulik's study of the *ch'in* 琴, no attempt has been made to assemble information on music from multiple perspectives into an investigation of aesthetics. L. Laloy's *La Musique Chinoise* remains an interesting study of music ideology, theory, and lore but neglects an examination of the technical aspects that relate his claims about cultural context to performance. Given that the impulse to integrate various fields of knowledge was important in early discussions of music, the segmentation of our work into recognized academic disciplines will naturally leave much "unfound" between the findings of specialists.[4] It should be recognized that

[2] Lieberman, *Chinese Music.*

[3] Kaufmann, *Musical References in the Chinese Classics.* A review of this work by Judith M. Boltz is in the *Journal of the American Oriental Society* 100, no. 1 (January–March 1980): 95.

[4] Confronting much the same problem in her investigation of aesthetics, Langer wrote: "Here we run into a difficulty in the scholarship of our times—the obstacle of *too much knowledge,* which forces us to accept the so-called 'findings' of specialists in other fields, 'findings' that are not made with reference to our searchings, and often leave the things that would be most important to us, unfound." *Philosophy in a New Key,* p. 218.

even translations reflect the specialized interests of the translator, through the selection of texts, emphasis of documentation and explication, and the shaping of semantic "equivalence." Much of value remains to be discovered in texts on social philosophy, ritual, and natural science, particularly as they relate to each other.

My acquaintance with the bibliography of this field was guided by two interests: the relationship between early literary theory and theories of other arts on the one hand; and, on the other, the nature and evolution of early science and technology, especially as reflected in theories relating man to his physical surroundings. These are two distinct areas of inquiry for contemporary sinologists, and the articulation of recent research on these subjects reflects that fact. I will argue, however, that these areas of inquiry were closely related in the minds of early Chinese thinkers, and our ultimate success in understanding either one will depend on our recognizing the essential homology of early aesthetic and cosmological theory. It is possible to formulate a general and tentative definition of aesthetics from early discussions, especially those about music. For the early Chinese, aesthetics was a field of inquiry into issues bearing on the mind of man and its modes of response to order and pattern in the world outside. The converse issues, outward expressions of order intrinsic to the mind, are given less attention in the pre-Six Dynasties period. The body of this monograph aims to refine that definition and demonstrate the continuity in both theory and style of argument from aesthetic to cosmologic subjects.

The main sources of information utilized here are texts which record discussions and describe experimental explorations of music and sound in early China. These sources include myths about the instruments, the pitches and tones, and the powers of music; theoretical discussions about the physics of music's constituent parts; and exhortations about the proper role of music in the art of governance. With some exceptions, they do not describe the performance of music, nor is there anything extant in the way of scores. I have studied music primarily as an intellectual and speculative tradition and secondarily as an experimental and technological area of exploration. Much of what early thinkers had to say about the arts is found in such discussions of music, and many of their speculations on natural processes derive from experiments in acoustics and related mathematical computations. In fact, until the Six Dynasties (A.D. 220-589), explicit evaluative discussion of the arts was largely confined to music. This is not to say that other arts were not of equal importance in practice or that

their presence was ignored by early thinkers. The diverse texts from the pre-Han and Han periods are filled with materials that have important implications for all of the arts, literary, musical, and visual; and the discussions in those texts demonstrate a highly developed sense of the artful dimensions of contemporaneous Chinese civilization, including formalized rites, martial skills, courtly social intercourse, and eloquent speech.[5] But of the arts narrowly defined, including literature, painting and sculpture, and music, only music is subjected to individual and sustained discussion by the classical philosophers and accorded its own chapters in the Han philosophical and historical collections.

Why is music the preeminent art in the investigation of aesthetics? Some explanations are specific to Chinese culture, e.g., the special importance attached to hearing as the central link between the mind and the outside world and the exploitation of hearing and aural sensitivity as a metaphor for perspicacity in general. The central importance of sound in cosmological speculation will be discussed below. But in Western culture as well, discussions of music have been central to discussions of aesthetics from the earliest times. Music is at one and the same time an area of great appeal to and consummate difficulty for philosophers of aesthetics. In Walter Pater's celebrated remark, "All art constantly aspires to the condition of music," there is the clear promise that to the extent we can understand and discuss the "condition of music," we can understand and discuss the condition of all art.[6]

Plato, Aristotle, and Horace dealt with music frequently and at length as an educational and cultural force. Close parallels to their ideas

[5] There were a number of formulations of the "Six Arts" (Liu-i 六藝) in early China. Among the most common was one pertaining to the six attainments of the cultivated gentleman. As preserved in the *Programs of Chou (Chou-li 周禮)*, these include both intellectual and physical disciplines: the rites, history, computation, literature, riding, and archery. In the Han they are narrowed to genres of classical learning, including the *Book of Changes (I-ching 易經)*, the *Book of Odes (Shih-ching 詩經)*, the *Book of Documents (Shu-ching 書經)*, the *Programs of Chou*, the *Spring and Autumn Annals (Ch'un-ch'iu 春秋)*, and Music (Yüeh 樂) (*History of the Han [Han-shu 漢書]*, "Records of Texts" ["I-wen-chih" 藝文志]). Music was included among the six genres of classical learning but was unique in that no classic of music was received by the Han.

[6] Pater, *The Renaissance*, p. 135.

are found in classical Chinese thought. More recently, aestheticians in the West, at least since Schopenhauer, have addressed music from a wider variety of perspectives. Schopenhauer's metaphysical speculations about music are not without parallels in early Chinese thought, and the same can be said about Leibnitz and his mathematical analysis. Susanne K. Langer, in her examination of the psychology of the arts and of aesthetic response, has focused on music as one of the central subjects for study. In fact, she adopted it as the metaphor for her first major project on aesthetics, *Philosophy in a New Key*. In her work, as well, we can find notions with parallels in early Chinese thought.

The difficulties in discussing music objectively are formidable. By nature, it is the most transient facet of early culture. As an event, music is performed and then gone. It lacks the durability of a work of written literature, which can in substance, if not material form, be preserved through the ages. And it lacks the durability of painting and sculpture, which can be preserved materially, documented secondarily in descriptive literature, or preserved through serial replication. Music as a body of value and technique is transmitted from master to student, but the true continuity of the specifics of value and technique are impossible to verify for periods before the technology for recording and thereby preserving sound existed. Thus, as we explore the history of Chinese culture, much of what we are able to say about musical performance and the musical dimension of mixed arts is destined to be conjectural, even when such arts are still practiced in the modern era. There are classically trained Chinese scholars who chant the *Tso Commentary (Tso-chuan 左傳)* and living traditions of theater that derive from the opera of the Yüan dynasty (A.D. 1279-1368). But the current practices, the prompt books, the libretti, scripts, and musical scores notwithstanding, most scholars will safely demur when asked about the music of the *Book of Odes*, Han Music Bureau songs (*yüeh-fu 樂府*), Sung dynasty (A.D. 979-1279) songs (Sung *tz'u 宋詞*), or Yüan drama *(tsa-chü 雜劇)*. If any component of the rituals and entertainments of an ancient civilization is to be recovered only partly and with the greatest expense of effort, it is the musical.[7]

[7] Elaborate studies have been done on the periphery of musical issues, for example, Dale R. Johnson, *Yuarn Music Dramas: Studies in Prosody and Structure and a Complete Catalogue of Northern Arias in the Dramatic Style*, Michigan Papers in Chinese Studies no. 40 (Ann Arbor: The

Further, it is often observed that, of all the arts, music is least responsive to verbal description, analysis, and record. Even the known music of our time is intractable if we ask, "What does it say?" or "How does it work?" While the inadequacy of a verbal description of a musical event is manifest, descriptive terminology that has its origins in discussions of music has, nonetheless, found wide use for critical description in other fields. We describe colors as "loud" and "muted," relations as "harmonious" or "discordant," and events as "well orchestrated." In the *Poetics*, Aristotle argues that the instinct for "harmony" and "rhythm" is one of two fundamental causes of poetry. Music is regarded as a more essential and valuable form of "imitation" than painting and sculpture, because music, like the activities of the human mind, takes place in time.[8] In early China, the term for music itself, *yüeh* 樂, was widely used as a pun with its homograph *lo* 樂, "joy" or "enjoyment"; and such musical terms as "harmony" (*ho* 和),[9] "resonance" (*ying* 應), and "gravity" (*pei* 悲) became central to the critical terminology of other arts.[10]

The problem of verbal description of music is a problem in the nature of meaning, and detailed consideration of it is beyond the scope of this work and beyond my competence. Still, some comments on meaning and affect in music bear mention because they are especially illuminating for

University of Michigan Center for Chinese Studies, 1980). These focus on questions of rhyme pattern, musical mode, and tempo but generally do not attempt to describe the music per se, that is, the melodic and rhythmic components of the performance. The useful exceptions to this demand skillful research, subtle interpretation, and often some degree of dependence on living traditions of performance. See, for example, Liang, *Chinese Ch'in;* Pian, *Song Dynasty Musical Sources;* and Picken, "*Shi Jing* Song-texts and Their Musical Implications," pp. 85-109. Some of Picken's hypotheses are discussed in the following chapter.

[8] Walter J. Bate, ed., *Criticism: The Major Texts* (New York: Harcourt, Brace, and World, Inc., 1952), introduction, pp. 4-5.

[9] In the synonymic equations of the *Erh-ya* 爾雅, *ho* is used as the defining term for five monomes that are not descriptive of sound and two binomes that are (*Erh-ya* 1B.8).

[10] Some highlights in the development of terminology are reviewed below. For a more extended treatment, see my article "Early Chinese Music."

the major Chinese notions. A cornerstone observation in many theories of music is a comparative one to those arts in which a "medium" like language, stone, paint, or metal is used. The medium stands between the formal system of the art and the phenomena outside the art itself that is represented. Music is without a medium in this sense because it does not make reference to something outside itself. There are, of course, theories of music as a language, a semantic system with some content separable from its musical embodiment, translatable into other semantic systems.[11] Schopenhauer described music as the language of the irrational mind. Certain musical sounds, called "sound effects," are identified through convention as references to something in the material world, e.g., cannons, hoof beats, thunder, and church bells. Just such effects are from time to time in the forefront of serious musical culture, for example, the sound painting of the romantic symphony. But the object value provided program music is always contrived; the referent is usually explained in the title and requires the addition of composer's notes or some other explanation to inform the listener. The music alone cannot inform the listener of its object value. Music is fundamentally nonrepresentative, exhibiting pure form not as an embellishment, but as its very essence.[12] In Susanne Langer's phrase, music places "practically nothing but tonal structures before us: no scene, no object, no fact."[13] Zuckerkandl argues that tones, in contrast to ordinary language, are not referential. "What tones mean musically is completely one with them, can only be represented through them, exists only in them."[14] Program music is the easiest kind of music to discuss because what it allegedly represents can be described.

[11] For a recent comparison of music and language, see Zuckerkandl, *Sound and Symbol*, pp. 66-71.

[12] An extreme example of program music, e.g., Leroy Anderson's "Typewriter Song," might be raised as a counterexample. It is, however, not only a very rare kind of music, but, like many forcedly representative pieces of music, it uses the object of representation itself to make its own sounds. A typewriter, like the cowbells, cannons, and church bells of Strauss and Mahler, is quite distinct from the essential instrumentation that characterizes symphonic performance.

[13] Langer, *Philosophy in a New Key*, p. 209.

[14] Zuckerkandl, *Sound and Symbol*, p. 67.

It is more than sheer intellectual challenge that draws discussions of aesthetics toward music. At least since Pater, the effort to differentiate that which is aesthetic from that which is not has focused on form and structure rather than on the "stuff" of art. "Stuff" in the case of music means modal or rhythmic resources. As Picken writes, "It must be emphasized that the fundamental and most distinctive characteristics of music are neither modal nor rhythmic (on a small time-scale) but formal."[15] In the literature, one finds the expressions "aesthetic form," "expressive form," and "significant form" offered as the primary and definitive requirement of art. In Benedetto Croce's words, "The aesthetic fact, therefore, is form, and nothing but form."[16] It is music's manifest purity of form, or total absorption of matter into form, that makes it the object of contemplation par excellence for the philosopher of aesthetics.[17] The claim that form is the definitive element in art is widely accepted as a premise in contemporary inquiries into aesthetics. The key to meaning in music is sought, therefore, through an examination of its structure, and what may be extended from music to other arts is in the realm of structural analogies. Zuckerkandl, in his study of the psychology of human response to music, refers always to the temporal and systematic character of musical art, using terms like "system of tone," "dynamic symbol," "tonal motion," "time images," and "flowing space." In his argument, what is aesthetically significant in music resides not in the individual tones, but in the relationship between one tone and another. Though Zuckerkandl reveals no knowledge of Chinese theories of the arts, many of his notions find close parallels in the discussions throughout this book.

Other contemporary discussions of music explore the structural features in a semasiological context. Leonard Meyer has investigated the nature of musical meaning by exploring parallels between musical structure

[15] Picken, "Shi Jing Song-texts and Their Musical Implications," p. 109.

[16] The observation is part of a consideration of three positions on the "aesthetic fact," that is, that which is aesthetic about something regarded as aesthetic: the content, the relation of the content to the form, or the form. Croce, Aesthetic, chap. 2: "Intuition and Art," esp. pp. 25-26.

[17] The history of attention to significant form and the notion of art as significant are reviewed by Langer, Philosophy in a New Key, chap. 8: "On Significance in Music," pp. 204-45.

and other systems of significance that have been analyzed with the re-
sources of information theory.[18] Hence, Meyer's premises include the
claim of a triangular relationship between signifying and signified elements
in musical significance. Meyer allows music a degree of referential mean-
ing through processes of association but is ultimately concerned with the
unfolding of pattern in the temporal span of performance.[19] Other recent
discussions of music have become highly formalist, with one argument
advancing a set-theoretical analysis, reminiscent of mathematical linguis-
tics theory, which compares structure at multiple levels and analyzes
probability of pattern occurrence.[20]

Following his declaration of music as the perfect art, there are two
points that Pater elaborated. Within itself, music is unique in that form
and matter are inseparable, whereas in other arts they are separable to
varying degrees. In contrast to the poet and landscape painter, the powers
of the musician are unfettered by matter and objects. In his later writings,
Pater moved to an extreme position where he argued that music is the only
discipline in which the artist is wholly free to modulate form without any
object conflict whatsoever. Outside itself, music is the art that links
together the infinitely diverse impulses of the cosmos, what Pater calls the
"perpetual flux." In what is essentially a Pythagorean argument, he sees a
world in flux, within which is the unity of a reasonable order. The
underlying principles are discovered in a search for "an antiphonal rhythm,

[18] Meyer, *Music, the Arts, and Ideas.*

[19] "Musical meaning arrives when an antecedent situation, requiring an
estimate of the probable modes of pattern continuation, produces
uncertainty about the temporal and tonal nature of the expected conse-
quent." Ibid., p. 11.

[20] In this literature, there is concern about either problems of structure or
problems of ontology. The central ontological problem is the relation-
ship of the work (which is unique) and performances (which can be
multiple). For a review of the literature, see Randall Dipert and R. M.
Whelden, "Set-Theoretical Musical Analysis," *Journal of Aesthetics and
Art Criticism* 35, no. 1 (Fall 1976): 15-22; and a counterthesis in the
same journal, vol. 35, no. 4 (Summer 1977): 471-73. Meyer presents a
general critique of "formalism," expressed in statistical theories of
music and analogies to mathematical models, in the section entitled
"Formalism in Music: Queries and Reservations," pp. 235-316 in his
Music, the Arts, and Ideas.

or logic, which proceeding uniformly from movement to movement, as in some intricate musical theme, might link together in one those contending, infinitely diverse impulses."[21] What is involved in the movement is all creation, and it is beyond ordinary comprehension; hence, the form, or structure, of that movement is pursued by the inquiring mind.

The points Pater made are worth reviewing because he invokes many of the same elements invoked by early Chinese investigators, who were involved with scientific thinking and technological activities. Pater extolled the natural science of his day, observing that "those sciences reveal types of life evanescing into each other by inexpressible refinements of change. These things pass into their opposites by accumulation of undefinable quantities."[22] Pondering similar theories of transformation, early Chinese thinkers sought to specify the exact transformation, from what to what and under what conditions of time and space. The conception of such transformations was by no means limited to merely the transformation of one thing into another. For example, foodstuffs are transformed into particular biological qualities:

> Eaters of grain are intelligent and refined. Eaters of grass are powerful, but stupid. Eaters of mulberry make silk and become moths. Eaters of meat are brave, but audacious. Eaters of earth have no hearts and do not breathe. Eaters of ch'i are spiritual and long-lived. Those who do not eat at all are immortal and divine.[23]

A prominent example stresses the seasonal rhythm of transformations in the "Monthly Ordinances" ("Yüeh-ling") chapter of the *Book of Rites*. In the "Monthly Ordinances," for instance, the transformation of "hawks to pigeons" is related to the middle of spring, the opening of peach blossoms,

[21] Walter Pater, *Plato and Platonism* (1893; library ed., London and New York: Macmillan and Co., 1910), pp. 17-18.

[22] Walter Pater, *Appreciations* (1889; library ed., London and New York: Macmillan and Co., 1910), p. 66.

[23] This widely quoted passage is found in the extant twenty-chapter version of Kan Pao's 干寶 *In Search of the Supernatural (Sou-shen-chi* 搜神記 12.300, *Shih-chieh shu-chü* ed., p. 89), but it was probably inserted into that text from other Kan Pao writings by Ming dynasty redactors. This statement, which goes on for several hundred words to catalogue various transformations in nature, and similar discussions are known as "Discourses on Transformation" ("Pien-hua lun" 變化論).

and an entire system of correlates more or less synchronous in nature's clocked processes.[24] Transformations of one thing into another were of a predictable nature and occurred within a predictable time frame. A normal avenue of scientific inquiry, then, was the determination and refinement of those specifics, the development of a complex taxonomic classification that followed the tropical year and branched throughout the phenomenal world. At the same time, a desire for parsimony, evident in the enunciation of principles, motivated the search for comprehensive and uniform principles encompassing the myriad transformations. Human processes being part of cosmic processes, the principles applied uniformly to human and nonhuman phenomena.

Pater understood art as an intensely human enterprise, but he, too, saw in music a fundamental order common to both the human mind and other ordered processes of nature. Early Chinese speculative thinkers seemed especially committed to the identification of a fundamental order in music and the pitches that could be applied uniformly and comprehensively to all the processes of nature that took place in time.

From the more narrowly focused standpoint of aesthetics, Pater attributes music's superiority to other arts to its temporal dimension. Human feelings, he argues, transform in time, and, of all the arts, music is most capable of imitating that process of transformation. This argument is, in essence, an elaboration of Aristotle's claims for music and must be addressed in any comprehensive treatment of aesthetic problems.[25] The temporal dimension of music was important for the cosmos-music-mind correspondences that early Chinese thinkers sought to define. But it creates for the aesthetician the same problem transformation theories create for the natural scientist. The obvious path for inquiry is to determine and refine the specific relations between music and feeling. In China, classical and Han thinkers labored over just such systems of "correlation."

But the simple experience of music, especially interculturally, has always confounded attempts to associate a particular piece, a genre of

[24] "Yüeh-ling," pp. 7b, 11a.

[25] See, for example, "Configurations in Space and Time Not Based on Qualitative Relations," chap. 3 in Stanislaw Ossowski, *The Foundations of Aesthetics,* trans. Jarina and Witold Rodzinski (Warsaw: Polish Scientific Publications, 1978), esp. pp. 26-29, where Ossowski discusses rhythm.

music, a key or mode, or a chord with particular feelings on a one-to-one basis. A sensitive connoisseur of a baroque mass might not react at all to a passionately stirring moment in Japanese *nagauta*. Langer subscribes to the essential definition of music as orderly change in time, but she refines the notion of the connection between music and human feeling by arguing that music represents the morphology of feelings. A determined one-to-one correspondence between a particular musical moment and a particular feeling cannot be reliably established. But the structure of feeling and the processes of change can be represented. That is to say, music tells us "how feelings go."[26] Music is articulation, and the central act of music, and of all art in time, is the creation of syntax, of meaningful arrangement.[27] This is essentially the premise of Zuckerkandl when he argues that the relation between tone and emotion is dynamic in process, either moving toward or moving away from something.[28]

The problem of the universality of musical experience was confronted by philosophers in the classical period. As early as Confucius, there are extensive comments on the differences between regional musics; and of all the arts with a heritage of orthodoxy, music seems to have been the most conspicuously vulnerable to outside influence. Instruments, tunings, and songs from the border areas are known to have enriched the performance practices in the court. In contrast to the literary arts, official machinery for music was established to introduce musical innovations and to oversee the training of performers at least since the Han dynasty Music Bureau. The exposure to a variety of musical traditions must have impeded efforts to establish music : feeling correlates in the same way that it taxed efforts to maintain the discipline of traditional orthodox forms. Though there were strong claims for the predictable correspondence between music, feeling, and numerous other correlates, some skepticism is evident in classical texts, and the same problems that Langer has considered were dealt with explicitly by no later than the third century A.D. Hsi K'ang 嵇康 (A.D. 223-62), for example, denied that a particular note or piece of music had the same effect on all listeners and yet acknowledged the capacity of music to evoke strong feelings.

[26] Quoted from a brief, but provocative discussion of Langer by Donald Davie in his *Articulate Energy*, p. 7.

[27] Langer, *Philosophy in a New Key*, pp. 204-45.

[28] Zuckerkandl, *Sound and Symbol*, pp. 60-62.

The discussion of art itself, either generally or in reference to a particular culture, is no more tractable than that of music. The study of Chinese aesthetics in the West has developed very gradually and is only now beginning to accelerate. Key primary texts in literary theory and painting theory have been known for some time, though they were largely read through the translations and adaptations of pioneering translators. Because of the extraordinary demands they make on language skills, the early poems and essays in which ideas about aesthetics are explored are usually very difficult to translate. With the luxury of more text-worthy scholars than the field has known before, we now see more and closer contact with important works on the theory of art spawning a new interest in aesthetics and a higher order of confidence in addressing the broader issues. What work has been done has dealt primarily with literature, using both literary and critical-theoretical sources, and secondarily with visual arts, using the object, descriptive writings, and theoretical writings. There has been almost nothing about music and aesthetics, in spite of the importance of music in native philosophies of art in both China and the West.[29] Reasons for this can be suggested. First, of the Six Arts (as fields of learning), only music does not have an extant classical text. Whatever slings and arrows of misfortune we might imagine assaulted the existence of archaic manuscripts, the absence of a classic of music is culturally significant. At the very least, it indicates that no known text was felt to be an exhaustive statement on the subject, worthy of canonization. This state of affairs leaves sinologists without even a disreputable text, like the *Book of Documents* or the *Programs of Chou*, with which to begin. We are in much the same situation as the Han redactors and compilers of the "Book of Music," having to reconstruct a canon from the bits and pieces of all known texts, earlier and later, and trying to sort consistent from contending views in order to position everything meaningfully on the circuit of prevailing theories. Even the "Book of Music" is burdened with textual flaws and variants that have not been fully scrutinized by scholars, and the dating of the work is the subject of widely varying opinions.

Not being a musicologist, I justify this essay on music by regarding it as an opportunity to investigate theories of aesthetics; that is, an opportunity to investigate the relationship among theories of music, aesthetics,

[29] An exception to this is a pioneering comparison of Chinese and Western music theories by Munro, *Oriental Aesthetics*, pp. 21-23.

and cosmology in early China. This approach will simplify the discussion of aesthetic theory because it derives a unity of analysis from the strong unity of perspective on art and existence exhibited by the early Chinese. To the extent that highly specialized discussions of philosophy of art lose sight of that unity, they risk losing intelligibility for many readers. Theories of art ultimately return to theories of creation and existence. Wallace Stevens expressed it succinctly in "Three Academic Pieces":

> The accuracy of accurate letters is an accuracy with respect to the structure of reality.

> Thus, if we desire to formulate an accurate theory of poetry, we find it necessary to examine the structure of reality, because reality is the central reference for poetry.[30]

The unity of perspective apparent in the aesthetic and cosmological theories in early China is manifest in the unity of terminology. A broad discussion on aesthetics will necessarily focus on the "Way" (Tao 道), just as would a broad essay on the nature of the cosmos. Other words, e.g., "configured energy" (ch'i 氣) and "representation" (hsiang 象), would likewise appear in both discussions. This unity of terminology is reflected in recent interpretations of early China, for example, James J. Y. Liu's chapter "Metaphysical Theories" in *Chinese Theories of Literature* and Frederick Mote's chapter "The Beginnings of a World View" in *The Intellectual Foundations of China*. The problem will always remain to define and explain the key terms in the ancient texts, because they are in fact the only keys to understanding the theories. Because music had an experimental tradition associated with it, it can contribute to our understanding of key terms from a perspective as yet unexplored by modern sinology.

The primary textual sources for the study of early music divide into two types of material: analytic-discursive (argument) and illustrative-narrative (lore). The influence of theory is evident in both argument and lore. Discursive texts and narratives are found in all periods. Typically, they are attuned to different concerns, with the discourses of one age laboring over the narratives of a former age and the narratives of one age adumbrating the discussions of a future age. The influence of several theoretical positions is present in each age, and that makes a chronological

[30] Stevens, "Three Academic Pieces," in *The Necessary Angel*, p. 71.

presentation of the material uninformative. Similarly, dividing the materials generically reveals more about the development of writing than it does about music. I will divide the subsequent discussion into a number of substantive areas that reflect, but do not follow precisely, chronological and generic distinctions: (1) archaeological and textual records of the earliest known performances; (2) early music theory and legend; (3) larger contexts of music theory and the application of music theory; (4) idealized concepts of performance, especially with the *ch'in* zither; and (5) general discussion of music and aesthetics in early China.

CHAPTER II

An Early Performance

Until the era of Ts'ao P'i 曹丕 (A.D. 187-226) and his contributions to literary theory, texts about art were deeply involved with music and sound and discussed them in distinct ways. Some focused on the *Book of Odes*, addressing the musical and literary components of its contents without differentiation. Some spoke generally of sound and acoustics, considering the sources of sound, ways of classifying the qualities of sound, the origins of pitch standards, the "piping" of the heavens, and the power or virtue of sound. Still others spoke explicitly of *yüeh*, which in its early meaning encompassed a range of performed music, including dance, mime, and other ritual and festival activities.[1] Dancing *(wu 舞)* and singing *(ko 歌)* appear with some regularity in early oracle-bone and bronze inscriptions, demonstrating that they played a recognized role in ritual and official functions.[2]

At least since Hsün-tzu's time, when *yüeh* was discussed at length it was construed as a complement to *li*, "ritual." As such, it was seen largely in moral terms, promoted as the most efficient means of transforming the people and the most accurate means of gauging the morality and morale of society. But on balance, the character for *yüeh* is infrequently used in classical China prior to the "Book of Music." With the exception of sections in the *Hsün-tzu* and the *Chuang-tzu* 莊子, *yüeh* is less prevalent and less important than its homograph *lo*, "joy" or "enjoyment."

[1] More will be said about *yüeh* and its etymology below. In terms of practice, Kenneth Robinson argues that *yüeh* meant "cheerful noise" in classical times and included a range of percussion sounds, dancing, and gestures. See his "New Thoughts on Ancient Chinese Music," p. 31.

[2] Chow Tse-tsung, "The Early History of the Chinese Word *Shih* (Poetry)," in *Wen-lin: Studies in the Chinese Humanities*, ed. Chow Tse-tsung (Madison: University of Wisconsin Press, 1968), p. 152.

In the "Canons of Shun" ("Shun-tien" 舜典) of the *Book of Documents,*
Shun appoints K'uei 夔 to be his music master and then makes the
following pronouncement: "Poetry expresses intent. Singing extends
speech, and sound follows that extension. The pitches make the sound
harmonious. When the eight instrumental timbres are in accord, one does
not encroach upon the place of another. Thus spirits and men are also in
accord."[3] This brief excerpt places music in a superior position to poetry
in terms of expressive potential, an idea that was expanded and recited in
most major works on poetry or music until the T'ang dynasty. The best-
known elaboration of it is the "Great Preface" ("Ta-hsü" 大序) of the Mao
edition of the *Odes.* This work, probably written by Wei Hung 衛宏 (first
century A.D.), is often cited as the *locus classicus* of the idea:

> Poetry is where the intention goes. Within the mind, it is inten-
> tion; issued forth in words, it is poetry. Feelings are stirred within.
> Their external form is in words. When words are not enough, feelings
> are expressed with exclamations. When exclamations are not enough,
> feelings are extended in song. When extending them in song is not
> enough, feelings are expressed unconsciously with waving [lit., "danc-
> ing"] hands and bouncing feet.[4]

This paragraph assembles the four activities in a group with a common
Ursprung, then puts poetry, exclamation, song, and dance in a series of
increasing expressiveness. Not only is this particular series quoted time
and again, but the idea of placing genres, subgenres, instruments, poets,
painters, and artists in a list according to their expressive potential, signi-
ficance, artistry, and so forth, becomes a common strategy in literature on
the arts.

[3] There are three sections about K'uei the music master and about music in
general early in the *Shu-ching.* These are variously included in either the
"Shun-tien" or the "Kao-yao mo" 臯陶謨. I have generally followed
Karlgren's arrangement of the text and use his translations below.
Karlgren, *Book of Documents,* pp. 6-7, 11-12. For another set of transla-
tions, see Kaufmann, *Chinese Classics,* pp. 22-24.

[4] For a discussion of the authorship of this passage and another translation,
see Chow, "Shih (Poetry)," pp. 157-58. A provocative analysis of the
"poetry" and "intent" relationship is found in Peter A. Boodberg, "On the
Semasiology of Chinese Poetry and Thought," one of Boodberg's "Cedules
from a Berkeley Workshop in Asiatic Philology," reprinted in the *Tsing-
Hua Journal of Chinese Studies,* n.s. 7, no. 2 (August 1969): 34-35.

In spite of widespread comments in early texts about the importance of music, textual records of early performances are rare. Furthermore, the noteworthy ones we do have are not objective descriptions that would provide for reconstruction of the music. Rather, they give us fleeting hints about the music and slightly more detail about the context of the performance. The main function of the narratives is to use the music and the performance event to illuminate in a moral light their particular historical moment and the historical figures involved. This is consistent with the function of classical narratives generally.

The texts of the *Odes*, the *Tso Commentary*, and the *Analects* provide clues to the nature of *Odes* music and the manner and significance of its performance. The *Book of Odes* is the earliest received text in which there is any material of specific musicological value:

> Hammering the bells—jingle, jingle,
> Strumming the *ch'in* zither, strumming the *se*,
> The reed flute and stone chimes—all blend in tone.
> Performing the Ya and playing the Nan,
> Even the short flute holds its own.[5]

The *Tso Commentary* records a visit by Duke Cha 公子札, fourth son of the king of Wu, to Duke Hsiang 襄公 of Lu. Lu, being the most "correct" state of the time, was regarded as the protector of orthodox music, and the passage is a unique record of a musical performance of the *Odes*. The ceremonial visit of Duke Cha took place in 543 B.C. (Duke Hsiang, twenty-ninth year, par. 12). After what is described as an enjoyable visit with Shu-sun Mu-tzu 叔孫穆子, Duke Cha requests that they listen to a performance of various musics. The text describes the singing of the airs of the states, the "Kuo-feng" 國風 section of the *Odes*, and then the singing of the remaining sections, the "Hsiao-ya" 小雅, "Ta-ya" 大雅, and "Sung" 頌. The traditional praise of Duke Cha's statesmanship notes that

[5] *Shih-ching*, Mao edition, no. 208. The translation is my own and differs somewhat from those of Waley and Kaufmann. I take *ku-chung* 鼓鐘 as a verb-object, "hammering the bells," rather than as two nouns, "drums and bells," to make the syntax consistently parallel in the stanza. See Waley, *Book of Songs*, p. 140; and Kaufmann, *Chinese Classics*, pp. 24-30. A *se* 瑟 is a larger zither than the *ch'in*. The reference to Ya and Nan has been taken as a reference to sections of the *Shih-ching* itself, in which case this poem is a description of selections from the *Shih-ching* being sung with musical accompaniment.

by listening to the music he learned of the moral climate in all of the states. Reflecting on this passage, Picken comments that at the moderate rate of ninety words/beats per minute, a complete performance of the *Odes* would require ten to fifteen hours, and he expresses skepticism that the performance ever really occurred.[6] Nothing in the text precludes the possibility that only selections were sung from each section, which would have made a more feasible performance. On the other hand, the *Tso Commentary* account goes on to list a continuation of the performance with the ceremonial musics of the sage-rulers. The full section deserves translation because it is expressive of the mid-Ch'un-ch'iu comparative perspective on both musical and moral qualities of the airs of the various states.

> The request was made that they listen to Chou music. So Shu-sun Mu-tzu had the performers sing the Chou-nan airs 周南 and the Shao-nan airs 召南. Cha said, "Beautiful! It is the starting of a foundation still left incomplete. Yet the music is encouraging and not at all resentful."
>
> They sang the airs of P'ei 邶, Yung 鄘, and Wei 衛 for him. Cha said, "Beautiful! Very profound. It is somber, but not depressing. I have heard that the virtues of K'ang-shu 康叔 of Wei and Duke Wu 武公 may be linked to these airs of Wei."
>
> They sang the airs of Wang 王 for him. "Beautiful!" Cha said. "Thoughtful, yet not timorous. This was the Chou having moved east."
>
> They sang the airs of Cheng 鄭 for him. "Beautiful!" Cha said. "In intricacy they have gone too far. The people will not be able to endure, so Cheng will be the first state to vanish."
>
> Then they sang for him the airs of Ch'i 齊. Cha said, "Beautiful! These have the sweep of great airs. It was their great ruler who won distinction by the eastern sea. This state is beyond measure."
>
> Then they sang for him the songs of Pin 豳. Cha said, "Beautiful! Their expansive qualities are enjoyable, but they are given to abandon. This, too, was the Chou having moved east."
>
> Then they sang for him the airs of Ch'in 秦. Cha said, "Beautiful! This is the sound of a glorious establishment. Being thus

[6] Picken, "*Shi Jing* Song-texts and Their Musical Implications," p. 90.

gloriously established, they grew and grew to great size. Is it not the old place of Chou?"

Then they sang for him the airs of Wei 魏. "Beautiful!" said Cha. "Full-flowing sound, vast yet graceful. It is dramatic, yet it moves with facility. With the aid of their virtue, the lords of Wei will be bright."

Then they sang the airs of T'ang 唐 for him. Cha said, "Deeply thoughtful! Are not these people what remains of the lines of T'ao 陶 and T'ang? Were it not so, could the feeling of concern extend so far? What people could have achieved this without the legacy of T'ao's and T'ang's virtue?"

Then they sang for him the airs of Ch'en 陳. Cha said, "When a state lacks a ruler, can it survive for long?" From the music of Kuei 鄶 to the end of the airs, he offered no critique.

Then they sang the "Hsiao-ya" for him. "Beautiful!" Cha said. "They are thoughtful, but not complaining; aggrieved, but keeping their peace. Is there decline in the virtue of Chou? These are still the people who have come down from the former kings."

Then they sang the "Ta-ya" for him. Cha said, "Vast! Glorious! The songs wind about, yet [the thrust of] their composition is straightforward. This is the virtue of King Wen 文."

Then they sang the "Sung" for him. Cha said, "The ultimate! These songs are straightforward, but not overbearing. They wind about but do not bend over. When pressing near, they do not crowd; when moving afar, they do not drift away. They move, but within bounds; they repeat but do not bring on boredom. They make one be attentive but do not make one worrisome. They are enjoyable, but not in an uncontrolled fashion. They are useful, but not consuming; they are vast, but not shouting; giving, but not wasting. They are taking without hoarding, managing without smothering, forthcoming, but not dissipating. The five sounds harmonize and the eight winds are in balance.[7] The rhythm is measured in a disciplined and orderly way. It is in full accord with virtue at the height of its bloom."

[7] The "eight winds" may be either a reference to the eight "timbres," or instrumental voices, discussed below or a reference to the influence of the "airs" of surrounding areas.

After that, Cha watched dances accompanied by ivory pipes and southern-style short flutes, and he said, "Beautiful! Yet, still it is regrettable." When he watched them perform the Grand Dance of King Wu, he said, "Beautiful! Chou at its very zenith was like this."

When he watched them perform the Shao-hu dance 韶護 [of the Yin king T'ang 殷湯], he said, "This displays the greatness of the sage. Yet it is shameful that his very virtue is what made difficulties for the sage."

When he watched the Ta-hsia dance 大夏 [of Yü 禹], he said, "Beautiful! Laboring away without assuming merit--who but Yü was capable of such refinement?"

Then he watched them perform the Shao-hsi dance 韶箾 [of Shun 舜]. Cha said, "This is virtue at its very extreme! Just as there is nothing beyond heaven's canopy and nothing reaching beyond the support of earth's surface, a virtue of whatever height could not add a bit to this. This is all a person need witness. If there be other music, I would not dare ask to hear it."[8]

The original *Spring and Autumn* text only mentioned the visit of Duke Cha to Lu. The commentary is the only documentation of this kind of performance of the *Odes* in the sixth century B.C. It reveals the regional (and hence generic) preferences of the commentator for the Ya music of Lu over the music of Cheng, in particular. It shows the high degree of specific correspondence seen between types of music and public morality and morale, and it shows the immediate apprehension of morality and morale by someone sensitive to the music. It names the historical musical genres credited to the sage-rulers of high antiquity, and, finally, the passage reveals something of particular aesthetic qualities that were held in esteem. Toward this last end, it introduces over two dozen descriptive terms that were used to criticize the works or the performance. All of these were areas of interest to classical and Han historians and theorists.

In an effort to reconstruct features of the music in such a performance, Picken makes a number of assumptions based on his familiarity with the *Odes*, later Chinese music, and liturgical music in other traditions. He views the verbal text as "indissolubly wedded to musical lines"; music is not

[8] For a somewhat different translation, see Legge, *The Chinese Classics*, 5:549-50.

seen as an attachment to or accessory of lyrics with an independent exis-tence.[9] He envisions a music sung in strict and evenly measured time, with one syllable (and therefore one graph) allotted one beat, and with a predominantly four-beat line suggested by the preponderance of four-syllable lines in the *Book of Odes* texts.[10] With a series of statistical analyses, he compares the texts of the airs of the various states, infers the extent of the variety and irregularity in the accompanying melody, and offers a tentative explanation of what "intricacy" *(hsi 細)* meant, the single most negative term in Duke Cha's lexicon of critical terminology with which he described the airs of Cheng. Picken writes, "In the degree of irregularity exhibited by the songs, Cheng . . . is characterized by a high degree of irregularity."[11] Picken sketches a vague, yet intriguing picture of how a performance of the *Odes* might have sounded.

Our ability to fill in the details of such a picture has improved unex-pectedly with several important archaeological discoveries in recent years. In March 1978 a large cache of musical instruments was excavated from the tomb of a Marquis Yi of Tseng 曾侯乙 , located in Hupei's Sui County. The sealing of the tomb has been convincingly set at 433 B.C. by archaeologists on the basis of dates engraved on excavated items and epigraphic analysis of the inscribed texts.[12] The region is the area of ancient Ch'u, the remote southern state to which Ch'ü Yüan was exiled and where he collected his *Songs of the South (Ch'u-tz'u* 楚辭*)*.

Within the tomb were one hundred twenty-four musical instruments, including drums, flutes, mouth organs, zithers, a thirty-two-chime litho-phone, and a sixty-four-piece bell set. The bell set is the largest and most complex discovered to date, and the instruments are, on the whole, in remarkably good condition. The find is evidence of the variety of instru-ments in circulation only one century after the *Tso Commentary* report of Duke Cha's trip. The intricate cast-relief on the grand hanging bell set, the

[9] Picken, "*Shi Jing* Song-texts and Their Musical Implications," pp. 89-90.
[10] Ibid., p. 87.
[11] Ibid., p. 103.
[12] For general background on the tomb, see Ch'iu Hsi-kuei, "Tseng Hou-i mu ti wen-tzu tzu-liao," p. 25. On the basis of historical records, the state of Tseng was not known prior to the excavation, but the location of the tomb and the inscriptions on the largest bell make clear that it was in or adjacent to the territory annexed by Ch'u.

slender and elegant dragon feet at the base of the meter-high chime stand, and the ornately carved and glossy lacquer body of the five-foot long *se* zither help conjure up an image of the orchestra before which Shu-sun Mu-tzu and Duke Cha might have sat.[13]

In each family of instruments there is a variety of pieces. There are a number of different drums covering a range of sizes and playing techniques. The zithers range from five to twenty-five strings, and they vary considerably in degree of sophistication, craftsmanship, and technical maturity. The variety in each family is suggestive of significant regional differences in instruments and instrument-making technology. It is quite possible that as Duke Cha listened to the airs of different states, special instruments appropriate to each region were added for their respective selections.

Inscriptions on the bells and chimes total more than four thousand characters. These have provided information on the musical theory and nomenclature of twenty-four hundred years ago, which had all but been lost until the excavation. Of great interest are the comparative data for the pitch systems of various regions. Different terminology is used for the pitch gamuts of Ch'u, Chin, Ch'i, and Chou, which attests to a degree of regional independence in the musical development of these ancient states. Complex nomenclature is used to describe the different pitches, the intervals, and the octave levels in this great span of bells, prompting a reassessment of the sophistication of archaic music theory. Finally, due to the number of bells in the set and the remarkable dual-pitch capabilities of the bells, musicologists have been obliged to reconsider their assessment of the complexity of modal resources in archaic Chinese music and the extent to which bells could participate in melodic performances. The scales

[13] For illustrations of a number of the most important instruments recovered from the Marquis of Tseng's tomb, see Lei-ku-tun fa-chüeh-tui, "Tseng Hou-i mu fa-chüeh chien-pao," pp. 1-24. Of particular interest are the *se* zither (insert pl. 8.3) and the lithophone (pl. 21). The stand of the lithophone is original, but the stones themselves had disintegrated and have been reconstructed. Exquisite photographs of a selection of treasures from the tomb are found in *Out of China's Earth: Archeological Discoveries in the People's Republic of China*, ed. Qian Hao, Chen Heyi, and Ru Suichu (Peking: China Pictorial; New York: Henry N. Abrams, Inc., 1981), pp. 45-55.

themselves differ from the orthodox system described by late Chou and early Han theorists, suggesting again a considerable variation of standards from area to area. Study of the dedicatory inscription has made clear that the bells were a formal gift presented by the king of Ch'u, and they were to find "eternal" use as ritual implements. There has not been any discussion as yet about what the repertoire might have been for the musicians who performed with these instruments. Although the Sui County tomb site is far removed from the ancient state of Lu, it is possible that many of the instruments resembled what would have been found at the Lu court of Duke Hsiang.

The critical terminology used by Duke Cha is difficult to interpret because its usage is not corroborated in similar contexts elsewhere in the *Tso Commentary* or in other archaic texts. Because they are often used in pairs, the terms have clear positive or negative senses. One term names a virtuous quality, the other the same quality taken to excess. It is good to be "straightforward" (*chih* 直), but not good to be "overbearing" (*chü* 倨); "thoughtful" (*ssu* 思), but not "timorous" (*chü* 懼); and "winding about" (*ch'ü* 曲), but not "bending over" (*ch'ü* 屈). Embellishment is praised, but wildness or abandon is criticized. Enjoyment is allowed, but only when kept within proper bounds. From the entire series of comments there emerges a preference for simplicity of surface, for balance and equality in measure, and for symmetry. No distinction is drawn between the music and the lyrics in Duke Cha's critiques; the aesthetic unity of the performance is preserved and judged as a whole. The expression of critical terms in pairs or larger sets becomes a characteristic of later theory and criticism. Virtues of the artistic act or object are seen in balance with their particular failures, usually excesses of the same qualities.

CHAPTER III

Music, Hearing, and the Mind

The interaction between music and public spirit that so occupied Duke Cha became the major concern of Confucian thinkers in their discussions of music. The relationship between music and the people had many facets. The music performed under the auspices of the ruler—for both ritual and entertainment purposes—had a moral influence on his population. The theme of music as an instrument of moral education was often mentioned by Confucius, according to both the *Analects* and the *Book of Rites*. It was first developed at length in sustained discourses by Hsün-tzu and Han-fei-tzu 韓非子 and subsequently canonized during the early Han in the "Book of Music" chapter of the *Book of Rites* and the "Treatise on Music" ("Yüeh-chih" 樂志) in the *Records of the Grand Historian (Shih-chi)*. The perception of music as a spontaneous expression of public sentiment or barometer of the spiritual condition of the people is pervasive. Confucius used it as justification for studying the *Odes*, and it was subsequently used as the rationale for establishing official bureaus commissioned to collect songs outside of court and introduce them into courtly entertainments. In the very degenerate states, music clearly reflects that degeneracy, though a highly articulated explanation of the details is not extant. By and large, the use of sound and music for diagnostic purposes is a matter of esoteric knowledge, whether it be a revelation of public spirit, a measure of the strength of an approaching army, or a portent of the destiny of a ruler and his state.

In the middle and late Chou texts, discussion of music centered around questions of morality and morale. By the Han, the inquiry into the interactive nature of music was broadened to include acoustical theories in the context of natural philosophy. Han thought reflected an element of empirical activity as well. The central concepts of music bore on theories of cosmology and aesthetics from two different perspectives, the moral and the acoustical-numerological. They are mutually illuminating areas of

29

concern in the earlier texts. In many ways, the investigation of acoustics was a natural result of the desire to improve musical instruments. But the thinking about acoustics, mostly in the context of numerological systems, was mandated by the cosmic significance imputed to sound and the moral efficacy imputed to music. Moral and acoustical theory are never closer than in the *Myriad Dewdrop Commentary on the Spring and Autumn Annals (Ch'un-ch'iu fan-lu)* of Tung Chung-shu, a text that strove to synthesize as much of the moral and acoustical knowledge inherited by the early Han as possible. The two perspectives tended to separate after the early Han, with acoustical physics occupying the more vital intellects.

Apparently, music attracted broad interest because it could be used to demonstrate interaction between physically separate entities. By analogy, the potential for remote interaction was imputed to other situations. The music of both court and street linked the lord and his people. The music of the sacrifice linked grateful descendants to the spirits of their ancestors. The music of the rituals linked the ruler with the powers of heaven. It was music that bound together the most intimate of friends. In the absence of anyone else, music provided for the lone wanderer an intense communion with nature. It was an instrument by which the technicians and mediums exerted control over ghosts and demons, and birds and other bearers of future knowledge communicated with diviners and sages. Moral theories defined in general terms the nature of music and its influence, seeking historical proof for the transforming influences of music and discussing its historical and regional varieties, recommending some things and proscribing others. Theories of acoustics took a more analytical look at the foundations of music, the tones and the pitches, and the exact rules governing the interactions and eventually contributed to precise theories of cosmos and history.

Given the range of possible uses of musical theory, few influential classical thinkers failed to give it some, if not always substantial, discussion. Most spoke of it favorably; there is no general condemnation of music in the classical canon. The *Analects* contains over two dozen references praising music for its potential moral and educative influence. Mencius emphasized the influential rather than the diagnostic role of music, making that facet of it the cornerstone of orthodox Confucian thought on the subject. Lao-tzu 老子 and Chuang-tzu explored the mysteries of natural and human sounds and, with sustained metaphors of piping, voice, and music, penetrated somewhat deeper than Confucian thinkers into the

mysteries of the mind, music, and nature. Mo-tzu is unique in his apparent antagonism toward music, but his antagonism is directed specifically against the opulence of aristocratic entertainments and rites, not music per se. In fact, he observes at one point, "Now if musical instruments were for the benefit of the people, I wouldn't venture to condemn them."[1] In both moral and physical theory, the discussion of music had become quite elaborate by the Han, and it was in fact recognized as the freely modulating system that revealed principles of order in diverse events, to borrow Pater's notion. Music understandably appealed to early Han thinkers, who were devoted to the pursuit of intelligible patterns in the "perpetual flux." Music, the uniter, would become a kind of intellectual "philosopher's stone" for them. The early Han scholar was burdened by a great mass of learning and argument from pre-Han times but was tormented by the fear that the wholeness of that learning was lost in the Ch'in bibliocaust and that the significance of the most germinal classical utterances had been corrupted by the passage of centuries. The Han scholar was at the same time innocent of any notion of intellectual specialization and sought some key to bring into wholeness the sum of human knowledge with which he felt compelled to deal. The early Han is a watershed for theories of music, the best vantage point from which to look either forward or backward. In the discussions that follow, texts from the early and late Han are interspersed with earlier texts because their compilers were engaged in the reconstruction and analysis of ideas with roots in antiquity.

Before turning to the technical details of tone and pitch systems, two underlying issues must be addressed. First, there are metaphoric elaborations pertaining to the mind of the sage scattered throughout early writings. These are important in understanding the role of sound and music. Second, there are particularized meanings of the term *ch'i* as it was used in discussions of sound and pitches.

Efforts to describe man's spiritual and intellectual achievements resort to terminology and metaphors that pertain to more readily describable sensory capabilities and sensible reality. Sense organs are taken as synecdoches for the whole mind, in much the same way that neurologists explore general neurological function by examining accessible and easily stimulated retinal cells. In the West, in fact, favoritism for the eye as the metaphoric window to the mind is an ancient strategy. We speak of "men

[1] Watson, *Mo-tzu,* p. 111.

of vision" and are familiar with the irony of the "blind seer." I can think of
no examples of "men of hearing" or "deaf listeners." We describe people as
"bright" or "enlightened," ideas as "clear" or "visionary," and the lack of
learning as being "in the dark," much as Plato compared understanding to a
cave fire or the sun. In the *Timaeus*, Plato wrote,

> The sight in my opinion is the source of the greatest benefit to us,
> for had we never seen the stars, and the sun, and the heaven, none of
> the words which we have spoken about the universe would even have
> been uttered. But now the sight of day and night, and the months and
> the revolutions of the years, have created number, and have given us
> a conception of time, and the power of enquiring about the nature of
> the universe; and from this source we have derived philosophy, than
> which no greater good ever was or will be given by the gods to mortal
> man.[2]

The English word "vision" is etymologically related to "wit," "wisdom," and
"wise," demonstrating the linguistic underpinnings of the family of eye
metaphors for the mind.

In China, a different situation prevailed. In Pan Ku's *Comprehensive
Discussions of Virtue in the White Tiger Hall (Pai-hu-t'ung te-lun)*, written
circa A.D. 80, his discussion of the sage *(sheng-jen* 聖人 *)* begins with the
following paragraph:

> What is meant by the term *sheng* in *sheng-jen*? *Sheng* : sage is
> what connects things; it is the Tao; it is *sheng* : sound. There is
> nothing to which his Tao does not connect and nothing on which his
> illumination does not shine. By listening to sounds, he knows the
> nature of things.[3]

The connection described by Pan Ku was made no later than the late classi-
cal period. In describing the sage, the *Spring and Autumn Annals of Mr. Lü
(Lü-shih ch'un-ch'iu)* says, "[The sage] listens to the sound and understands
the 'winds.' "[4] It credits the sage with the ability to hear the "soundless
sound": "The sage hears the soundless."[5] The *Huai-nan-tzu* likens the

[2] B. Jowett, trans., *The Dialogues of Plato*, 2 vols. (New York: Random House, 1937), 2:27-28.
[3] *Pai-hu-t'ung te-lun* 2.15.
[4] *Lü-shih ch'un-ch'iu* 6.6b.
[5] Ibid., 18.6a.

interaction of the people and their sage-ruler to a sound and its echo: "The empire follows the rule of a sage like an echo follows its sound."[6] Hsü Shen's 許慎 etymological dictionary *Explaining the Graphs and Explicating Their Combinations (Shuo-wen chieh-tzu* 説文解字) defines "sage" as *t'ung* 通 : to pipe, connect, or canalise. And Ying Shao's collection of essays, *Penetrating Popular Ways (Feng-su t'ung-i)*, provides a functional explanation of the link between the sage and sound: *"Sheng* : sage is *sheng* : sound. It bespeaks the fact that the sage hears sounds and understands the nature of things."[7]

The logic of Pan Ku's paragraph and these other arguments depends partly on the appearance of the ear radical *(erh* 耳 , no. 128) in both *sheng* : sage and *sheng* 聲 : sound. The same radical is found in *ts'ung* 聰 , a word that evolved into the contemporary term for perspicacity from the original sense of good hearing or an acute ear.[8]

The proximity of archaic pronunciations of several graphs that incorporate the ear radical suggests that the radical was phonetic as well as etymonic in *sheng* : sage, *sheng* : sound, and *ts'ung* : perspicacious. A philological study of this group, employing new information from the *Lao-tzu* text recently discovered in the Ma-wang-tui tombs, makes a convincing argument for an alternate pronunciation of the ear radical that would have it as a homonym for "sage" and associate it with other words with the ear radical, including *t'ing* 聽 , "hear." On the basis of the philological material and a review of important early textual contexts, a suggested, etymologically transparent rendering of *sheng* : sage was "audient," or "aurally perceptive."[9] Other important words that relate to mind or intellect are derived from music and sound etymons. For example, *i* 意 : intent, constructed by placing *yin* 音 : tone over *hsin* 心 : mind, is defined by Hsü

[6] *Huai-nan-tzu* 9.2b.

[7] This remark is attributed to the *Feng-su t'ung-i* but is not in the extant version. See *Feng-su t'ung-i t'ung-chien* 風俗通義通鑑 (Peking: Centre Franco-Chinois d'Études Sinologique, 1943), p. 94.

[8] "The acute ear of the music master K'uang, without the pitchpipes, could not determine correctly the five tones." *Mencius*, chap. 4: "Li-lou" 離婁, v. 1.

[9] William G. Boltz, "Comparative Notes on the Pelliot and Ma-wang-tui Manuscripts of the *Lao-tzu*" (Paper presented to the Thirtieth Annual Meeting of the Association for Asian Studies, Chicago, 1978).

Shen: "*I* is intent; it comes from 'tone' and 'mind.' Words [expressed outwardly] are examined to know [inner] intent."

The consummately refined sensory skill of the sage was his hearing; it was perhaps the most important means by which his sagacity was made apparent to the world. He had the ability to hear the faintest tones, distinguish the finest interval, and judge the subtlest qualities of timbre. The point is nicely reflected in the "Hsiao-chih" 嘯旨 [Whistling pointers]:

> In ancient times, there were those who roamed about the Su-men Mountains.[10] Sometimes they would hear the sound of the phoenix. The phoenix tones were the very sound of beauty and breadth, no different from the phoenix itself. There are those who cannot hear the tone of the phoenix. How were the wanderers of Su-men capable of getting to know the phoenix's voice? Whoever would seek its sound should hereafter know that it is precisely the immortal's long whistle.[11]

Long, pendant ears were an external sign of the sage. According to an apocryphal commentary on the *Spring and Autumn Annals*, "The ears are signs of the mind."[12] Ko Hung discusses the vision of Lao-tzu conjured up in the meditations of the immortality seeker and notes that Lao-tzu had ears some seven inches long.[13] Lao-tzu's ears were a frequent issue of speculation, and other texts credit him with "ears of three portals."[14]

[10] A mountain range in Honan.

[11] "Hsiao-chih," in *T'u-shu chi-ch'eng* 圖書集成, "Ching-chi-hui" 經濟 彙 [Polity section], "Yüeh-lü tien" 樂律典 [Canon of music and pitches], 76.45b. For a different translation, see Edwards, "Principles of Whistling," p. 226.

[12] Quoted from the apocryphal text *Ch'un-ch'iu yüan-ming pao* 春秋元 命苞 [Primal destinies in the spring and autumn annals], in the *T'ai-p'ing yü-lan*, p. 1812. The full extant text is reproduced in the *Han-hsüeh-t'ang ts'ung-shu* 漢學堂叢書 [Han Studies Hall collectanea].

[13] *Pao-p'u-tzu* 抱朴子 [Master embracing simplicity], *Ssu-pu pei-yao ed.*, *nei-p'ien*, 15.6b. Translated in James R. Ware, *Alchemy, Medicine, and Religion in the China of A.D. 320: The Nei P'ien of Ko Hung (Pao-p'u-tzu)* (Cambridge: M. I. T. Press, 1966), p. 256.

[14] The *Lai-hsiang-chi* 瀨鄉記 [Records of Lai-hsiang], quoted in the *T'ai-p'ing yü-lan*, p. 1812. Lai-hsiang is a village noted for an important shrine to Lao-tzu. See *Chin-shu*, p. 2469. The full text of the *Lai-hsiang-chi* is in the *Han T'ang ti-li-shu ch'ao* 漢唐地理書鈔 [Copies of the geographical works from the Han to the T'ang].

Among the most ancient sages associated with music and the playing of the ch'in was Wu Kuang 務光, described in his biography as a "Hsia dynasty man, with ears some seven inches long."[15] Large dangling ears were recognized by physiognomists as a sign of sagacity and nobility. The association was so well known that it was the subject of humor by the T'ang.

> The emperor said [to Li Chung-ch'en] : "Sir, you have large ears, a sign of nobility."
>
> Chung-ch'en replied, "I have heard that an ass has large ears and a dragon tiny ones. Though I have large ears, they are but the ears of an ass!"
>
> The emperor was amused.[16]

For metaphors in this vein, hearing plays a role in early China analogous to that of vision in the Western tradition. It is not that either is an exclusive metaphor for mental attainment or superiority. Vision and vision-related concepts, especially *ming* 明 : illumination, are found widely in classical discourse. But the ears and sound play a rather more dominant role in early Chinese discourse, and there developed a family of related terms that are important in discussions of sound, music, and sagacity. *Sheng* : sound, *sheng* : sage, *ts'ung* : perspicacious, and *t'ing* : hear are comparable to "vision," "wise," "wisdom," and "wit." We might expect the concepts of harmony and discord to serve a comparable metaphoric function to brightness and darkness, and the idea of supernal pitch and piping to that of divine illumination.

Examples in which the pervasiveness of this metaphoric referent is illustrated are recurrent through much of the classical texts. Perhaps the best-known is Confucius' description of the stages of his own spiritual development.

> The master said, "At fifteen I established my will to learn. At thirty I stood [on firm ground]. At forty I lost all doubts and at fifty knew the mandate of heaven. At sixty my ear was attuned. And at

[15] From the biography of Wu Kuang in the *Lieh-hsien-chuan* 列仙傳 [Biographies of immortals]. For a translation, see Lionel Giles, *A Gallery of Chinese Immortals* (London: John Murray, 1948), pp. 18-19.

[16] Li Chung-ch'en 李忠臣 lived during the reign of Te-tsung (A.D. 779-805). *Chiu T'ang-shu*, p. 3942.

seventy, to be decorous was to obey the dictates of my heart. I could never breach the rules."[17]

We might expect the master to say that at sixty his vision was clear, and the reference to his ears would indeed be puzzling without an appreciation of the metaphoric importance of hearing. Sound achievers are sages. In Chuang-tzu's "Discussion on Making All Things Equal" ("Ch'i-wu-lun" 齊物論), Yen Ch'eng Tzu-yu asks Tzu-ch'i what preoccupies his attention.

Tzu-ch'i said, "You do well to ask the question, Yen. Now I have lost myself. Do you understand that? You hear the piping of men, but you haven't heard the piping of earth. Or if you've heard the piping of earth, you haven't heard the piping of heaven."

Tzu-yu said, "May I venture to ask what this means?"

Tzu-ch'i said, "The great clod belches out breath and its name is wind. So long as it doesn't come forth, nothing happens. But when it does, the ten thousand hollows begin crying wildly. Can't you hear them, long drawn out? In the mountain forests that lash and sway, there are huge trees a hundred spans around with hollows and openings like noses, like mouths, like ears, like jugs, like cups, like mortars, like rifts, like ruts. They roar like waves, whistle like arrows, screech, gasp, cry, wail, moan, and howl, those in the lead calling out *yeee!*, those behind calling out *yuuu!* In a gentle breeze they answer faintly, but in a full gale the chorus is gigantic. And when the fierce wind has passed on, then all the hollows are empty again. Have you ever seen the tossing and trembling that goes on?"

Tzu-yu said, "By piping of the earth, then, you mean simply [the sound of] these hollows, and by the piping of man [the sound of] flutes and whistles. But may I ask about the piping of Heaven?"

Tzu-ch'i said, "Blowing on ten thousand things in a different way, so that each can be itself—all take what they want for themselves, but who does the sounding?"[18]

[17] *Analects*, chap. 2: "Wei-cheng" 為政, v. 4.

[18] Watson, *Chuang-tzu*, pp. 36-37. For another translation of the text, see A. C. Graham, "Chuang-tzu's Essay on Seeing Things as Equal," *History of Religions* 9, nos. 2-3 (November-February 1969-70): 150.

In the *Huai-nan-tzu* and the *Spring and Autumn Annals of Mr. Lü*, there are numerous comments on the sage, his hearing, and his music, most of which speak to the great sensitivity of the sage's ear, his ability to hear the faintest music, even soundless music, and his skill in interpreting the nature of things by hearing their sounds. The claim for superior aural ability reached from the lofty sages of the Taoist classics all the way to the humble and oft-maligned diviners, mediums, and magicians of the early Six Dynasties. Kuan Lu 管輅 of the Three Kingdoms Wei made his reputation as an auspicator, a diviner of bird calls, whose extraordinary hearing was recognized as a child and marked him as a "spirit youth" *(shen-t'ung* 神童). Divination by means of sounds has a continuous history extending back at least to the *Tso Commentary.* Armies are appraised by the sound (usually inaudible to most people) of their approach; the tones of the winds foretell major events; bird calls are analyzed for their prognosticatory import; voices are studied as physiognomic clues; and pitches are analyzed to determine surnames. Some of these techniques will be considered below with my analysis of correspondences. To this point, we have seen examples of piping, pitches, sounds, and animal calls—not even music as yet—around which a rather remarkable body of lore accumulated.

Music and sound were related to underlying philosophical concerns through the idea of *ch'i.* [19] *Ch'i* is a very simple notion, but the term was committed by early writers to a diverse array of functions. This is not to say that it was casually defined and carelessly adapted. Its broad use is indicative of its importance as the nexus of many areas of philosophical inquiry. Whereas the varied contexts in which *ch'i* is used may challenge or confound the would-be translator, they provide shadowless illumination of the term's meaning to the scholar of primary texts. In contemporary usage, the majority of compounds using *ch'i* have meanings related to air. The

[19] I have already used the term "configured energy" as a translation for *ch'i.* *Ch'i* is a fundamental term in music, aesthetics, and cosmology, and it deserves special handling. "Configured energy" is a translation offered by Manfred Porkert in *The Theoretical Foundations of Chinese Medicine.* Porkert has a thoughtful, dialectic way of rendering difficult terms and variously translates *ch'i* as "configured energy" and "energetic configuration," depending on the particular medical context with which he is dealing. I will transliterate the term here, reasoning that using different translations appropriate to the different contexts would obfuscate the unity of the original term.

second and third most common meanings are related to energy and to inner qualities of the mind, the latter including facets of spirit, inspiration, temperament, and character. In the earliest textual discussions of music and sound, the meanings of *ch'i* are associated with experiential reality. *Ch'i* is air in motion, with the emphasis on its energetic potential and ready commutability. This includes air as a medium for sound waves; air as the energy transmitter and the vibrating medium for pipes; air as wind; and air as breath. Air in motion, wind, and breath are associated in Chuang-tzu's speculative "explanation" of the P'eng 鵬 bird's seasonal migration:

> When the P'eng makes his seasonal migration to the Southern Sea, the waters are roiled [by his great wings] for three thousand *li*. He gathers together a swirling column of air and soars upward on it, ninety thousand *li*. His going is the air-motion of the six-month winds, the shimmering heat, traces of dust, the air-motion in which living things share breath.[20]

Much of the early discussion of sound and the pitches is empirical. For those in early China who sought to test the physical nature of *ch'i*, air in motion provided something to detect, assay, and quantify. It provided the simplest demonstration of "remote interaction" (transmission of energy through a fluid medium) and "transformation" (e.g., transducing of lung power to sound). In *ch'i* laboratories of the late Chou and early Han, scholars constructed long tuning zithers, cut precise resonating pipes, pulverized the finest pith-soot, and cautiously blended metals for bells to mimic the cosmic pitches.

Extant records of the efforts to explore the physical nature of sound and *ch'i* are sporadic until the early Han. The concerns they reflect are clearly more ancient concerns, though more ancient records documenting experimentation are scattered and uncertain. One could argue that the burden of the experimental tradition as it matured in the Han was to prove what had been claimed by moral philosophers and cosmological speculators from the earliest times. The fascination with *ch'i* in the senses I am discussing is closely related to the claims for sound already mentioned, including its ability to transmit force or influence from one thing to another without any visible connection; its ability to communicate between regions,

[20] *Chuang-tzu*, chap. 1: "Hsiao-yao yu" 逍遙遊 [Free and easy wandering], p. 1b. For another translation, see Watson, *Chuang-tzu*, p. 29.

between realms (of the living and the dead), and between earth and heaven; and its ability to influence the moral behavior of individuals or of societies as a whole toward virtue or vice. What else but the wind itself could be seen and heard in its power from afar and at the same time felt close at hand? As the "Great Preface" to the *Odes* observes, "The 'airs' [of the states] are the wind. It is the wind that sets things in motion."

Music is the means by which the sage stirs heaven and earth, moves the ghosts and spirits, shepherds the multitude of men, and completes the natures of all diverse things.

Feng-su t'ung-i, p. 1439.

CHAPTER IV

Classical and Han Theory

We have noted some features in the metaphoric elaboration of the sage's mind and some particular refinements of the meanings of *ch'i*. What were the kinds of distinctions the sage could hear? How was sound divided in order to perform its diverse functions? The Han Chinese penchant for building great systems of "regularities" is evident to any scholar of that period. The systems of tone and pitch were among the earliest and probably the most central in conception; and they proved to be so persuasive as patterns of order that they were employed by speculators as systems of logic in their own right. But unlike many of the Han systems, those of tone and pitch were constrained by their actual involvement with the performance of music. The fact that they were verifiable systems enhanced their relevance and appeal. At the same time, it retarded any sproutings of speculation beyond the range of what was verifiable. In studying them, it is important to keep in mind that tone and pitch systems had a dual nature-- one that was primarily acoustical (experiential) and provided the basis for the creation of musical instruments and composition, and one that was primarily numerological (abstract) and provided the framework for correlative systems of other regularities.

There is a basic fivefold division of sound, the *wu-yin* 五音, named consistently in Han texts *kung* 宮, *shang* 商, *chiao* 角, *chih* 徵, and *yü* 羽. This particular order, which is a significant sequence, is found in virtually all of the transmitted textual examples dating from the Warring States period or later. It is an orthodox set, related to conceptions of orthodoxy in both music and theory. Interestingly, archaeologists have uncovered records of variant names and sequences of pitches and tones that had all but been expunged from the transmitted texts.[1]

[1] Huang describes the order of the *wu-yin* on the Marquis of Tseng's bell set as *e* (?) 峇, *yü*, *kung*, *shang*, and *chiao*. He identifies this as a sequence concurring with that recorded in the *Kuan-tzu* 管子, "Ti-yüan"

43

The *wu-yin*, a term which I translate as "five tones," are thought to have originally differentiated several qualities of sound, including, but not limited to, the pitch relation of one to the others in the series. These qualities might have included volume, articulation, composition of harmonics—in short, qualities we might describe as timbre.[2] Needham and Robinson state that by the fourth century B.C., the *wu-yin* had evolved into normal terms for the five relationships of the pentatonic scale. Recently, archaeologists studying stone and ceramic *hsün* 塤, ocarina-like instruments that have been found in a large number of sites dating back to the neolithic and Yang-shao cultures, have argued that the five tones were recognized as a tone system at least as early as the Shang.[3] Care must be taken in describing the five tones, for they are not to be construed as fixed pitches but are rather a "movable doh scale."[4] By this description, the five tones comprised a system of five relata without any predetermined pitch and only of intervallic significance. When any one of the five was fixed with a keynote, the entire group was fixed with respect to pitch and became a mode-key, i.e., a distinct performance group of five tones. In the second century B.C., Cheng Hsüan 鄭玄 provided a mathematical description of the five tones: *kung* as tonic, *shang* 8:9 (major second), *chiao* 4:5 (major third), *chih* 2:3 (fifth), and *yü* 3:5 (sixth).[5]

地賁, as opposed to the orthodox sequence recorded in the *Lü-shih ch'un-ch'iu*, for example. This important bit of evidence authenticates the Ch'un-ch'iu origins of at least some of the *Kuan-tzu* material. The system of theory inscribed on the bell set also records a large number of additional notes and differentiates between octaves by prefacing a *ta* 大 to the tone name in the lower octave and a *shao* 少 to the tone name in the higher octave. Huang Hsiang-p'eng, "Tseng Hou-i mu ti ku yüeh-ch'i," p. 35.

[2] Needham, *Science and Civilisation in China*, vol. 4, pt. 1, pp. 140–41.

[3] The *hsün*, variously called *hsüan* 塤 or *t'ao-hsiao* 陶哨, have been restored, sounded, and subjected to oscilloscopic pitch analysis. Although on the basis of artifacts now in hand it is impossible to determine with certainty how systematic were the three-, four-, and five-tone systems prior to the Shang, Lü Chi reports a striking uniformity of the tonal ratios in instruments dating as far back as the neolithic. Lü Chi, "Wo-kuo wu-sheng yin-chieh," pp. 54–61.

[4] Needham, *Science and Civilisation in China*, vol. 4, pt. 1, pp. 157–63.

[5] The ratios refer to fractions of a string or pipe length, the whole of which generates the tonic.

The unfixed pitch level of the five tones was an important character-istic for cosmological speculators, one which permitted imaginative exten-sion of them in correlation with the five phases (*wu-hsing* 五行). However, in practice they were fixed to a certain extent, a necessity imposed by fixed-pitch instruments such as bell sets. The fifth-century B.C. bells from the tomb of the Marquis of Tseng (hereafter, MT bells) have the five tones inscribed on the fronts of the bells. This not only confirms the inclination to fix the tones; it has also revealed the extent to which the theoretically perfect pentatonic scale was expanded, at least in the Ch'u-area orches-tra. Many of the pitches the bells are capable of sounding are recognized as "expansion," "changed," or "exchanged" pitches (*pien* 變), something purists regarded as a corruption of the system. These are inscribed with combination names, like *kung-chiao* 宮角, indicating that they were con-ceived as either intermediate pitches created to make a six-tone or seven-tone scale possible, or adjusted pitches, an effort at tempering the scale to make more modulation possible within the mode-key system. The latter point will be discussed in more detail below. The MT bells also have anoth-er distinct individual tone name, *ho* 龢, an early form of *ho* 和: harmony, which names an interval of a fourth, indicating that the fourth was felt to be as basic an interval in the tonal system as any in the original set of five.[6] At least a six-tone, if not a seven-tone, scale was well established in the Marquis's region by the fifth century. In the received textual tradition, there is little disagreement with the instruction that orthodox music be limited to the five tones and the charge that the use of more intervals was corruptive. The inscription on the MT bells proves that the "intricate" music of Cheng described by Duke Cha could have been played on them and suggests that the dogma expressed in the Confucian texts was already a reaction against the use in performance of a six- or seven-tone scale. The existence of more complex tone systems than the five tones is further substantiated by the ceramic *hsün*.[7]

[6] Huang Hsiang-p'eng, "Tseng Hou-i mu ti ku yüeh-ch'i", p. 36.
[7] Over twenty *hsün* found in Yu-men, Kansu, in 1976, which are indivi-dually capable of producing four tones but can collectively produce a heptatonic scale. Whether this proves the systematic use of a heptatonic scale or insufficient technology to make the instruments uniform is unclear and will require the discovery of more instruments for analysis. Single *hsün* capable of sounding a six-tone scale that predate the Han have not been found. See Lü Chi, "Wo-kuo wu-sheng yin-chieh," pp. 58-59.

In contrast to the *wu-yin* fivefold division of sound is the gamut of twelve pitches, the twelve *lü* 律. The twelve pitches are a chromatic-pitch gamut in just intonation, believed to be absolute and invariable and related to standards of cosmic authority. Like the five tones, their sequence was significant, and, in the orthodox lists, each was assigned a name.[8] The fundamental pitch, the "yellow bell" *(huang-chung* 黃鐘*)*, was immutable in theory, but it was not always known with precision to mankind. The fixed-pitch level of the twelve pitches was an important characteristic for theorists, permitting imaginative extension of them in correlation with the twelve or twenty-four divisions of the tropical year.[9] As standards, the twelve pitches were duplicated in bells, lithophones, pipes, strings, and, according to the conjecture of some scholars, jade disks.[10] Control of the twelve pitches, exemplified by the possession of high-quality, credible tuning instruments, was an important sign of the authority to govern.

The key to maintaining the accuracy of the twelve pitches was the yellow bell, the lowest pitch. Once the yellow-bell pitch was known, the others could be generated by careful division on a string tuner. The degree of confidence about the accuracy of the yellow-bell pitch varied, in much the same way that certainty about the significance of passages in the *Spring and Autumn Annals* varied. Certification or recovery of the yellow-bell pitch was an issue of imperial concern during the Han and the source of vigorous debate and discussion at court. The remaining eleven pitches in the gamut were generated from the yellow bell by calculating a spiral of fifths. An algorithm called the "Three-Part Subtraction-Addition" (San-fen sun-i 三分損益) was employed to make possible the generation of the spiral within a single octave. Although the twelve pitches are often related in early writings to pitchpipes, the actual determination of the

[8] The significance of the names is a matter of uncertainty that may be clarified by archaeological finds. The orthodox nomenclature for the twelve pitches and the other systems is recorded in the *Chou-li,* probably the earliest extant record of them. In the central section of the "Spring Offices" ("Ch'un-kuan" 春官), the music offices, instrumentation, orthodox systems, and ritual programs for the court are described.

[9] See, for example, the "Yüeh-ling" section of the *Li-chi (chüan* 6) and the *Huai-nan-tzu,* chap. 3.

[10] Kuttner, "Archaic Chinese Jades," pp. 25-50.

gamut appears to have been done with string tuners called *chün*. Two variant characters are used, *chün* 均 : equal division and *chün* 鈞 : standard weight (both **kiwen*, *GSR* 391c, e).[11] The words illustrate the importance attached to regularity and precision in the calculation. The claim that string-generated pitches were the primary standard was originally a hypothesis based on the relative simplicity of dividing strings as compared to pipes. But the claim has been convincingly supported by the MT bells. The inscriptions on a number of those bells make explicit reference to stop positions on the zither boards by which they were tuned.[12] To develop the twelve pitches, a string length and tension were set to sound the yellow-bell pitch. The string length was then divided into thirds and decremented by one-third. This, in turn, was divided into thirds and either decremented or incremented, whichever would keep the product within the octave, that is, between the original string length and one-half its original length. More simply stated, the string length was repeatedly multiplied by either two-thirds or four-thirds, the former being known as "inferior generation" and associated with *yin* 陰 processes, the latter being known as "superior generation" and associated with *yang* 陽 processes. There are two sequences created in this process. One is the sequence of half-tone ascension, step by step from low note to high note. The other is the sequence of generation, the order in which the tones are produced in the cycle of fifths. Both had scientific significance and enriched the inventory for numerological speculation. According to their method of generation, the pitches were divided into six *yin* and six *yang*, respectively known as *lü* 呂 and *lü* 律 . Conveniently, the *yin* and *yang* pitches alternate in both the sequence of ascension and the sequence of generation. Coordinated to the divisions of the year, the sequence of ascension follows the temporal progress of the months. The sequence of generation is 11-6-1-8-3-10-5-12-7-2-9-4. Each step moves forward by seven months or back by five, thus alternating between odd and even numbers and complementary seasons of the year. The yellow bell was fixed at the winter solstice, establishing a permanent relationship between the twelve pitches and time as marked by the cosmic clock.

[11] *GSR* numbers refer to Karlgren's *Grammata Serica Recensa*. For details on the *chün* tuners, see Needham, *Science and Civilisation in China*, vol. 4, pt. 1, pp. 185–86.

[12] Huang Hsiang-p'eng, "Tseng Hou-i mu ti ku yüeh-ch'i," p. 35.

In theory, the twelve pitches did not make a scale on which music could be played. Rather, each of the twelve provided a pitch level at which one of the five tones could be set for the establishment of a mode-key and the performance of music.[13] The twelve pitches were merely initializing sounds, used only to begin a performance and fix the position of the movable pentatonic relata. In the *Tales of the States (Kuo-yü* 國語*)*, the process of sounding a bell to start a performance is called "moving the sound" *(tung-sheng* 動聲*)*.[14] This statement exploits the graphic and phonetic proximity of *chung* 鐘: bell *(*tiung, GSR 1188z)* and *tung* 動 : move *(*d'ung, GSR 1188m)*. The starting of a performance was a powerful act of just authority that had precedents in the mythology of high antiquity. Control over the moment and pitch at which the music began was control over the entire performance.

In practice, the playing of any fixed-pitch instrument tuned to the twelve pitches in more than a single mode-key was problematic. The twelve pitches were calculated in precise just intonation. The pitch of the highest note was considerably sharper than a perfect octave achieved by halving a string, and the intervals between adjacent tones were uneven. As a result, only the initializing pitch could be sounded harmoniously in any given mode-key. Only for the mode-key created by initializing *kung* at the yellow-bell pitch would the other four of the five tones fit the gamut. In no other case would there be perfect correspondence between the five tones and available pitches in the gamut. Hence, no other mode-key could be played perfectly on the gamut.

Any of the twelve pitches could initialize any of the five tones to make a distinctive mode-key. Thus, sixty mode-keys were possible with fundamentals within the octave defined by the twelve pitches. This cycle

[13] I have adopted the term "mode-key" to describe the performance systems, following Robinson and Needham. The use of the terms "mode" and "key" require qualification. As used here, "mode-key" describes the sixty systems of tones possible with all arrangements of the five tones and the twelve pitches. For further explanation, see the excellent article by Powers, "Mode," pp. 376-450, esp. p. 442. There is greater detail in Pian, *Sonq Dynasty Musical Sources*, tables 2-4 (pp. 46-49, 52-53), pp. 43ff.

[14] *Kuo-yü*, "Chou-yü" 周語 [Tales of Chou], 3.12a; cited in Needham, *Science and Civilisation in China*, vol. 4, pt. 1, p. 169.

of sixty possible mode-keys was recognized no later than the early Han, when it was discussed in the *Huai-nan-tzu.* [15] The mode-keys were identified by combining a name from the five-tone series, e.g., *kung,* with a name from the twelve-pitch series, e.g., *huang(-chung)* : yellow bell, to make *kung-huang* 宮黃 . This was analogous to the sexagenary counting cycle created by combining the name of a heavenly stem *(t'ien-kan* 天干 *)* with the name of an earthly branch *(ti-chih* 地支 *).* The process by which the sixty mode-keys were formed exhausted the permutations of a movable and a fixed order of signs. This kind of manipulation was common in early numerology because it was believed to reflect the nature of phasic cosmic processes. It was a dimension of musical theory that must have been particularly appealing to speculative philosophers.

That there should be so many mode-keys possible in theory, yet only one playable on a fixed-pitch instrument, was a great challenge to instrument makers. Whereas in theory a neater and more compatible system than the five tones, twelve pitches, and sixty mode-keys could hardly be imagined, in the performance of music the just intonation of the twelve pitches disabled bells, chimes, and pipes in same the way just intonation disabled keyboard instruments during their early life in the West. Without some accommodation, accurate musical scales could be performed only by variable pitch instruments, e.g., zithers and the human voice, or confined to the monotony of a few mode-keys. In terms of performance, there were three possible responses to this situation, all of which ran a course: impoverishment, elaboration, and compromise. The sixty mode-keys could only be a theoretical possibility; although ritual regulation ostensibly restricted the choice and number of mode-keys, the real limitation in the actual performance of music was the instruments. As we have seen and will continue to see, in the most orthodox music there was a strong inclination toward reduction in the number of played notes and mode-keys. The *Programs of Chou,* for example, allows only eight of the possible sixty mode-keys in prescribing those to be used at the three most important ritual functions: the winter solstice, the summer solstice, and ancestral sacrifices. According to a Sung record of music lore, during the Sui dynasty (A.D. 589-618) ceremonial music was performed in only a single mode-key, the *kung-huang.* [16]

[15] Needham, *Science and Civilisation in China,* vol. 4, pt. 1, p. 161.
[16] Ibid.

A second response was the attempt to build instruments capable of just intonation for all the mode-keys. There is no indication that such instruments were ever made for performance, but there is a continuous history of experimental tuners that were designed for high-accuracy extension of the cycle of fifths to various lengths. Full half-tone scales developed from each of the twelve pitches would require one hundred thirty-three bells, a seemingly impracticable number. Microtonic experiments were carried out, but they were confined to strings, and we have no evidence of behemoth bell sets ever being attempted. Judging by the men who pursued these experiments, the interest of the microtonic experimenter was apparently theoretical, that is, not performance-oriented. The first notable example is Ching Fang 京房, an early Han cosmologist and physicist whose numerological commentary on the *Book of Changes* was a popular diviner's handbook for centuries. Ching Fang designed a ten-foot long tuner, the great length of which permitted accurate division of the strings, which he called a *chun* 準 : standard. By means of the algorithm described above, he achieved sixty degrees of pitch within the octave. In the fifth century, similar experiments were conducted by Ch'ien Lo-chih 錢樂之, who carried the process out to three hundred sixty pitches.[17]

Refinements to that degree would exceed the discrimination of all but the finest ears, and instruments would be impractical in terms of complexity as well as size. A third response was to temper the scale, that is, to find approximations for pitches that would allow a single pitch to serve for two or more mode-keys, even though it might not be a precise pitch in any mode-key. An equally tempered scale would establish a true octave and divide it into equal steps, providing a scale of equal intervals between any pitch and its adjacent pitch. This development occurred in the West and has made keyboard and orchestral music possible since the baroque. Musicologists have demonstrated that equal temperament was discovered in China by Chu Tsai-yü 朱載堉, whose *New Theories of Pitch Study (Lü-hsüeh hsin-shuo* 律學新說) was published in 1584.[18] Up to the

[17] Needham, *Science and Civilisation in China,* vol. 4, pt. 1, p. 219.

[18] Kenneth Robinson, *A Critical Study of Chu Tsai-yü's Contribution to the Theory of Equal Temperament in Chinese Music* (Wiesbaden: Franz Steiner Verlag, 1980); and Robinson's contribution in ibid., "Sound (Acoustics)," vol. 4, pt. 1, pp. 126-228. For a critical review of Robinson's interpretations, see Bell Yung's review of his book in the *Journal of Asian Studies* 40, no. 4 (August 1981): 775-76.

time of Chu Tsai-yü, we can surmise that several other approaches to temperament were tried. In the tenth century, Wang P'u 王朴 took the difference between a perfect octave and the octave established by a spiral of fifths (that difference known as the Pythagorean comma) and distributed equal fractions of it over the eleven intervals to obtain twelve tones spanning a true octave. By at least the fourth century, theorists recognized that the perfect octave, not the cycle of fifths, was the key to temperament.[19] The theoretical writings constitute a rather sporadic record of the struggle with temperament needs, and study of them has not revealed much about what instrument makers were actually doing.

The MT bells have further revolutionized thinking about both the performance role of bells and temperament. Clearly, the bells were not simply initializing instruments to establish the pitch and begin a piece; they were played throughout the performance as a voice in the orchestra. The bell makers had a remarkable solution to the temperament problem. First, the set was simply expanded to sixty-four bells instead of twelve. Second, and most remarkable, each bell was designed to sound two fundamental pitches depending on whether it was struck on the "lip" (sui-pu 隧部) or the "waist" (yu-ku-pu 右鼓部). A dual fundamental is not possible with a round bell, no matter how it is struck. The MT bells are made of a curved back plate and a curved front plate that are joined at sharp side ridges. This design permits two fundamental axes of vibration and the capacity to sound two "parallel" pitches. This parallel tone capacity is not uncommon in Shang and Chou bells, with the pitch relationship between the lip tone and the waist tone varying from a major second to a minor third. Given the parallel pitch capabilities, a set such as the MT bells had a theoretical potential of one hundred twenty-eight tones. Study of the vibrating frequency has shown that the bells were not tuned to perfect cycle-of-fifth pitches developed from the twelve pitches; they were adjusted with comma fractions that made them playable in more than one mode-key.[20] The lip tones provide the basic five- to seven-tone scale, and, with the waist notes added, there is a respectable half-note scale for nearly three octaves, playable in half of the possible mode-keys.[21] On the backs of most of the

[19] Needham, Science and Civilisation in China, vol. 4, pt. 1, pp. 219-20.

[20] Huang Hsiang-p'eng, "Tseng Hou-i mu ti ku yüeh-ch'i," p. 37.

[21] Ibid., pp. 36-37. For an exact arrangement of the pitches, see Huang's chart of ninety tones in the middle-tier bells, pp. 38-39.

bells are inscribed the pitch from the twelve-pitch series and the name of one of the five-tone notes, the theoretical mode-key note. On the fronts are inscribed the lip tone and the waist tone, accompanied by a more highly articulated nomenclature than the simple five-tone names for the benefit of the performer.[22] With additional study of the MT bells' inscriptions and further comparisons with other Shang and Chou bells, it will be possible to advance our understanding of the classical systems of intervals and temperament in what was a much more complex and mature system than has heretofore been recognized.

Finally, there was an eightfold system of instrumental timbre, the "eight voices" *(pa-yin 八音)*. The eight voices are mentioned in the *Book of Documents* and are first found in the *Programs of Chou,* which lists them as "metal," "stone," "earth," "skin," "silk," "wood," "gourd," and "bamboo." This listing was not persuasive for other discussions. The "Book of Music" and many other texts divide instruments into only four classes, "metal," "stone," "silk," and "bamboo," which is a fairly inclusive list, given that earth (clay) instruments are rare, gourd and bamboo are easily subsumed under wood, and skin drums have frames of other materials. The early formulation of the eight voices was probably more a response to numerological interest than a description of the essential instrumentation of the orchestra of the day. Timbre is an important variable in composition and performance, but the interest it elicits in later theories and criticism involves its variation on a single instrument, for example, the *ch'in.* The eight voices find a place in correlative systems but are otherwise discussed comparatively.

The three systems described above, the tones, the pitches, and the voices, fit neatly with the numerological interests of early Han philosophers. With a system of five tones to match the five phases, one of twelve pitches to match the calendric festivals and earthly branches, and one of eight voices to match the trigrams, complex and highly particularized associations between music and other systems were established.

The terms for both the five tones and the eight voices incorporate the same word, *yin,* a word that bridges the gap between the twelve pitches (as

[22] Lei-ku-tun fa-chüeh-tui, "Tseng Hou-i mu fa-chüeh chien-pao," p. 4. This report provides a wealth of detail on the dimensions and physical characteristics of the bells.

absolute cosmic standards) and music (an activity invariably involving man). In the classical writings, *yin* is usually found in binomes, mostly *wu-yin* and *pa-yin* themselves. But in the "Book of Music," much more is said about the meaning of *yin* outside the systems of five and eight that helps us to understand the significance of its dual use for the basic systems. *Yin* is sound that is patterned or marked by virtue of being placed in an ordered context. The context is primarily other sounds that define a system with particular contrastive features. These features, in the most general sense of *yin*, include pitch, timbre, volume—in short, all of the qualities thought to have been addressed in the early sense of the five tones. *Yin* are sounds whose tonal features are recognized as significantly contrastive to each other.

In the "Book of Music," *yin* is defined by the word *wen* 文 , meaning "markings," "orderly pattern," or "design." *Wen* is a crucially important word in classical writings. It was Fu Hsi's 伏羲 observation of the *wen* in nature that prompted him to develop the trigrams to express or represent natural patterns.[23] *Wen* as "markings" evolved into *wen* as "literature" and *wen* as "culture."[24] The "Book of Music" says, "All *yin* are born of the human mind. Feelings are stirred within; their external form is sound. When sound achieves pattern, it is called *yin*."[25] The structure of this

[23] The story is told in the "Great Commentary" ("Ta-chuan" 大傳) of the *I-ching*. See Wilhelm, *Book of Changes*, pp. 328-36.

[24] For a detailed account of this term, see Chow Tse-tsung, "Ancient Chinese Views on Literature," pp. 5-12.

[25] The "Yüeh chi" is a collection of fragments, many of which were certainly of Chou origin. But the compilation of the book as it now exists, as a chapter in the *Li-chi*, is of uncertain date. The bibliography of the *History of the Sui (Sui-shu* 隋書, "Ching-chi chih" 經籍志[Record of texts]) attributes it to a Kung-sun Ni-tzu 公孫尼子 on the basis of a Six Dynasties discussion. Kung-sun Ni-tzu was a Warring States Juist about whom almost nothing is known. The "Yüeh chi" is to a large degree derivative from Hsün-tzu's "Discussion of Music" ("Yüeh-lun" 樂論), translated in Watson, *Hsün-tzu*, pp. 112-20. Its contents are very close to the "Yüeh-chih" in the *Shih-chi*, which suggests that it was certainly near its present form by the first century B.C. For a review of the scholarship on the text, see Ch'iu Ch'iung-sun 丘瓊蓀 , *Li-tai yüeh-chih lü-chih chiao-shih* 歷代樂志律志校釋 [A comparative explication of treatises on music and pitches in early history] (Peking: Chung-hua shu-chü, 1964-), 1:1-9.

sentence and the strategy of the argument are identical to that quoted above from the "Great Preface." *Yin* is compared to words, an external formation from an emotion stirred within. Emotion is here introduced to the concept of tone, which had previously been discussed only in a technical sense. An earlier paragraph refers to "movement of the mind" rather than emotion, which occurs when the mind is "impinged upon by external things."[26] The process in temporal sequence is: external things (= manifest differentiation in the outside world) impinge upon (or are perceived by) the mind, stirring it to motion (= emotion), which in turn is manifest in *yin*. *Yin*, like *wen*, is inseparable from human apprehension of it: "All *yin* are born of the human mind. Music relates to order and reason. This being the case, the birds and the beasts understand sound but do not understand *yin*. Common people understand *yin* but do not understand music."[27] Music is a higher order of organization than *yin*; the superior man alone can know music, while all men can know *yin*. All creatures can know sound.

The proposition that music relates to order (*lun* 倫) and reason (*li* 理) is similar to Pater's claim that music links the infinitely diverse impulses of the cosmos into the unity of a reasonable order. Other statements on the relation of sound to *yin* return us to the generative principle of the five tones. "Sounds resonate sympathetically, so they give birth to [harmonic] derivatives. When these derivatives form a complete pattern, they are called *yin*. Placed alongside the *yin* is music, and one finds enjoyment in that."[28] The "alongside" expression is *pi-yin* 比音, a comparative and parallel placement, much like the graduated strings of a harp.

The present "Yüeh chi" follows a theme and variation style itself, with short and highly reiterative paragraphs, often punctuated with a few lines that do not seem to fit at all. The quality of its contents varies widely. At its best, the book is perceptive, pithy, and suggestive; at its worst, dogmatic or evasive. Quotations are translated from the *Ssu-pu pei-yao* edition of the *Li-chi hsün-tsuan*, *chüan* 19. This quotation is on p. 2a.

[26] "Yüeh chi," p. 1a. This will be discussed in detail below.

[27] Ibid., p. 3a.

[28] Ibid., pp. 1a-b.

CHAPTER V

Mythology and Cosmology

In its terse accounts of the sage-emperors, the *Book of Documents* describes the prominent role of music in governance. Yü proposes a range of initiatives to spread his civilizing influence across the land and says: "I want to hear the 6 pitch-pipes, the 5 notes, the (8 sounds =) sounds of the eight instruments, and the 7 primary tones, sung in order to bring out and bring back (sc. antiphonally) the 5 (kinds of) words (to the music); do you listen?"[1] The scene of the ancestral sacrifices is described by Music Master K'uei.

> K'uei said, "The sounding-boxes, the singing *k'iu*-stone, the small leathern drum, the guitar and the lute, when with them one sings, the (Spirits of the) ancestors come, (Yü =) Shun's guests (sc. the Spirits) are in their high positions (at the sacrifice). All the princes (virtuously yield =) are virtuously modest. Below these are the flutes, the hand-drums, and the drums, jointly (with them) there are the hammer and the *chu* and *yü* sounding boxes; the reed-organs and the bells are in between. Birds and beasts dance. When the *shao* music of the Pan-flutes is achieved in 9 parts, the male and female phoenixes come and (arrive =) put in an appearance."[2]

K'uei continues to describe the assertion of control by sounding the pitch-stones, called "moving the sound": "Oh, when I strike the stone, when I knock on the stone, all the animals follow (it) and dance, all the governors (i.e. officials) become truly harmonious."[3]

In his *Spring and Autumn Annals of Mr. Lü* (ca. 239 B.C.), Lü Pu-wei included several chapters that have versions of the origin of music. His

[1] Karlgren, *Book of Documents*, p. 11, no. 12.
[2] Ibid., p. 12, no. 18.
[3] Ibid., p. 12, no. 19.

accounts emphasize the continuity of the processes that reach from the origin of the cosmos to the origin of civilization.

> The origin of music is in the very remote past. It was born of equal measurement and rooted in the Grand Unity. The Grand Unity gave birth to the Counterparts [heaven and earth]. The Counterparts gave birth to *yin* and *yang*. The *yin* and *yang* transformed and stratified into higher and lower levels. These came together and formed regular patterns. Rolling over and about, again and again, they would separate, then come together, come together and then separate. This is called the constancy of heaven; the turning wheel of heaven and earth coming to an end begins again, reaching its ultimate source. All things are part of this process.
>
> The sun, the moon, the stars, and the planets move sometimes slowly, sometimes quickly. The cycles of the sun and the moon differ, wherein each completes its course. The four seasons arise in rotation, some hot, some cold. There is the shortness [of winter's days], the length [of summer's days], the balminess [of spring's days], and the briskness [of autumn's days]. The emergence of the myriad diverse things is the creation of the Grand Unity, transformed by *yin* and *yang*. Like the sprouts of a bean, they begin with a burst of movement and crystallize into solid form. Their physical forms are varied, and they all produce sound. The sounds issue in harmony, and that creates accord. From this harmonious accord was born music, set down by the sage-rulers.[4]

Even prior to the era of Yao and Shun, the power of music is put to use by sage-rulers:

> In high antiquity, the Scarlet Emperor Yen brought rule to the world. There were great winds, and the *yang ch'i* collected and accumulated. The myriad diverse things spread and dissipated, and nothing came to fruition. As a result, his minister Shih Ta created the five-string *se* zither in order to bring forth the *yin ch'i* and settle the crowds of living things.[5]

By the early Han, many scholars were recording versions of the history of high antiquity. Living in the era after the burning of books and

[4] *Lü-shih ch'un-ch'iu* 5.3a–b.

[5] Ibid., 5.7a.

burying of scholars during the Ch'in dynasty, Han literati felt a deep concern over the knowledge that had been lost, and, as part of that concern, they tried to complete the record of their past. In the writings of many scholars, the *ch'in* zither had begun to emerge as a civilized and civilizing instrument of special importance; the invention of the *ch'in* and the discovery of its voices and music were attributed to high antiquity. It was often included in the founding acts of civilization, those crucial acts of the Yellow Emperor, Shen Nung 神農 , Fu Hsi, Yao, Shun, et al., which separated the Chinese from surrounding tribes and from the beasts. The discovery of the *ch'in* was generally placed directly after the discovery of patterns in nature and the shaping of signs, like the trigrams, to convey those patterns. The tones of the *ch'in* were, in these schemes, yet another representation of natural patterns.

There was disagreement over the originator of the *ch'in*. The *Erh-ya*, Ts'ai Yung 蔡邕 , and Yang Hsiung 揚雄 attribute it to Fu Hsi, perhaps because of his skillful correlation of natural systems. Most texts, however, including the *Huai-nan-tzu*, the etymological dictionary *Explaining the Graphs and Explicating Their Combinations*, *Penetrating Popular Ways*, and some extant variants of the *Book of Documents*, attribute it to Shen Nung, perhaps because of his association with silk-making. The availability of silk fiber made it possible to fabricate long, tension-bearing strings for the zither. The "Book of Music" in the established canon has: "In ancient times Shun invented the *ch'in* of five strings, in order to sing the 'Southern Airs' ('Nan-feng' 南風)."

We have already argued for the primacy of stringed instruments in the tuning process. That they played a pivotal role in this process has been indicated by the archaeological evidence discussed above. Recently, new materials for epigraphic analysis have corroborated the claim of the textual records for the antiquity of strings. The character *yüeh* : music has been scrutinized since the Han dynasty for clues to the origin of music.[6] In

[6] To the reader unfamiliar with the tradition of etymologizing in China, it may seem strange to look for historical clues by dissecting words. Reading history in the components of characters is a methodology in the native traditions of scholarship that goes back at least two thousand years. Understanding what Han scholars saw in a character is important to understanding how they used it. Whether by modern standards their opinions can be sustained or not, their writings on the etymology of a

Explaining the Graphs and Explicating Their Combinations, Hsü Shen defined *yüeh* as a general name for the five sounds (= tones) and eight voices. He wrote that the character resembled a large drum and hand drums, with the "wood" radical at the bottom representing the drum post or stand. In the customary manner, commentators elaborated and debated Hsü Shen's proposed etymology of the character. The earliest such elaborations looked at the archaic form of the character, typically written 樂 , and described it as a large drum 〇 between two suspended pairs of hand drums 8 8 , all atop a wooden stand 木 . The top peripheral components were subsequently identified as the archaic form of a graph for "silk" or, verbally extended, "to suspend," and emphasis turned to the fact that the drums were suspended. This explanation was used to expand the reference of the etymology to include not only drums, but hanging bells and chimes as well.

More recent studies of oracle-bone scripts have brought to light variants of the character, many written 樂 , without the center component, the drum. This has prompted scholars of epigraphy and etymology in recent decades to drop "drum" from the reference altogether and to recognize the archaic graph as a representation of silk suspended over wood. A consensus has emerged that it was a pictograph of an instrument with strings drawn over a wooden sounding board. The additional center component might be another string, slightly reshaped, or the element *pai* 白 , which in this context would mean to "strum" or "press" the strings. The early shell and bronze forms vary significantly, but the conclusion that they are derived from the zither is a convincing one.[7]

One scholar has suggested that historically there was an instrument predating the *ch'in* and *se* zithers, possibly an instrument called a *yüeh*.[8] Archaeologists have uncovered a variety of zithers, ranging from five to twenty-five strings, with no indication of what they were named. The *ch'in*

character are part of the mythology of the subject. But beyond the benefits of entering into their epistemological world, there is information to be gained from analyzing the vestigial pictographic elements in some characters because of the remarkable stability of written graphs.

[7] For a history of these interpretations and copious illustrations of the variant forms, see Chou Fa-kao, *Chin-wen ku-lin,* no. 0768 (pp. 3762-74).

[8] Mizuhara Ikō, "Chūgoku kodai ongaku shisō kenkyū," pp. 208ff.

and *se* are mentioned prominently in the *Odes*, yet in earlier shell and
bronze records one does not find those names, only *yüeh* and the names of
several percussion and wind instruments. There are no characters identi-
fied as the names of string instruments in the oracle-bone lexicon, which
leads one to conclude either that there were no string instruments or that
we have yet to recognize their names. Mizuhara cites bone inscriptions as
evidence that sericulture existed during the Shang; indeed, *yüeh* itself
argues that point. Mizuhara also suggests that ritual sacrifices were made
to deities responsible for sericulture. He calls attention to the frequent
association of Fu Hsi and Shen Nung, two of the putative inventors of the
zither, with sericulture. Mizuhara concludes that the sericulture technol-
ogy for string instruments existed and that the absence of any other char-
acters for known string instruments strongly suggests that *yüeh* itself, in its
early form, was the name of a stringed instrument, not a generic name for
music. The character *yüeh* pictured a zither or, with the addition of the
central *pai*, possibly meant the playing of the zither. In time it was gener-
alized into the word for "music," because of the overriding importance of
the zither in the early notion of music.[9]

The mythologies tell us that the pitches were discovered in high
antiquity by the Yellow Emperor's minister, Ling Lun 伶倫. Ling Lun, who
is the grand progenitor of music masters, has a name that bespeaks struc-
ture and order.

In ancient times, the Yellow Emperor ordered Ling Lun to make
pitch standards. Ling Lun traveled from west of Ta-hsia all the way
to the northern slopes of the Juan-yü Mountains. He gathered bam-
boo from the valleys of Hsieh-ch'i, and, selecting those pieces with
chambers and walls of uniform thickness, he cut a section from
between two nodes. The length of a section was 3.9 inches, and he
blew it. That sound he took to be the *kung* tone at the yellow-bell
pitch level. Blowing it, he said, "This is good!" and proceeded to
make shortened sections in a series, creating twelve pipes.

He carried these back to the foot of Juan-yü Mountain where he
listened to the songs of the male and female phoenix in order to
divide the twelve pitches. The male calls numbered six and the

[9] On rather less compelling evidence, Mizuhara also speculates that the
instrument was played in a sacrificial rite to the silkworm deities.

female calls numbered six. Proper concord was achieved by their relation to the *kung* tone at the yellow-bell pitch. The *kung* tone at the yellow-bell pitch could generate all of the rest. Therefore, Ling Lun said that the *kung* tone at the yellow-bell pitch was the origin of all the *yang* (= *lü* 律) and *yin* (= *lü* 呂) pitches.

The Yellow Emperor subsequently ordered Ling Lun to join with Jung Chiang to cast twelve bronze bells. These would provide harmonious placements of the five tones and allow the harmonious symphony to be performed. In the middle of spring, on the twelfth day of the cycle of sixty, when the sun was in the lunar lodging Straddler,[10] it was performed for the first time. He ordered it to be called Hsien-shih 咸池.[11]

In this story, the pitches are abstract pitch levels, without sound until the *kung* tone is positioned and sounded at them. The *lü*, whether translated as "pitch," "pitch level," or "pitchpipe," express more essentially a sense of generalized dimension rather than one of tone. They were the duodecimal standards for primarily temporal phenomena with a cardinality of twelve. The *lü* were seen as inherent in nature, playing a timely role in natural processes, and, as we shall see below, were thought to be measurable with precision instruments.

The fact that the twelve pitches were inherent in nature was important. The sage did not create them; he discovered them. Then he found a system by which to make them explicit and useful to mankind. This script is consistent with incidents in which order and pattern in nature are discovered and then rendered in one system of representation or another. The best-known embodiment of this idea is found in the story of Fu Hsi, who observes the patterns of heaven and earth, perceives the principles of order in them, and then renders that order in a system of eight trigrams.[12] In the expanded versions of this account, when the discovery of the *ch'in* is credited to him, it follows immediately upon his making of the trigrams. The materials and design of his *ch'in* were taken wholly from nature as well.

[10] I have adopted names for the lunar lodgings *(hsiu* 宿 *)* from Edward H. Schafer, *Pacing the Void: T'ang Images of the Stars* (Berkeley: University of California Press, 1977), pp. 75-84.

[11] *Lü-shih ch'un-ch'iu* 5.8a-9a.

[12] See p. 53 above.

The Ling Lun story stresses not only the careful and orderly imitation of the phoenix standard, but also the natural perfection of the available materials, the bamboo. Only bamboo that was precisely even (chün 均 , the same word used for the tuning zithers) would make tubes capable of the true pitch. A popular theme in later literary celebrations of music is the materials found in nature and the musical potentials that are inherent in them. In nature are found both the pitch and the materials to give it voice.

The Hsien-shih Harmonious Symphony was a piece or genre uniquely associated with the Yellow Emperor. Chuang-tzu has a splendid description of it that foreshadows many ideas developed in later writings on music.

Ch'eng of North Gate said to the Yellow Emperor, "When Your Majesty performed the Hsien-ch'ih[13] music in the wilds around Lake Tung-t'ing, I listened and at first I was afraid. I listened some more and felt weary, and then I listened to the end and felt confused. Overwhelmed, speechless, I couldn't get hold of myself."

"It's not surprising you felt that way," said the emperor. "I performed it through man, tuned it to Heaven, went forward with ritual principle, and established it in Great Purity. Perfect music must first respond to the needs of man, accord with the reason of Heaven, proceed by the Five Virtues, and blend with spontaneity; only then can it bring order to the four seasons and bestow a final harmony upon the ten thousand things. Then the four seasons will rise one after the other, the ten thousand things will take their turn at living. Now flourishing, now decaying, the civil and military strains will keep them in step, now with clear notes, now with dull ones, the yin and the yang will blend all in harmony, the sounds flowing forth like light, like hibernating insects that start to wriggle again, like the clash of thunder with which I awe the world. At the end, no tail; at the beginning, no head; now dead, now alive, now flat on the ground, now up on its feet, its constancy is unending, yet there is nothing that can be counted on. That's why you felt afraid. . . .

"Then I played it with unwearying notes and tuned it to the command of spontaneity. Therefore there seemed to be a chaos where things grow in thickets together, a maturity where nothing takes

[13] I have followed the suggestion of most commentators and read 池 as *shih* in this special case. Watson uses the conventional reading.

form, a universal plucking where nothing gets pulled, a clouded obscurity where there is no sound. It moved in no direction at all, rested in mysterious shadow. Some called it death, some called it life, some called it fruit, some called it flower. It flowed and scattered, and bowed before no constant tone. The world, perplexed by it, went to the sage for instruction, for the sage is the comprehender of true form and the completer of fate. When the Heavenly mechanism is not put into action and yet the five vital organs are all complete—this may be called the music of Heaven. Wordless, it delights the mind. Therefore the lord of Yen sang its praises thus: 'Listen—you do not hear its sound; look—you do not see its form. It fills all Heaven and earth, enwraps all the six directions.' You wanted to hear it but had no way to go about it. That was why you felt confused."[14]

In a note to this translation, Watson points out that the expression "perfect music" (chih-yüeh 至樂) also means "perfect joy." He also says that the passage is paradoxical and complex. The "wordlessness" of the perfect music is in contrast to the Confucian identification of the Odes as the perfect music. The fact that the music of heaven has no sound will be alluded to in numerous poems, stories, and discussions about the ultimate music, in which silence and stringless zithers become the performance ideals. More importantly, Chuang-tzu puts the performance of music on a cosmic scale and portrays it as an event in nature, in contrast to the Confucian view, represented by the Duke Cha concert, in which it is an event in society. As an event in nature, its most compelling feature is its changes. Its changes are the changes of the cosmos. In much of the description of the Yellow Emperor's concert, the subject is lost; it might be either the music or the cosmos, as the perpetual flux is described. Music being such a precise correlate to the processes of cosmic change, its systems of tone, pitch, and voice will be a framework on which to build a description of those changes.

The Chuang-tzu passage is a compelling literary illustration of the contrast that I have suggested between China and the West in metaphors for mind and enlightenment. The choice of tone, pitch, and voice systems as the center of a cosmology is consistent with the contrast between hearing and vision metaphors. I have quoted Plato's description of vision as the

[14] Watson, Chuang-tzu, pp. 156–58.

primary intellectual cause: "But now the sight of day and night, and the months and the revolutions of the years, have created number, and have given us a conception of time."[15] The ability to relate the basic sensory perception to numbers and the processes of change over time is common to both traditions. In the *Timaeus*, Plato describes a role for hearing and smell, but it is explicitly secondary to vision. His taxonomy of light and color is not as highly articulated as that of pitch, tone, and voice in the Chinese tradition, which is entirely predictable given the vast difference in technological demands between mathematical descriptions of color and pitch. The logical connection between vision and numbers is simply that we perceive the cosmic regularities with our eyes; hence, the numbers, which are defined by cosmic movements, are impressed upon us through our vision. Preceding the statement quoted above is Plato's remarkable description of the light of the eye and the light of the sun, the means by which they meet, and the origins of visual perception. Plato's theory of perception, the description of the process of light meeting light, should be carefully compared to Chinese theories of *ch'i*.

Before discussing the abstract schemes of correlation, a description of some practical dimensions to the extension of musical systems to other areas is in order. Musical systems occupied a central position in early metrology. Needham writes:

> While other early civilisations concerned themselves with linear measure, capacity, and weight in formulating their metrological systems, the Chinese were apparently unique in including pitch measure *(lü)*, and not merely on a par with, but as the basis of the other three. As the *Shih-chi* emphatically puts it: "The six *lü* are the rootstock of the myriad things."[16]

Tables associating both linear and volumetric measure are found in the *Tales of the States* ("Chou-yü," 3.15a-18b) and in the twenty-first chapter of the *History of the Han*. The connections described in these cases are

[15] See above, p. 32.

[16] Needham, *Science and Civilisation in China*, vol. 4, pt. 1, p. 199. A fuller explanation can be found in H. H. Dubs, "Standard Weights and Measures of Han Times," chap. 4, app. 1, in the *History of the Former Han Dynasty*, 3 vols. (Baltimore: Waverly, 1938-55), 1:226-80. For the primary texts in which the correlations are presented, see the *Han-shu*, p. 961.

physical and direct. The length of a pitchpipe true to the yellow-bell pitch is ninety *fen* 分. One *fen* equals the width of a grain of medium black millet. The weight of millet that will fill such a tube is twelve *chu* 銖. The central measuring standard, here described as a tube, had previously been a bell. The same character is still used for both "scoop" and "bell." According to references in the *Programs of Chou*, the *Tso Commentary*, and the *Lieh-tzu* 列子, the *chung* 鐘 derived from a millet scoop, which in practice associated the accuracy of the measure with the tone of the scoop. An accurate scoop would emit the *kung* tone at the yellow-bell pitch. Testing the pitch of linear and volumetric measuring devices, assuming that other variables were controlled, would be an accurate technique for standardizing measures, but the practicality of doing so, given the difficulty of controlling the other variables, is open to question.

It was by relatively simple arithmetic that the yellow bell generated the remaining eleven pitches, and equally simple arithmetic related a full system of metrology to it. The affinity for the musical systems in all discussions of numbers is strong. In early texts, numbers are almost always found in proximity to musical and acoustical terms. Even in nontechnical contexts this is true. In a single passage, the *Tso Commentary* speaks of the five sounds, six pitches, eight winds, and nine songs.[17] The fact that pitch could readily be related to pipe and string length and to bell volume made it a natural reference for linear and volumetric measure. The fact that the musical systems were easily added or multiplied in any number of classificatory schemes distinguished acoustics from other physical sciences. This compatibility between musical systems and numbers contributed to the popularity of sound as a reference for relating other phenomena to proposed cosmic standards. Numbers or their surrogates were the coin of early Han correlative philosophy; hence, orderly sound was the pivot in their approach to phenomena.

For many Han thinkers, describing cosmic changes became a preoccupation. The "Theory of Heaven-Man Parallels" (T'ien-jen shuo 天人說) justified the most careful examination of all recurrent and extraordinary natural phenomena for knowledge of man's current state and future prospects. Historians were involved with the apparent concurrence of natural signs and human events in the known past and their implications for the

[17] *Tso-chuan*, Chao 昭, year 20.

present. Court prognosticators, working in several different systems, put this knowledge of the past to present use, making determinations in a wide variety of what were called "matters of doubt." It was crucial to fit the regularities of nature's processes into an orderly scheme so that anomalies might be clearly recognized and analyzed. Then it was necessary to correlate such regularities specifically to human affairs so that they might be interpreted.[18]

Universal histories and commentaries and natural philosophies, primarily those associated with the New Text School,[19] were interested in broad systems of correlations, patterns on a universal scale that revealed the regularity in the myriad things and the constant flux. They always have music sections, which usually begin with a mythic account of music's origins, argue for its basal position in natural and social orders, and proceed to define a complex and far-reaching network of correspondences. These systems of correspondences varied widely in their details and, like the absolute frequency of the yellow-bell pitch itself, were debated with passion and often with serious political consequences.

A new genre of work, the apocryphal text, emerged during the Han, ostensibly to provide the "weft" threads (wei 緯) for the "warp" of the classics (ching 經). The apocrypha were in the mainstream of commentary writing. Just as the Tso Commentary attempted to fill in the details not made evident in the Spring and Autumn Annals, the apocrypha discussed what was implicit, but not necessarily obvious, in the classics. Characteristic of Han commentaries like the Myriad Dewdrop Commentary on the Spring and Autumn Annals, the apocrypha dealt in correlations and

[18] For more details about the Theory of Heaven-Man Parallels, see my Doctors, Diviners, and Magicians of Ancient China: Biographies of Han and Six Dynasties Fang-shih (New York: Columbia University Press, forthcoming). See also Wolfram Eberhard, "The Political Function of Astronomy and Astronomers in Han China," in Chinese Thought and Institutions, ed. John K. Fairbank (Chicago: University of Chicago Press, 1957), pp. 33-70.

[19] The New Text School was the dominant intellectual faction of the early Han, so named because its adherents preferred versions of classical texts that were newly transcribed from the memories of scholars to those that were putatively preserved in material form and written in ancient graph styles.

developed apparently unfettered by the content or structure of the classics to which they allegedly pertained.[20] This is particularly true for the apocrypha on music. They were the weft for a warp that did not exist, since there was no music classic extant in the Han. Of those apocrypha that specialized in music and sound there is very little extant. The bibliography in the *History of the Sui*, which is the earliest dynastic history bibliography extant after that in the *History of the Han*, lists only one, the *Apocrypha on Music (Yüeh-wei* 樂緯*)*, and attributes it to a Liu Sung compiler. But fragments of at least five apocrypha have been recovered: *Apocryphal Treatise on Music: A Graphic Presentation of Its Harmonies (Yüeh-wei hsieh-t'u-cheng* 樂緯叶圖徵*)*; *Apocryphal Treatise on Music: Meanings of Movements and Sounds (Yüeh-wei tung-sheng-i* 樂緯動聲儀*)*; *Apocryphal Treatise on Music: Felicities Upon Examining Its Light (Yüeh-wei chi-yao chia* 樂緯稽耀嘉*)*; *Apocryphal Treatise on Music (Yüeh-wei* 樂緯*)*; and *Graphic Representation of the Five Birds (Wu-niao t'u* 五鳥圖*)*.[21] Of these five, the first is best preserved and offers the most interesting fragments. The text comprises a cosmology, with the pitches substituted for the Tao: "The yellow bell gives birth to the myriad things." The bells are rung and in proper intonation make known the virtue of the ruler.[22] The interests of the apocrypha are still the legitimate concerns of statecraft; their cosmology is that of an explicitly moral cosmos. Another long fragment describes the ritual of the Eight Skilled Gentlemen playing cosmic music to facilitate the passage of *ch'i* at the solstice. Similar descriptions are found in ritual texts and the treatises on pitchpipes and calendars in the dynastic histories. We might surmise that the apocrypha on music comprised the most concentrated sources for cosmological speculation on the pitches and *ch'i* and the best records of whatever miscellaneous fragments on music survived from the classical period.[23]

[20] For a discussion of the apocrypha in the context of Han intellectual history, see Tjan, *Po Hu T'ung*, pp. 100-120.

[21] Collected in Yasui Kōzan and Nakamura Shōhachi, *Isho shūsei*, vol. 3. For a chart illustrating these collections and the Chinese collectanea in which the fragments are found, see Yasui and Nakamura, *Isho no kiso-teki kenkyū*, p. 362. I have used the materials reproduced in Ma Kuo-han, *Yü-han shan-fang*.

[22] Ma Kuo-han, *Yü-han shan-fang*, 4:2036.

[23] For a review of the musical contents of the apocrypha based on extant fragments, see Tjan, *Po Hu T'ung*, pp. 100ff; and Yasui Kōzan and Nakamura Shōhachi, *Isho no kiso-teki kenkyū*, pp. 444-48.

By the Han, the "Vast Plan" ("Hung fan" 洪範) of the *Book of Documents* had established a core of numerological relations that included musical systems. The *Kuan-tzu* chapter on agronomy had made a structured numerological correlation between music and agriculture. The twelve pitches had become inseparably linked to calendric calculations, and the five tones were woven into five-part schemes structured on the five phases. The major systems of correspondence had shown their affinity for the music systems, embracing one or more of the basic five-, eight-, or twelve-part groups. Trigrams, hexagrams, seasons, directions, magic numbers, months and festivals, lunar lodgings, and the stems and branches were at the hub of vast correlative schemes. They reached out in all directions to all areas of interest to the Han thinkers. It was in the nature of the early Han thinker to strive for universality, integrating his study of heaven, earth, and man into orderly and comprehensive, if not fully convincing, correlations. In the writings, the zeal for universality vied with the political necessity for a concentration of polemic thrust, which created an inclination to particularized emphasis within the framework of universal works. There was disagreement from work to work on details of the correlations. But in addition to disagreement over details, there was disagreement over the very scope and the very point of such systems. One widely held aim was to reconcile different ideas and different approaches to knowledge that had been inherited from the pre-Han periods. A disorderly collection of sundry works on administrative and military strategy, cosmology, poetry, moral philosophy, mystic philosophy, and history was inherited by the Han. Some were recognized as the works of contending schools. But some were felt to be part of a select, orthodox canon that imposed on scholars the obligation to eliminate discrepancies, illuminate obscurities, and reveal a consistent and unified vision. By the early Han, the corpus of written learning had grown beyond the bounds of even the greatest minds, and so we find the struggle to gain control of information expressed in the compiling of bibliographies and the mounting of imperially commissioned programs to acquire books, reconstruct their faulty parts, and summarize their contents. The articulation of universal systems of correlations was another response to the proliferation of texts, facts, and ideas. The systems themselves encompassed both the one and the many, the principle of order and the myriad differentiated forms. But as a genre of philosophical writing and an aid to understanding, such compilations ultimately fell victim to their own disorderly proliferation.

The primary literature is substantial, but study of the major works is problematic. There has been interest in the fact that such systems exist, but little attempt to explore the internal coherence of the systems. The Han and Sui bibliographies list many of the major texts among "Miscellaneous Philosophies" ("Tsa-chia" 雜家), commentaries on the *Book of Changes,* and "Computational Arts" ("Shu-shu" 數術). Important ones are the "Vast Plan" of the *Book of Documents;* the "Monthly Ordinances" of the *Book of Rites;* the essays on pitches and calendrics in the dynastic histories; the *Spring and Autumn Annals of Mr. Lü;* the *Huai-nan-tzu;* the *Myriad Dewdrop Commentary on the Spring and Autumn Annals;* the *Comprehensive Discussions of Virtue in the White Tiger Hall;* the *Kuan-tzu;* the *Yellow Emperor's Inner Classic (Huang-ti nei-ching* 黃帝內經); the *Book of Changes: Commentary of Ching Fang (I-ching: Chou-i Ching Fang chuan* 易經：周易京房傳); the *Forest of Changes (I-lin* 易林) by Chiao Kan 焦贛 ; the *Classic of the Grand Mystery (T'ai-hsüan ching* 太玄經) by Yang Hsiung; and the fragments of the apocrypha. The definitive Western study of Han correlative systems is still Eberhard's "Beiträge zur Kosmologischen Spekulation Chinas in der Han Zeit."

Among the systems Eberhard discusses are the five phases—a classification of all things in a fivefold categorization; disastrous geography--the correlation of places and events on earth with regions of the heavens and movements of the asterisms; and cyclical timing--the counting and qualification of time with the sexagenary-cycle characters and their correlates. Eberhard's list of five-phases correlates extends to over one hundred items and is especially useful because it shows the various discrepancies between the sources. Still, there is far more agreement than disagreement, showing a remarkably wide constituency among Han thinkers who accepted the central lines of thought. Under columns headed by the five phases (wood, fire, earth, metal, and water), there are groups of: winds, weather phenomena, sensory functions, visceral functions, smells, tastes, colors, emotions, social classes, sage-rulers, planets, creature classes, seasons, directions, trees, and on and on.[24] The twelve pitches associate with periodic ritual festivals and the seasons through their calendric correlations. They assume directional implications, become closely tied to the twelve earthly

[24] Eberhard, "Kosmologischen Spekulation Chinas," pp. 48-52.

branches, and are related to a select group of hexagrams from the *Book of Changes.*[25]

The five tones are related directly to the five phases or to their correlates. On the basis of these correlations, various claims are made for the potency of the defined relationships. For example, an early Han Music Bureau official, Huan T'an 桓譚, wrote:

> Each of the five tones follows its own direction: spring corresponds with *chiao*, summer with *chih*, autumn with *shang*, and winter with *yü*; *kung* stays in the center, uniting the four seasons of the year. The five tones are incomplete without *kung*. This can be illustrated by a flowery, five-colored screen in the hallway. If we look at it from a distance, then each color—green, red, white, yellow, and black—is distinct, but if we examine it closely, they all have a yellow base adorned by the four other colors. If you want the music of the four seasons and the five phases, then all music should have the *kung* sound as base with the four other sounds [*chiao, chih, shang,* and *yü*] adorning it.[26]

Each major text has a unique emphasis that distinguishes it from the others; until the systems began to collapse under their own weight, each new writer contributed to the central theory. In reviewing the evolution of the earlier and simpler systems to the more complex ones, we can see the important role played by the music systems. The earlier works, like the *Spring and Autumn Annals of Mr. Lü,* are primarily directed at the establishment of correlative groups, the sorting of included sets into the proper columns. Lü Pu-wei developed basic duodecimal seasonal correlations for the twelve pitches and phase correlations for the five tones. When he described a season, mid-summer or late summer, for example, he attached correlates that revealed the cosmic and moral dimensions of the music that were appropriate to the season. His work is thus primarily taxonomic and does not advance the theory.

[25] Nakaseko, "Symbolism in Ancient Chinese Music Theory," esp. pp. 168-72.

[26] Pokora, *Hsin-lun*, p. 119. I have modified a few of the terms Pokora used in his translations for consistency with my own terminology outside of the quotation. Yellow is the color associated with the *kung* tone, the earth, the first tone of the pitch gamut, the Yellow Emperor, and the center.

A more sophisticated stage is apparent in the *Huai-nan-tzu* chapters on astrology and topology (i.e., heaven and earth), which emphasize the mathematics of the standards and their intervals, their combinations, and the numerological schemes or arithmetic manipulations with which the phasic relations of the five tones and seasonal relations of the twelve pitches might be perfected. In the *Kuan-tzu*, the *Huai-nan-tzu*, and the *Records of the Grand Historian*, the yellow-bell pitch is assigned the number 81. According to the theory of the twelve pitches and *yin* and *yang*, applying the Three-Part Subtraction-Addition algorithm to 81, the yellow-bell number, should yield numbers for all of the twelve pitches and return in its final application to the number 81. It does not, in fact, return to 81; rather, it goes to 80, a symptom of sharpness attributable to the Pythagorean comma that separates the cycle-of-fifths octave from the perfect octave. The *Huai-nan-tzu* finds a manipulation for the numbers that makes the beginning and end come out correctly. The *Huai-nan-tzu* solution to the problem, which required raising all of the figures fractionally from the sixth computation on, became the generally accepted solution for correlative philosophers, even though dividing the tuner strings with the adjusted ratios would in practice produce an audibly imperfect gamut of pitches.

In other approaches, the emphasis was less on taxonomy or technicalia and more on the mysterious nature of the correlates and their mechanisms of interaction. Yang Hsiung writes that the "Grand Mystery" (T'ai-hsüan 太玄) forms a trinity with *yin* and *yang*; then, through two sequential squaring calculations, becomes 81 "houses" (*chia* 家). Yang Hsiung's logic is still the logic of numbers, but his interests depart from the relatively sterile concerns of Ching Fang's *Book of Changes* commentary or the *Huai-nan-tzu*'s mathematical treatises. Still working within the conceptual framework of correlative thinking—"there is identity in origin but separation in growth"—he expounds a theory of human birth and development. He writes of several cycles of human life, including the birth of consciousness, intellectual development, external attainment, and inevitable decline.[27] The tendency to humanize correlative thinking, that is, to explore in more and more detail the implications for the individual human life and mind, is an important and increasingly pronounced tendency as we approach the Six Dynasties and the development of theories of aesthetics in a more familiar context.

[27] Fung, *Chinese Philosophy*, 2:142.

The systems of correlation invite two kinds of study. How and why did the correlations "work," and what were the implications for human action? What effect did these conventional and explicit correlations have on the arts, musical, verbal, and graphic?

When the tones of the bell are attuned, then the way of the lord is attained, and the yellow-bell and "luxuriant" (jui-pin 蕤賓) pitches respond. Should the way of the lord not be attained, then the tones of the bells will not be attuned, and the yellow-bell and luxuriant pitches will not respond. When the tones of the drums are attuned, then the way of the ministers is attained. If the way of the ministers is attained, then the "great budding" (t'ai-ts'u 太簇) pitch will respond. When the tones of the pipe are attuned, then the pitch gamut and calendar will be correct. When the pitch gamut and calendar are correct, then the "equalizing" (i-tse 夷則) pitch will respond. When the tones of the stone chimes are attuned, then the way of the people is attained. If the way of the people is attained, then the "forest-bell" (lin-chung 林鐘) pitch will respond. When the tone of the reed flute is attuned, then the system of laws is attained. If the system of laws is attained, then the "tireless" (wu-i 無射) pitch will respond. When the ch'in zither tone is attuned, the four seas are conjoined, and the ch'i of the crop cycle and hundred streams find union. The way of spirit virtue comes forth, and the way of the sacrificial rites is attained. This being the case, then the "old and purified" (ku-hsi 姑洗) pitch will respond. When the music of the five instruments is fully attained, then the pitches of the correspondent bells will respond. The harmonious ch'i of heaven and earth arrives, and it responds. Should the harmonious ch'i not arrive, then this ch'i of heaven and earth does not respond.[28]

This pronouncement from the apocrypha provides some elaboration on the manner in which the specific correlations manifest themselves. In addition to the claim of a direct relation between certain activities and certain pitches, there is the claim that some kind of remote interaction occurs between correlated phenomena.

There are many assertions for the ability of sound to connect remote things and many illustrations in the historical record. Han cosmologists

[28] Ma Kuo-han, Yü-han shan-fang, 4:2035.

formulated descriptions of the mechanism of interaction to support the claim for its existence. To the extent that they could argue convincingly for the potential for significant interaction between correlates, the efforts they expended in compiling their taxonomic systems were justified. Tung Chung-shu advanced an influential argument with his theory of categories in a chapter entitled "Similar Classes Mutually Motivate (= Interact)" ("T'ung-lei hsiang-tung" 同類相動).

> If water is poured on level ground it will avoid the parts which are dry and move towards those that are wet. If (two) identical pieces of firewood are exposed to fire, the latter will ignore the damp and ignite the dry one. All things reject what is different (to themselves) and follow what is akin. Thus it is that if (two) *ch'i* are similar, they will coalesce; if notes correspond, they resonate. The experimental proof of this is extraordinarily clear. Try tuning musical instruments. The *kung* note or the *shang* note struck upon one lute will be answered by the *kung* or *shang* note from other stringed instruments. They sound by themselves. This is nothing miraculous but the Five Notes [= five tones] being in relation; they are what they are according to Numbers (whereby the world is constructed).
>
> (Similarly) lovely things summon others among the class of lovely things; repulsive things summon others among the class of repulsive things. This arises from the complementary way in which a thing of the same class responds--as for instance if a horse whinnies another horse whinnies in answer, and if a cow lows another cow lows in response.[29]

The argument for similar classes is developed from the two perspectives of the two interacting entities. Things of a given class excite or energize only other things of their class, and things receive such stimulation from disturbances that originate in their same class. The process is not one of causation, but of sympathetic resonance, the existence of which is proven in the

[29] The interpolations in parentheses are those of Needham and Ho. Quotation translated in Joseph Needham and Ho Ping-yü, "Theories of Categories in Early Mediaeval Chinese Alchemy," *Journal of the Wahrburg and Courtland Institute* 22 (1959): 189. Needham and Ho discuss this theory in the context of chemical processes. For additional information, see Derk Bodde, "Types of Chinese Categorical Thinking," *Journal of the American Oriental Society* 59 (1939): 200.

vibrating string experiments that Tung Chung-shu cites. He calls the sympathetic resonance of an identically tuned string "self-sounding" *(tzu-ming* 自鳴*)*. From the standpoint of the string sounded by visible contact, the corresponding string "corresponds" or "responds" *(ying* 應*)*. This tuning process was referred to often in the correlation texts and alludes back to an explanation that is at least as old as the *Chuang-tzu.*

Lu Chu said, "[What you describe] is simply a case of taking *yang* to call *yang* and taking *yin* to call *yin.* It is not what I call Tao. I will demonstrate my Tao to you." He thereupon tuned a pair of *se* zithers and placed one in the outer hall and one in the inner chamber. When he struck the *kung* on one, the *kung* on the other sounded. The pitch of the tones was identical.[30]

The experiments with sympathetic resonance did not, strictly speaking, prove the capacity of nonidentical things of the same category to interact. But it did validate certain theories about *ch'i,* viz., it existed; it was configured or configurable; its configurations correlated to the twelve pitches, the five tones, and the eight voices; and, finally, it could be detected by appropriately constructed sympathetic resonators. As the "Book of Music" put it, "The eight winds follow the pitchpipes, and they are not rebellious."[31] The term *kuan* 管 , "tube," "pipe," or "resonator," had already expanded semantically in classical times to include the notion of "manage" and "control."[32]

The *Tso Commentary* recorded a comment about the particular configurations of *ch'i* and their manifestation in sound: "Heaven has six *ch'i.* When it descends it makes the five flavors. When it bursts forth it makes the five colors. They are proven by the five sounds [= tones]."[33] The six *ch'i* are *yin, yang,* rain, wind, light, and dark. Chuang-tzu uses the term "six channeling tubes" as an apparent synonym for the six *ch'i,* demonstrating how close in conception were the notions of the configured *ch'i* and

[30] *Chuang-tzu,* chap. 24: "Hsü Wu-kui" 徐無鬼 , pp. 15a-b.

[31] "Yüeh chi," p. 22b.

[32] Karlgren translates the usage in the *Chou-li* as "manage" or "control" (*GSR* 157h). For a polysemous use of the term that encompasses pitches and control, see the quotation translated from the *Hou Han-shu,* "Lü-li-chih" 律曆志 [Treatise on the pitchpipes and calendar], translated below, p. 81, n. 56.

[33] *Tso-chuan,* Chao 昭 , year 1.

the pipes that detected it. The ancients were complete in their preparation, he argues. They were

> the match of spirit illumination, refined as heaven and earth, nourishers of the myriad things, harmonizers of all under heaven. Their benefits flower everywhere among the common people. The fundamental regularities were close to them, close to the ultimate degree. Through all six of the channeling tubes and throughout the four directions, from little to big, fine to coarse, where did their circulation not extend?[34]

With techniques similar to those described by Tung Chung-shu in his essay on similar classes, sympathetic resonance was used to tune instruments. A large, single-string tuner set to a known pitch standard and divided carefully could be placed near another stringed instrument, a bell, a chime, or a pipe. It would sound sympathetically when the other instrument met the frequency of the string tuner. The string on the tuner would not be touched, just listened to carefully, a splendid example of accomplishment through nonaction. If the string did not sound, resetting, filing, filling, chipping, or cutting of the zither, bell, chime, or pipe was needed. Because sympathetic resonance would occur only within a specific narrow bandwidth, tuning for resonance had some practical advantages over tuning by the comparison of two "forced" tones. No subjective judgment is required of two tones that are possibly very different in timbre. Tuning devices, such as the ten-foot tuner invented by Ching Fang, gained in both precision of division and sensitivity as they got longer. The fact that the responding string was not visibly stimulated effectively demonstrated the remote interaction.

Needham provides many interesting examples of canalising ch'i, i.e., detecting it by placing in the path of its movement a pipe that would resonate sympathetically and either sound or provide other indications of response. His discussion focuses on the well-documented practice of gathering military intelligence by means of "humming tubes."[35] While there may or may not be an explanation for this practice that is credible to us, it was clearly a widely used military technique. Needham draws his examples from pre-Han texts, which are sketchy in their description of the humming

[34] *Chuang-tzu*, chap. 33: "T'ien-hsia" 天下 [Under heaven], pp. 34b-35a.
[35] Needham, *Science and Civilisation in China*, vol. 4, pt. 1, pp. 134-41.

tubes. Below is a later and more elaborate description from the *Six Strategies (Liu-t'ao* 六韜), a manual of military tactics that purports to be classical but is Han at the earliest.

King Wu asked T'ai-kung, "Can one by means of the sounds of the pitches and tones know the waxing and waning of the three armies and decide victory and defeat?"

T'ai-kung replied, "Profound indeed, Your Majesty's question! In the gamut of twelve pitchpipes, the essential set is the five tones, *kung, shang, chiao, chih,* and *yü.* These are the orthodox sounds. They have not changed in ten thousand generations because they possess the constancy of the divine Way of the five phases.

"With them one can know the enemy's posture with respect to the five phases, metal, wood, water, fire, and earth, and then select an attacking phase that will conquer him.[36] In ancient times, during the era of the Three August Emperors, it was solely by means of the five phases—this was even before writing existed—that their empty and nonacting temperaments were able to control those who were adamant and unyielding. The way of the five phases is the self-realization of heaven and earth. The 'Distinction of the Six Chia Counters' represents an art subtle beyond subtle.[37]

"It works like this: on a clear and quiet night, free from clouds, obscurities, wind, and rain, go forth at midnight on a light-footed mount all the way to within nine hundred paces of the perimeter of the enemy camp. Then hold the pipes to your ear and shout out so as to excite the enemy. There will be a returning sound, sympathetic to one of the pipes, though it will be extremely subtle. If it is the *chiao*

[36] Several different sequences of the five phases were debated during the Han, some of which were generative, others conquering, masking, or controlling. The suggestion here is to identify the phase in which the enemy army is situated, temporally and spatially, and select from the conquering sequence the proper phase to conquer it. For a description of the sequences, see Needham, *Science and Civilisation in China,* 2:253-65.

[37] The "Six Chia Counters" are the first, eleventh, twenty-first, thirty-first, forty-first, and fifty-first combinations of the sexagenary cycle. They all contain the premier heavenly stem, *chia* 甲, and form a set of premier counters often used in divination.

tube that responds, then it signifies the White Tiger. If it is the *chih* tube that responds, then it signifies the Murky Warrior; the *shang* tube, the Red Bird; and the *yü* tube, the Hooked Array. If none of the five tubes responds, then it signifies the Blue Dragon.[38] These all correlate to the five phases, the signs of [heavenly] aid toward victory, the very triggers of success or failure."

The king replied, "Excellent!" T'ai-kung continued, "These subtlest of all tones are also distinctly marked in other ways." King Wu said, "Can you tell me about them?"

"When the enemy soldiers are startled into action, listen to them. If you hear the tones of sticks beating drums, it is *chiao*. If you see the light of their fires, it is *chih*. If you hear the clashing of iron shields and swords, it is *shang*. If you hear shouting and whistling, it is *yü*. If there is silence with nothing to be heard at all, it is *kung*. These five are the correlations of sound and sight."[39]

T'ai-kung 太公 , possibly to be construed as Duke T'ai, is the putative author of the *Six Strategies* and other military works. He speaks directly to the relation of music systems to warfare. The instrument he describes is a multitube resonator tuned to the tones of the *kung-huang* mode-key. I would not rule out the possibility that such instruments might in actuality have been fashioned to function as ear trumpets, i.e., amplifying traps rather than resonators. They might also have functioned as aeolian pipes, not unlike the zithers placed in windows that later became a popular theme. What is subtle about the sounds is that an extremely keen ear is required to discern them with the pipes.

What T'ai-kung described is one of many prognostication arts based on sound that make use of the correlative schemes of Han thinkers. The uses of sound and music in esoteric arts were diverse. Some techniques exploited their ability to convey knowledge from a remote source to the sensitive ear of a medium or diviner. Some exploited their ability to exert a remote, yet positive influence on other things that were categorically

[38] The tiger, warrior, bird, and dragon are the animal deities that dominate the four quadrants of the sky. The Hooked Array is a constellation of six stars in the central heavens, four of which are in the handle of Ursa Minor. This divination combines an element of disastrous geography with a five-phases analysis.

[39] *Liu-t'ao, Ssu-pu ts'ung-k'an* ed., 3.23a-24a.

related. Some more simply used the pitches as number surrogates in counting and correlating. Needham finds a precedent for the esoteric use of sound in ancient ancestral sacrifices. At the scene of the ritual, vapors from the cooking pot rise, delicious emanations that mingle with the chants and music of the assembly, reach to the ancestors, and lure their attention to the efforts of the living.[40] Ch'i rendered visible by the water vapor and ch'i rendered audible by the music are proof that the sacrificial effort is being successfully conveyed to the other realm.

The ritual of wu 巫 mediums is dance, as recorded in both the *Songs of the South* and the *Programs of Chou.* Dance and music are employed to hasten entry into a trance; they are the conveyance, in effect, to another world. When the medium is in the trance and away from his assembled onlookers, song and dance convey back to them an account of the medium's progress.[41] Mediums who used exorcistic powers against possessing spirits did so with chants and drums, the drums being an expression of control comparable to Music Master K'uei's starting the ritual and making the birds and beasts dance. Some exorcistic techniques developed in time into the arts of the medieval *fang-shih* 方士, doctors, diviners, and magicians who could exorcise possessing demons, force demonic impersonators to manifest their true form, make birds dance and fish leap, and influence all manner of events remotely with their pipes, drums, and chants.[42]

Tsou Yen, the great naturalist of the third century B.C., farmed with his pitchpipes: "In the north there was a valley of good earth but so cold always that the five grains would not grow there. Tsou Yen blew on his pipe, however, and (permanently) warmed its climate, so that grain and millet could be raised abundantly."[43] In the *Book of Documents*, K'uei draws the phoenixes near with his music. The "Hsiao-chih" tells of whistling performances that could cause the earth to quake and of the whistling of the Su-men Mountain sages that brought on the winds and rains.[44]

[40] Needham, *Science and Civilisation in China*, vol. 4, pt. 1, p. 133.

[41] Mircea Eliade, *Shamanism: Archaic Techniques of Ecstacy* (Princeton: Princeton University Press, 1964), pp. 174-80.

[42] For a discussion of these techniques and translations of the biographies of important *fang-shih*, see my *Doctors, Diviners, and Magicians of Ancient China.*

[43] Translated in Needham, *Science and Civilisation in China*, vol. 4, pt. 1, p. 29.

[44] Edwards, "Principles of Whistling," pp. 225-26.

Among Six Dynasties records of attempts to influence nature is the account of Liu Hsin's clay dragon that made rain by blowing a pitchpipe.

Liu Hsin's instrument for bringing rain was an earthen dragon which blew a pitchpipe. All of the many magicians were prepared to arrange it. Huan T'an asked why he made an earthen dragon for the purpose of seeking rain. His answer was, "When the dragon appears, then wind and rain arise to escort him. Therefore, copying the appearance of its kind, I created the earthen dragon."[45] Making the clay image according to the appearance of a real dragon provided the basis for the interaction of like kinds.

The officers described by T'ai-kung who gathered military intelligence with their humming tubes were ancestors of other kinds of mediums and diviners, keen-eared interpreters of bird calls, animal sounds, wind tones, folk songs, and even the accuracy of the emperor's own pitch standards. Physiognomists considered voice to be as pertinent a physical feature as any other. "The techniques for physiognomic examination of people include: some in the face, some in the feet and hands, some in the gait, and some in the voice."[46] I have mentioned Kuan Lu, an itinerant diviner of the third century A.D. who could interpret bird calls and the sound of the wind. Lu was consulted when bird anomalies were observed, i.e., birds making odd sounds or making calls at an unaccustomed time of year. Lu was also consulted when boulders cracked open and "spoke" and when other sound-related anomalies occurred. He was a master of the very popular technique of Wind Angles, the foretelling of future events by the direction, strength, and tone of the winds.[47]

[45] Pokora, *Hsin-lun*, p. 121. The quotation is taken from Liu Chao's commentary to the *Hou Han-shu*. The extent to which this sympathetic interaction was possible is discussed not only by Huan T'an, but by Wang Ch'ung as well, in his chapter devoted to dragons and dragon myths, "Falsehoods Pertaining to Dragons" ("Lung-hsü" 龍虛), *Han Wei ts'ung-shu* ed., pp. 1722-30.

[46] *Ch'ien-fu lun* 6.6b; essay entitled "Hsiang-lieh" 相列 [Physiognomy] .

[47] Ngo Van Xuyet, *Divination, Magie et Politique dans la Chine ancienne*, Bibliothèque de l'École des Hautes Études vol. 78 (Paris: Presses Universitaires de France, 1976), pp. 186-90.

One of the most curious of the divinational uses of the pitches was in helping to determine genealogies and surnames. Wang Ch'ung's *Balancing Discourses (Lun-heng)* says, "Confucius blew the pipes, and he thereby came to know that he was a descendant of the house of Yin."[48] Ching Fang, author of the favorite commentary on the *Book of Changes* for diviners, "originally had the surname Li. But by projecting from the twelve pitches, he himself made it Ching."[49] The *Imperial Digest of the T'ai-p'ing Era* quotes a lost commentary to the *Book of Changes:* "When the sages first arose, they did not know about surnames or given names. They blew on pipes and listened to the sounds and in this manner distinguished the surnames."[50]

In the *Comprehensive Discussions of Virtue in the White Tiger Hall* and the *Balancing Discourses,* there are more detailed descriptions of the systems:

> In ancient times, the sages would sound pipes to determine surnames and then keep records of their lineages. People are born in possession of five constancies. There are also five correct sounds, the *kung, shang, chiao, chih,* and *yü.* By cyclical combinations these are multiplied. Five by five makes twenty-five. By further cyclical combinations with the four seasons and their different *ch'i,* the system of differentiated tones becomes complete. As a result, there are a total of one hundred surnames.[51]

> The *Art of Charting Residences* says, "There are eight arts associated with residences. By means of the names of the Six Chia, they are systematized and ranked. The ranking is determined and the names are established, the *kung* and the *shang* are differentiated. These are the five tones for residences and the five sounds for surnames. If the residence is not befitting the surname then disorder will occur, followed by death, and trespass will bring on disasters."[52]

[48] *Lun-heng,* "Ch'i-kuai p'ien" 奇怪篇 [Discourse on curiosities], 3.30a.

[49] *Han-shu,* "Ching Fang chuan" 京房傳 [Biography of Ching Fang], pp. 3160-78.

[50] *T'ai-p'ing yü-lan,* p. 1795, quoting the *I-shih lei-mo* 易是類謀. Other variants of this quotation attribute the discovery to the Yellow Emperor.

[51] *Pai-hu-t'ung te-lun* 2.35b; *chüan* entitled "Hsing-ming" 姓名 [Surnames and names].

[52] *Lun-heng,* "Chieh-shu p'ien" 詰術篇 [Criticizing esoteric arts], 25.1a.

Wang Ch'ung's discussion goes on to debunk the usefulness of this technique, consistent with the tradition of skepticism in which his thinking had developed. Wang Fu said succinctly, "There were also the absurd traditions of surnames according to the five tones. These are complete lies, of the very worst sort."[53] The frequent critical mention of this technique by late Han skeptics suggests it was rather prevalent in that time.

The effort to refine and demonstrate the correlations challenged early Chinese who were engaged in scientific thinking and technological activities. The sympathetic resonance experiments had demonstrated the interaction of identical members of a category, but what of nonidentical members? The proposed correlation between pitches and time would seem extraordinarily difficult to demonstrate experimentally, yet their role in the management of seasonal rituals made them extraordinarily important to the practice of statecraft. Ching Fang, whose *chun* tuner was capable of sixty degrees of the cycle of fifths, is quoted in the "Treatise on the Pitchpipes and Calendar" in the *History of the Later Han*. The construction of his tuner is described, and then all sixty of the pitches are described in terms of the calculated ratio to the yellow bell, the length of the attuned pipe, the length of the attuned string on the *chun* tuner, and other pitches coincident with the five tones at that pitch level.[54] After the completion of this list, the treatise says, "Section the tubes to make pitchpipes; then blow them to verify the sound. Array these in order to materialize the *ch'i*. This is the root source of the Tao."[55] What Ching Fang was referring to when he wrote "array these in order to materialize the *ch'i*" is an experimental procedure known as "watching the ethers" (*hou-ch'i* 候氣).

[53] *Ch'ien-fu lun* 6.2a; essay entitled "Pu-lieh p'ien" 卜列篇 [Divination].

[54] For example: "Yellow Bell; 177,147; By inferior generation makes forest bell; With yellow bell as *kung*, great budding is *shang*, and forest bell is *chih*. . . . Its pipe is nine inches and its string is nine feet." These length measurements become more complex as the measurements go further into the cycles. *Hou Han-shu*, pp. 3002-14.

[55] Ibid., p. 3014. I have followed the original *Hou Han-shu* text, which has *wu-ch'i* 物氣, rather than accept, as Derk Bodde did, the *Chin-shu* emendation of that term. Bodde writes that *wu-ch'i* "yields no sense," but I think, quite to the contrary, that it has a sense of to "materialize the *ch'i*," which was of crucial significance. See Bodde, "Watching for the Ethers," p. 18, n. 1.

The same chapter of the *History of the Later Han* admits the difficulty of keeping the pitches true from era to era and the sorry state of pitch studies in its time:

We can go back and read in the old canon. We can even get possession of some of the old instruments and configure them exactly as Ching Fang prescribed. Still, we cannot set the tension of the strings exactly. There is no way in writing to make people clear on a precise tone. Those in the past who knew it may have desired to teach but had no takers. The very enlightened knew it intrinsically without the need for teachers. Therefore, we gradually lost those in the historian's office who could discriminate the high from the low. There are really only two means by which these can be transmitted, either by deriving them from unchanging numbers or by watching the ethers.[56]

The accuracy of the pitches was debated passionately at court. The yellow-bell pitch, being the pitch on which the other eleven were ultimately based, had to be accurate or the entire system failed. At least since the beginning of the Han, scholars were not assured of the accuracy of the yellow-bell pitch, and it became symbolic of what was lost from China's classical age. Tuners were lost through neglect during the tumultuous years of the late Chou. Detailed and reliable instructions were destroyed by the Ch'in. Various efforts were made to recover the correct standard, but a sense prevailed that the situation was getting worse. At the end of the Han, there were complaints that even the art of instrument-making was in decline. In the early third century, a prominent musicologist, metallurgist, and diviner, Tu K'uei 杜夔, made an attempt to readjust the standards according to ancient rules. Though his reputation was

[56] *Hou Han-shu,* p. 3015. The numbers are "constant" in the sense that they are universal counters, significant for a variety of object systems. This is explained earlier in the chapter:

"The records claim that [the Yellow Emperor's minister] Ta Nao 大橈 made the sexagenary cycle counters and [his minister] Li Shou 隸首 made the numbers. Once the counters and numbers were set up, they provided measure of the progress of the days and means to manage [= canalise, pipe] the myriad things. To explain this, 'one,' 'ten,' 'hundred,' 'thousand,' and 'ten thousand' are universally used, whereas 'pitch,' 'length,' 'capacity,' 'weight,' and 'time' are their specialized applications" (p. 2999).

unmarred and his skills widely applauded, he became engaged in a bitter factional rivalry with one Ch'ai Yü 柴玉 over the casting of a bell. Ch'ai Yü ended up a groom in the emperor's stables, but Tu K'uei also suffered public repudiation by the emperor. His efforts to restore the correct pitch standards were frustrated, and his contemporaries lamented that even the linear measurements of their day were no longer reliable.[57]

Something more reliable than ancient rules and bell dimensions was needed to maintain standards that would command widespread confidence. Because the yellow bell was an immutable standard in nature and was, in fact, realized in its configuration of *ch'i*, techniques were explored to "measure" the dimensions of the *ch'i*. It had long been recognized that there was an orderly commutation of *ch'i* between heaven and earth.

> The *ch'i* of earth ascends to heaven's level; that of heaven descends to earth. The *yin* and *yang* press upon each other; heaven and earth jostle each other. That makes drumming for peals of thunder, then with thunder there is wind and rain, movement for the four seasons, and illumination for the sun and moon. This is how the hundred transformations arise, the way in which music is the harmony of heaven and earth.[58]

The experiment as documented in the dynastic histories sought to verify the correlation between the pitchpipes and twelve festivals of the solar year. Theory held that the festivals marked critical moments in the annual cycle, during which *ch'i*, specifically configured for that moment, was in motion. Pipes of precisely the correct dimensions to resonate with the *ch'i* of a given configuration could detect the motion. An array of pipes capable of canalising the *ch'i* could, in effect, measure the cosmic tide, simultaneously confirming both the pitchpipe lengths and the festival times. Various techniques were tried, including the use of sensitive pinwheel detectors. It was recognized that the detection of the cosmic tides required great sensitivity, beyond the hearing of even the keenest ear. A method was developed no later than the Han dynasty that went as follows.

[57] *San-kuo chih*, p. 806.

[58] "Yüeh chi," p. 8b. The same concept is expressed in the "Yüeh-ling": "During this month, the *ch'i* of heaven descends and that of earth springs up. With heaven and earth in harmonious accord, the grasses and trees stir forth with new buds" (p. 6a).

The twelve pipes of precisely calculated length, progressing from the yellow bell on down, were buried vertically in the ground. They were placed in circular array, with each pipe at a point on the compass according to its geographic and seasonal affinities. This instrument was surrounded by a triple-walled enclosure with a specially constructed canopy, all designed to insure that no extraneous air movement would influence the readings. The upper end of each tube was filled with a finely ground ash made from the pith of reeds. Because the tide was too subtle to sound the pipes, the ash indicator would be dislodged and "materialize" the ch'i when it was successfully canalised. The technique was so refined that the pattern of dislodged ash could be analyzed, first to verify that it was indeed the ch'i that dislodged it and not wind or a person, and second to glean any prognosticatory import from the vigor of the cosmic tide.[59] The experiment was conducted throughout premodern China, though in later times the emphasis seemed to shift to prognostication.[60] Originally, the major goal of the experiment was to refine the pitchpipe lengths, according to the Han treatise. Gnomen measurements had long been in use and provided an alternate means of verifying the winter solstice. With the solstice established by the gnomen, a variance between the cosmic tide measurements and the gnomen template would indicate that the lengths of the pitchpipes were not correct. Theoretically, the ash of the yellow-bell tube would disperse during the winter solstice. From that point, the pipes would assumedly canalise in sequence, confirming the accuracy of their length or the accuracy of the gnomen marking template for the twelve festivals. The process of measuring the cosmic tide brought together the systems of physical metrology and calendrics. This provided the empirical foundation for the conjunction of pitchpipes and calendrics that endured throughout premodern China in a number of dynastic history treatises on them (e.g., "Lü-li-chih," "Lü-li-shu" 律曆書).

[59] Ashes that were "clumped" together were judged to have been dislodged by the wind or a person. Ashes dislodged by the ch'i would be finely dispersed. Hou Han-shu, p. 3016.

[60] Bodde, "Watching for the Ethers," pp. 14-35.

CHAPTER VI

The "Book of Music"

Correlations developed in larger schemes, like that described by Tung Chung-shu, included sets of human virtues, social classes, family relations, rulership strata, and other orders central to Confucian moral and political philosophy. Tung Chung-shu and Yang Hsiung were both regarded as great Confucian scholars of their day. Whatever the reach of their cosmic speculations, they returned unfailingly to political and moral concerns.

We have already seen the association between music and morality postulated in the earliest mythologies. Basic civilizing acts were moral acts. The instruments of civilization bestowed by the sage-rulers on mankind were largely moral instruments, clearly in the interests of benevolent governance, harmonious society, fair commerce, and a balanced cosmos. Precision and propriety in the use of pitches and tone set the tone for harmonious society. This is described in the *History of the Han:* "In the ultimately governed era, the *ch'i* of heaven and earth combine to create wind. The *ch'i* and winds of the cosmos are thus correct, and the twelve pitches become fixed."[1]

One basic impulse in early discussions of music is to identify and, to the extent possible, describe the court music of the early sage-rulers, the better to know the details by which they achieved virtuous rule. In the discussion of metrology above, we have seen how the pitches were potentially useful in maintaining the accuracy of weights and measures. This important act of regulation was seen in classical times as a concrete application of the pitches in the well-governed era. The *Tales of the States* says, "For this reason, the ancient kings made as their standard the *chung* vessel, (and decreed that) the 'size' of its pitch should not exceed that

[1] *Han-shu,* p. 959.

(produced by the string) of a *chün* (seven-foot tuner), and that its weight should not exceed a stone (*tan;* 120 catties)."[2]

The pitches as a component of music were regulators of length, volume, and weight. As measures of the cosmic tide, they were regulators of mankind's division of the tropical year. No later than the *Kuan-tzu*, *lü* : pitches was used to mean "law" or "regulation": "The laws [*lü*] serve to distinguish each person's portion and place, and to put a stop to quarrels."[3] The claims seem to allude to the function of the stones and drums in ritual, that of starting the dance, regulating its pace, and stopping the dance at its completion. If music could keep a group of dancers in harmonious movement, could it not do the same for society at large? This is the thinking of Juan Chi 阮籍 in an eloquent statement on music's potential for bringing harmony to mankind:

> Now, music is part and parcel of the very structure of the universe and the beings that inhabit it. When music is in accord with this structure and assimilates this nature, then it will be harmonious; but when it departs from them both, then it will be discordant. When the saints of old invented music, they made it to be in conformity with the structure of the universe and to bring to perfection the nature of the beings that inhabit it. Thus they determined the instruments belonging to each of the eight directions of the universe so they might correspond with the sounds of the eight winds pushed abroad by the alternation of the *yin* and *yang;* they adjusted the musical tube *huang-chung* ["yellow bell"], the tube of central harmony, and thereby opened up the affections of all living beings.
>
> Since [music is thus intimately related to all human and natural phenomena], when the musical scale is well tuned, the *yin* and *yang* will be harmonious; when the instruments are in tune, all beings will remain true to their species. Men and women will not change their places; the sovereign and his ministers will not infringe upon one another's position. Within the Four Seas, all will have the same outlook; the Nine Provinces will all fall into step. When music is

[2] Needham, *Science and Civilisation in China*, vol. 4, pt. 1, p. 199.

[3] Joseph Needham, "Human Law and the Laws of Nature," chap. 8 of *The Grand Titration* (London: Allen and Unwin Ltd., 1969). Needham describes *lü* as "one ancient Chinese word which does seem to link the spheres of non-human phenomena and human law" (p. 313).

played at the round hill, heavenly spirits will descend; when it is played at the square mound, earthly spirits will arise. When heaven and earth thus unite their virtues, all beings will be concordant in their lives. Punishments and awards will not be used and the people will be peaceful of themselves.[4]

Juan Chi's description harkens back to the sacrifices to heaven and to earth (the "round hill" and the "square mound") and carries the analogy from regulation of the sacrifice to regulation of all society and then all Nine Provinces. His claim that music can "bring perfection to the nature of the beings that inhabit" the universe summarizes the central themes of Confucian polemics on music in the classical and Han periods.

Prior to the time much had been said about acoustics or cosmology, writers concerned themselves with the moral importance of music at an individualized and concrete level. What is the nature of music's good and ill effects, and how does music work on society and the individual? How does it relate to other instruments of influence, education, and control? How precisely can the relationship between music and morality be defined?

Duke Cha's comments on the music of the various states reveal what is often an admiring, yet sometimes critical response to the manifestations of virtue in the various songs. The *Book of Documents* resorts to the analogy between harmony in music and harmony in governance by the sage-rulers. The *Book of Odes* emphasizes much the same theme, and the *Tso Commentary* is replete with examples.

Lü Pu-wei identifies the moral imperative in music. "It is from the highest antiquity that music has come down to us. It is always, unavoidably, either restrained or excessive, either correct or lascivious. For the wise, music is the means to prosperity; for the immoral, the instrument of their demise."[5] Lü subsequently provides a number of historical examples in which music played a role in governance. He then explains them as follows:

> All tones are produced in the human mind. Things impinge upon the mind, and it moves to make tones. Tones come into being externally, but their influence is internal. Therefore, it is said, "Listen to

[4] Holzman, *Poetry and Politics*, p. 89. I have taken the liberty of changing a few names to make the terminology consistent with my own.

[5] *Lü-shih ch'un-ch'iu* 5.7b.

the sounds to know [people's] ways; examine their ways and know their intent. Observe their intent and know whether virtue is rising or falling, whether rule is sage or dissolute."

Superior men and petty men alike reveal themselves in music; they cannot hide. Therefore, the claim that "music is the thing to watch" is profound. Grass and trees will not grow from barren soil; fish and tortoise will not prosper in troubled waters. When the times are murky, the rites are confused and music is salacious. Take the sounds of Cheng and Wei, the tones of "Mulberry Grove"--that is what states in chaos love, what is a delight to those of failing virtue.[6]

Lü's statement formulates ideas that are illustrated in a number of classical accounts, e.g., the *Tso Commentary* account of the physician Ho:

The marquis of Chin requested a physician from the state of Ch'in. The earl of Ch'in sent a physician named Ho to make the diagnosis. "I cannot act on this disease," said Ho. "It is said that a man who is always near the women's chambers will suffer an affliction akin to taking poisons from the most venomous creatures. Such a disorder is neither the workings of ghosts nor the result of diet. Infatuation has sapped the will. Your good minister is soon to die. It is a matter of heavenly fate that he will not be aided."

The duke said, "You mean that one cannot be near women?" Ho replied, "Be restrained! The music of the sage-rulers was the means to restrain people in their diverse affairs. Therefore, the music had five rhythms [= restraints]. Fast or slow, from beginning to end, continuity was achieved, and the notes were perfectly centered for the presentation. After five presentations, further playing was not permitted.[7]

"This being so, the gentleman will not listen when agitated hands produce lascivious sounds, smothering the ears and mind in delight, abandoning thought of balance and harmony. Physically things will

[6] *Lü-shih ch'un-ch'iu* 7.6a-b.

[7] I have translated *chiang* 降 as "presentation" in the sense of "bestowal." The word is problematic when used in connection with music. Needham, *Science and Civilisation in China*, vol. 4, pt. 1, p. 134. Needham relates it to the "descent" or "incorporation" of cosmic *ch'i* associated with pitchpipe sounding, and I have translated it accordingly when used in a cosmological context. See p. 82 and n. 58 above.

follow this. When they reach the point of agitation, they must abandon their course right away, so there will be no generative source of disorder. The gentleman who closely embraces his *ch'in* or *se* zither does so with decorum and restraint. It is not to delight his mind."[8]

The same word, *chieh* 節 , means both "rhythm" and "restraint," adding the force of paronomasia to the strategy of Ho's argument. Rhythm as discipline again recalls K'uei's striking the stone. The concrete sense of *chieh* as the joints of bamboo—it was between the *chieh* that Ling Lun sectioned his pitchpipes--suggests a recurrence of a simple pattern, as seen, for example, in the teeth of a comb *(chieh* 櫛*)*. The quality of sentiment described in the word "delight" *(t'ao* 慆 *)* is opposite that of music's homograph "enjoy" *(lo* 樂 *)*, "delight" being an act of turpitude, not cultivation.

Of all the classical texts identified with the Confucian school, the *Hsün-tzu* makes the most significant contribution to music theory. The argument in "A Discussion of Music" is fully occupied with refuting attacks on music which Hsün-tzu ascribes to Mo-tzu. The hyperbole of the rhetoric in Hsün-tzu's discussion is an expression of the fervor of the debate between proponents of the Confucian view and those of the Mohist view. The defense for music that Hsün-tzu assembles is characteristic of his thinking. Just as did Confucius and Mencius, Hsün-tzu continues to concern himself with the influential power of music, but rather than discuss the moral cultivation of the gentleman and the ruler, he discusses music's direct moral influence on the masses of people.

Music enters deeply into men and transforms them rapidly. Therefore, the former kings were careful to give it the proper form. When music is moderate and tranquil, the people become harmonious and shun excess. When music is stern and majestic, the people become well behaved and shun disorder. When the people are harmonious and well behaved, then the troops will be keen in striking power and the cities well guarded, and enemy states will not dare to launch an attack. In such a case, the common people will dwell in safety, take delight in their communities, and look up to their superiors with complete satisfaction. The fame of the state will become known abroad, its glory will shine forth greatly, and all people within the

[8] *Tso-chuan,* Chao 昭 , year 1.

four seas will long to become its subjects. Then at last a true king may be said to have arisen.

But if music is seductive and depraved, then the people will become abandoned and mean-mannered. Those who are abandoned will fall into disorder; those who are mean-mannered will fall to quarreling; and where there is disorder and quarreling, the troops will be weak, the cities will revolt, and the state will be menaced by foreign enemies. In such a case the common people will find no safety in their dwellings and no delight in their communities, and they will feel only dissatisfaction toward their superiors. Hence, the turn away from the proper rites and music and to allow evil music to spread is the source of danger and disgrace. For this reason, the former kings honored the proper rites and music and despised evil music. As I have said before, it is the duty of the chief director of music to enforce the ordinances and commands, to examine songs and writings, and to abolish licentious music, attending to all matters at the appropriate time, so that strange and barbaric music is not allowed to confuse the elegant classical modes.[9]

The influence is particularly apparent in the context of primary social and familial relations:

When music is performed in the ancestral temple of the ruler, and the ruler and his ministers, superiors and inferiors, listen to it together, there are none who are not filled with a spirit of harmonious reverence. When it is performed within the household, and father and sons, elder and younger brothers listen to it together, there are none who are not filled with a spirit of harmonious kinship. And when it is performed in the community, and old people and young listen together to it, there are none who are not filled with a spirit of harmonious obedience. Hence music brings about complete unity and induces harmony.[10]

Along with his description of the basic nature of man as evil, Hsün-tzu reasonably stresses the influential power of all instruments of civilization. Civilization is the aggregate of means by which the evil nature of man is changed and harmony displaces chaos.

[9] Watson, *Hsün-tzu*, pp. 114-15.
[10] Ibid., p. 113.

Of all of the Han texts about music, the "Book of Music" is the most elaborate discussion of its morality and its influence. In the absence of a classic of music to study and reconstruct, its compilers made a pastiche of contemporaneous and classical utterances that appeared to support the Confucian positions on music and ritual at court. Much of the contents of the "Book of Music" was taken from the *Hsün-tzu*, but the book also includes some innovative sections that are not found in earlier writings.

The natural philosophy as it unfolds in the "Book of Music" is less a theory of cosmology, attending to the pitches, and more a theory of psychology, looking to music as a complete and complex human phenomenon. The contributions of the Han cosmologists were codified and preserved in the dynastic history treatises on pitchpipes and calendrics; those of the "Book of Music" were codified in the dynastic history treatises on music ("Yüeh-chih" 樂志). A division between cosmological and moral-psychological philosophy emerges with this division between treatises in the dynastic histories, which appears in the first dynastic history and endures. One implication of this division is that different groups of experts were called upon to contribute to the two types of treatises. As the discussion of music became more and more involved with moral concerns, it also became more involved with ritual. Some later dynastic histories simply combined music and ritual in a single treatise to emphasize their complementary role (e.g., *Hsin T'ang-shu* 新唐書 [New history of the T'ang] and *Yüan-shih* 元史 [History of the Yüan]).

Hsün-tzu establishes the contrast between music and ritual:

> Music embodies an unchanging harmony, while rites represent unalterable reason. Music unites that which is the same; rites distinguish that which is different; and through the combination of rites and music the human heart is governed. To seek out the beginning and exhaust all change—this is the emotional nature of music; to illuminate the truth and do away with what is false--this is the essence of ritual.[11]

Hsün-tzu selects music and ritual as the two most significant instruments of civilization for influencing man's nature. By placing them in an interactive, dualistic framework, structurally analogous to *yin* and *yang*, he argues, *sotto voce*, for their primacy and their comprehensiveness.

[11] Watson, *Hsün-tzu*, p. 117.

The "Book of Music" returns again and again to the contrast between music and ritual. "Music expresses the harmony of the universe, while ritual expresses the order of the universe." "Music is the uniter, while ritual is the distinguisher." Music always speaks to closeness and familiarity, ritual to distance and respect. Music is the creation of heaven; ritual is under the influence of earth. The human virtue of reciprocity (jen 仁) is close to music, whereas righteousness (i 義) is close to ritual. Music represents natural forces, ritual the things of creation. Heaven is ever in motion, and earth is ever still. Music thus has *yang* characteristics, and ritual has *yin* characteristics. Through this final association, the relation between music and ritual is elevated to that of a dynamic process. Music is found in ritual, and ritual is found in music. Each gives birth to and is born of the other.[12]

The "Book of Filial Piety" ("Hsiao-ching" 孝經) attributes to Confucius a quotation comparing the influential realms of music and ritual. "For influencing airs and changing ways, nothing is better than music. For keeping the powers above tranquil and controlling the people below, nothing is better than ritual."[13] Here again, part of the strategy of the argument is the paronomasia in the expression "influencing airs," which might well be translated "transplanting local songs," *feng* 風 meaning "air" both as general cultural "atmosphere" and "folk song."

The "influencing of airs" could be corruptive as well as beneficial, something we have already seen in Duke Cha's comments. Duke Cha criticized the lascivious music of Cheng, which had already been identified by Confucius in the *Analects:* "I hate the way in which the purple takes away the luster of red. I hate the way in which the songs of Cheng confound the music of the *ya.*"[14] Red is a primary color, purple a blend, the analogy being to the music of the *ya* performed with the primary mode-keys, and that of Cheng with elaborated ones. In discoursing on proper models, Confucius said, "For music follow the Shao dances. Banish the music of Cheng! . . . The music of Cheng is salacious!"[15]

Hsün-tzu expands the critique of the music of Cheng: "Seductive looks and the songs of Cheng and Wei cause the heart to grow licentious,

[12] "Yüeh chi," pp. 4b-5a.
[13] "Hsiao-ching," p. 12.
[14] *Analects,* chap. 17: "Yang-huo" 陽貨 , v. 17.
[15] Ibid., chap. 15: "Wei-ling-kung" 衛靈公 , v. 11.

while the donning of court robes, sashes, and formal caps, the Shao dance and the Wu song, cause the heart to feel brave and majestic."[16] The "Book of Music" places the music of Cheng and Wei in a historical context:

> The tones of Cheng and Wei were tones of a world in chaos and compare to the dilatory ways of the peoples. The tones of the Mulberry Grove above the P'u River were tones of a state facing extinction. The administration was dissolute, and the people wandered about haplessly. They vilified their superiors and behaved with such selfish abandon that nothing could save the situation.[17]

Another section of the "Book of Music" credits Tzu-hsia 子夏 , a disciple of Confucius, with the following remark:

> Cheng tones are of a mind that tends toward doting excess and licentiousness. Sung tones are of a mind frail and effeminate. Those of Wei are of a mind rushed and vexed, those of Ch'i a mind haughty and remote. All four of these are excessive in their [external] attractiveness, and they are therefore harmful to one's virtue. For these reasons, they are proscribed from use in the sacrifices and rites.[18]

Picken's analysis of the line structure in the *Book of Odes* led him to conclude that the airs of Cheng were more irregular in their lines than the airs of other states. Most scholars have associated the music of Cheng with the elaborated tones (*pien-yin* 璗音) which, added to the pentatonic scales, make possible a six- or seven-tone scale. Since the discovery of the Marquis of Tseng bell set, there can be no doubt that such elaboration was widely used in music performance. In the writings of the Confucians, the

[16] Watson, *Hsün-tzu*, p. 116.

[17] "Yüeh chi," pp. 2b-3a. The Mulberry Grove music was salacious music that the degenerate last king of the Shang, Chou 紂 , forced Music Master Yen to compose. The music master drowned himself in the P'u River after complying with Chou's order. The Mulberry Grove music will be mentioned again below, in the story of Duke P'ing of Chin. Along with the music of Cheng, the Mulberry Grove was the bane of Confucian thinkers. The salacious Mulberry Grove music is "Sang-chien" 桑 間 , not to be confused with the rain-seeking Mulberry Grove music ("Sang-lin" 桑林) of the virtuous Shang king T'ang. See *Tso-chuan*, Duke Hsiang 襄公 , year 10; and Watson, *Chuang-tzu*, p. 50.

[18] "Yüeh chi," pp. 18a-b.

popularity of immoral music is acknowledged even as the defenders of the orthodox *ya* importune rulers to restrain themselves from indulgence in the pleasures of Cheng-style entertainments:

> Marquis Wen of Wei asked Tzu-hsia, "When I don my ritual regalia and listen to the ancient music, the only thing I fear is that I will keel over [from boredom]. But when I listen to the tones of Cheng and Wei, I never feel the least bit sated with it. May I be so bold as to ask why the ancient music is that way when the new is not?"[19]

The marquis's inquiry is answered at length by Tzu-hsia, who criticizes the new music for its loudness, complexity, vulgarity, and mixing of men and women in performance and reviews the venerated moral influence of the ancient music. But the Confucian aversion to the new music apparently did not effectively control its popularity at the court, where others, either in the Han Music Bureaus or in positions of responsibility for court entertainments, approved of the more intricate and interesting styles: "A house without trimming is not the equal of the O-fang Palace. An uncarved beam is not the equal of a polished rafter. Dark-colored liquors are not the equal of Ts'ang-wu wines. The *k'ung* and the *chieh* (instruments) are not the equal of the flowing music of Cheng."[20] This argument, made by Huan T'an, who was prefect of the Music Bureau under Han emperor Hsiao-ch'eng 孝成 (32-6 B.C.), is followed by another in which he charges that those who criticize modern music do not understand music and hold resolutely to dogma.

> Yang Tzu-yün was a man of great talent, but he did not understand musical tones. I grew detached from the court music and came to prefer modern tunes. Tzu-yün said, "It is very easy to be pleased by shallow things, but the profound can be understood only with difficulty. It is fitting that you do not like the court odes and delight in the tunes of Cheng."[21]

The music of Cheng became a metaphor in all of the arts for vulgarization and degeneration.

The "Book of Music" resorts to characteristic Han correlative argument to refine its descriptions of music's specific moral indications.

[19] "Yüeh chi," p. 17b.
[20] Pokora, *Hsin-lun*, pp. 66-67.
[21] Ibid., pp. 118-19.

Kung is the ruler, *shang* the ministers. *Chiao* is the people and *chih* the affairs of mankind. *Yü* is the things [of the world]. If these five are not in disarray, there will be no cacophonous tones. But if *kung* is in disarray, there will be disaster, because the ruler is arrogant. If *shang* is in disarray, the state will topple, because the ministers are corrupt. If *chiao* is in disarray, there will be suffering, because the people are aggrieved. If *chih* is in disarray, there will be sorrow, because the affairs of men are in turmoil. If *yü* is in disarray, there is danger, because the material means are depleted. If all five tones are in disarray, they will clash and trespass each other's bounds. Should this happen, the end of the state cannot be far off.[22]

The "Book of Music" also elaborates on the perceptible qualities of orthodox music.

Therefore ultimately proper ritual offering is not the most richly flavored food. The *se* zithers in the clear temple are strung with boiled-soft silk and made with resonating holes broad across [for vapid tone]. One sings forth, and three others only breathe their tones. Sometimes the tones are inaudible. Dark wine is most highly regarded for the ultimate food offering at the sacrifice, and the raw fish and meat broth on the tables are not blended [with spices]; the flavor is left unelicited.[23]

Commentators point out that if the externals of the music or the food were too attractive, attention would be diverted from the main issue of the rites, namely, virtue.

In its many diverse paragraphs, the "Book of Music" reiterates what had become the definitive issues of Confucian thought on music, most of which had already been expressed in classical texts. On the other hand, in key ways it foreshadowed the interests of the late Han and early Six Dynasties period, especially in its opening sections, with their preoccupation with the human mind. Hsün-tzu began his discussion of music with comments about feeling:

Music is joy, an emotion which man cannot help but feel at times. Since man cannot help feeling joy, his joy must find an outlet in voice and an expression in movement. The outcries and

[22] "Yüeh chi," p. 2b.
[23] Ibid., p. 3b.

movements, and the inner emotional changes that occasion them, must be given full expression in accordance with the way of man. Man must have his joy, and joy must have its expression, but if that expression is not guided by the principles of the Way, then it will inevitably become disordered.[24]

The claims of the argument depend on the homographic relationship between "music" and "joy," and several alternate readings of the paragraph are possible. The argument echoes the *Book of Documents* and the "Great Preface" to the *Odes*, both of which describe a hierarchy of expressive means available to man. But in this particular area, the "Book of Music" does not carry forward Hsün-tzu's argument; rather, it looks more critically at the inner workings of the responding mind.

I have quoted the important opening sections of the "Book of Music" in the discussion of five tones and *yin* at the end of Chapter IV. *Yin* is not definable without reference to the human mind and the mind's interactions with outside entities or influences. *Yin :* tone is distinguished from *sheng :* sound in two ways. It exists in graduated array, never singly.[25] It is the object of intelligent production, intelligent apprehension, or both. Sounds and tones are issued forth when the mind is impinged upon by external things. The "Book of Music" attempts to correlate states of mind with definable qualities of the tones issued forth.

Music is born from the tones. Its source is the movement of the mind by external things. Therefore, when a mind is moved to grief, its sounds achieve a scathing quality by being abrupt. When a mind is moved to joy, its sounds achieve an unstressed feeling by being melodious. When a mind is moved to great delight, its sounds are persuasive by being openly expressed. When a mind is moved to anger, its sounds achieve severity by being coarse. When a mind is moved to respect, its sounds achieve honesty by being direct. When a mind is moved to love, its sounds achieve softness by being harmonious. These six [states of mind] are not matters of inborn nature. Only when impinged upon by external things does the mind stir.[26]

[24] Watson, *Hsün-tzu*, p. 112; reiterated in the "Yüeh chi," p. 23b.

[25] See Zuckerkandl, *Sound and Symbol*, p. 31: "The basis of the dynamic qualities of tone is not to be sought in the individual tone, but in the relations of the individual tone to other tones."

[26] "Yüeh chi," p. 1b.

Though this paragraph describes correlations between mind and sound from the expressive side, the "Book of Music" does not differentiate such correlations in an expressive context from those in an affective context. It presents the two in a balanced equation. The specific kinds of sound issued by a mind in a specific state will impinge upon another mind and move it to a like state. A mind moved to anger will issue coarse sounds that will move other minds to anger. Conversely stated, coarse sounds will be issued by a mind moved to anger and be perceived by another mind in movement to anger. In its careful description of this process, the "Book of Music" defines a process that is closer to sympathetic resonance than to causation. Confounding attempts at definitive translation, the verb *kan* 感 means, on the one hand, to "impinge," "affect," or "move" and, on the other, to "perceive," "feel," or "sense." In the description of the mind and external things, the agent and object relationship varies from statement to statement. That is, the "Book of Music" notes the significant concurrence of "coarse sound" and a "mind moved to anger" without attempting to establish the agency, or causality, of the concurrence.

With coarse tones about, there will be anger in people's minds. This is the premise on which the "Book of Music" bases its description of the great care exercised by the sage-rulers in shaping ritual and music. In subsequent sections, the text elaborates on sound and mind correlations as they, in turn, are related to public concerns. In spite of its interest in the individual mind and music, the "Book of Music" asserts its Confucian identity by ascribing the varied emotions of the individual to the virtue of the ruler and the state of society. One takes pleasure in harmonious government, becomes angry at corruption, and grieves over a state about to perish. The origin of individual feeling lies in the state of society and the quality of governance; and the end of music and ritual is public good, not private pleasure.

"Therefore, when the sage-rulers regularized ritual and music, they did not do it as an ultimate provision for the desires of the palate, the belly, the eyes, or the ears. They did it to teach people to level out their likes and dislikes and return to the correct way of life."[27] Likes and dislikes require restraint (*chieh* = rhythm). The more level the likes and dislikes of the people, the better they might be integrated into the common public endeavor. Still, the achievement of public good is not ultimately at

[27] "Yüeh chi," p. 4a.

the expense of personal pleasure. In spite of the restraint and austerity demanded by the orthodox styles, it is ultimately the regularity of the music itself that brings pleasure to the person and peace to the state, thereby achieving a harmony of self and society.

Music is something in which the ancient sages took pleasure and which can improve the minds of men.

Therefore it is said that "music is joy." The superior man takes joy in achieving his way, whereas the petty person takes joy in satisfying his desires. When one's way constrains desire, there is joy without chaos. But when one follows desire and forgets the Way, there will be uncertainty and no joy to be had.[28]

[28] "Yüeh chi," pp. 10a, 13b.

Governing the state is comparable to playing the *ch'in.*
If the large strings are too tight, the small strings break.

Han Ying 韓嬰 , *Han-shih wai-chuan* 韓詩外傳
[Han's nonstandard commentary to the book of odes] ,
Han Wei ts'ung-shu ed., 1.9a.

CHAPTER VII

The *Ch'in* and Its Way

Late Han writers were skeptical about the more extravagant claims for correlations and the prognosticatory value of such correlations that were made by their preinterregnum ancestors. During Wang Mang's 王莽 interruption of Han rule (A.D. 9-25), the use of anomalies as portents to justify initiatives, influence opinion, and shape court protocol was taken to new heights. This deflated the credibility of correlative schemes and their applications. With the exception of Wang Mang's immediate successor, Emperor Kuang-wu 光武 (A.D. 25-58), later Han rulers and their ministers neither showed interest in nor lavished support on the study and interpretation of correlations and portents to the extent of their early Han ancestors. The skepticism of Old Text School thinkers, including Yang Hsiung, Wang Ch'ung, and Ying Shao, was clearly reflected in pointed attacks on the Theory of Heaven-Man Parallels and the *yin* and *yang* school of thought; ultimately, they simply turned away from the earlier concerns altogether. The new interest in music was of two kinds, one a restrained mysticism and the other a kind of positivism. The two were complementary reactions to discredited facets of the Theory of Heaven-Man Parallels.

The mysticism is expressed already at the end of the early Han in Yang Hsiung's *Classic of the Grand Mystery*. The Grand Mystery, modeled on the Way and its processes, is an area that is unfathomable to the human mind. Earlier thought of the *yin* and *yang* school defined that which was unfathomable by ordinary means as *shen* 神 but allowed that the universe held no secrets from the greatest minds, those that penetrated *shen*. The "Great Commentary" of the *Book of Changes* has: "That which is unfathomable by *yin* and *yang* is called *shen*."[1] *Shen* or *shen-ming* 神明 , the latter meaning "knowledgeable spirits" or "spiritual knowledge," could be

[1] *I-ching*, "Ta-chuan," *chüan* 1, v. 5.

"reached" (= penetrated, *t'ung* 通) by the sages and was the basis of knowledge of the Changes.

The mystical point of the late Han theory was that there were ultimately inexplicable facets to natural processes; and, consequently, there was unavoidable uncertainty about the significance of present events and prospects for the future. Hsün Yüeh 荀 悦, criticizing the early Han theories of correlation, argued that heaven, earth, and man had different ways and concluded that "one may dimly envision an approximation of truth."[2] Skeptical about man's ability to learn ultimate truth, Hsün Yüeh analyzed the founding of the Han and wrote, "What is contingent cannot be predicted; what is ever-changing cannot be foreseen."[3]

There is an obvious affection for the idea that things might not be entirely predictable. Certain mystic themes from the Taoist classics that speak to limits of knowledge, to uncertainty, and to unpredictability were revived with commentaries that highlighted the ideal of "self-so-ness" and nonaction (or "nonpurposeful action," *wu-wei* 無 為) in human conduct. The ideal of self-so-ness (= spontaneity, *tzu-jan* 自 然), which becomes the central theme of the aesthete life-style in the early Six Dynasties, is articulated by Yang Hsiung: "What is to be esteemed in a writer is his conformity to and embodiment of the ideal of self-so-ness . . . what is primary and substantive lies in self-so-ness; what is supplementary and decorative lies in [pursuit of] human affairs."[4] Yang Hsiung provides a definition of the limits of knowledge: "The *yang* knows the *yang*, but not the *yin*. The *yin* knows the *yin*, but not the *yang*."[5] Wang Ch'ung describes

[2] Chi-yun Chen, *Hsün Yüeh (A.D. 148-209): The Life and Reflections of an Early Medieval Confucian* (Cambridge: Cambridge University Press, 1975), p. 107.

[3] Quoted from the first discourse of Hsün Yüeh's *Records of the Han (Han-chi* 漢記), in ibid., p. 111.

[4] Fung, *Chinese Philosophy*, 2:139. I have altered Bodde's translation to use "self-so-ness" instead of "spontaneity." The *T'ai-hsüan ching* is itself a numerological interpretation of cosmic change, introducing a cosmogonic theory of *yin* and *yang* in a tripartite scheme. Sequential squaring of three yields nine and then eighty-one, illustrated in the text with eighty-one graphs. The graphs are tetragrams consisting of four lines represented in one, two, or three sections. Similar to the hexagrams in the *I-ching*, each is a chapter title. The first tetragram, *chung* 中 , is described as "latent and inchoate in the Huang-kung [tone]" (1.4a).

[5] Fung, *Chinese Philosophy*, 2:140.

natural processes with the same vocabulary that Yang Hsiung used for the writer, arguing that self-so-ness produced the cosmos and that heaven's influence on events on earth is by means of nonaction.[6] Chang Heng described the mystery as the "root of self-so-ness" in a fragment of *The Plan of the Mystery (Hsüan-t'u* 玄圖*)* attributed to him: "The mystery—in the class of the formless, the root of self-so-ness, created in the Great Beginning, preceded by nothing, embracing all-reaching powers, concealed in the *ch'ien* and *k'un* hexagrams."[7]

This epistemological challenge to the *yin* and *yang* school of thought is also reflected in a new element of positivism in the writings of Wang Ch'ung and Ying Shao. There is a continuity in the curiosity about nature that motivated the early Han speculators and a continuity in scientific thinking. But, reacting to the unbridled speculation of the previous centuries, late Han scholars methodically reinvestigated key historical accounts on the basis of what was known to be plausible and likely from current experience. The interpretation and import of past events was subject to reflection by their self-consciously methodical intellects. The discussions of music began increasingly to focus on those aspects of the pitches and tones known to be demonstrable and on physical descriptions of the instruments themselves; Ying Shao catalogued more than twenty instruments and included details about their construction and dimensions. The love of lore is not diminished among late Han thinkers; but lore begins to be quoted as lore, as an artifice of their culture, not as a verifiable experience of their ancestors.

In terms of subsequent intellectual history as it related to music and aesthetics, the more important of these two reactions was the trend toward mysticism and the rebirth of interest in the Taoist classics. The Grand Mystery of Yang Hsiung evolved into a body of thought known as "Mysterious Learning" (Hsüan-hsüeh 玄學). Wang Ch'ung's naturalism and the emphasis on spontaneity and nonaction in his cosmogony were central to the thinking of such major Neo-Taoist philosophers as Wang Pi 王弼, Ho Yen 何晏, Kuo Hsiang 郭象, Juan Chi, and Hsi K'ang. The new views are found in new commentaries on the *Analects* and the *Book of Changes*, and in numerous essays and discourses on music, feeling, and sagehood.

[6] Fung, *Chinese Philosophy*, 2:152.

[7] *Hsüan-t'u*, in Yen K'o-chün, comp., *Ch'üan Shang-ku wen*, p. 779.

Just as the limits of human knowledge were questioned and the pre-
dictability of the future opened to doubt, so, too, was the precision of the
correspondences claimed for music and feeling called into question by the
Neo-Taoists.[8] The ancient association between sageness and sound is
revived in a new mystical context by a number of discourses that ask
whether the sage had emotions or whether music has emotional content. A
prominent example is Hsi K'ang's "Discourse on the Nonemotional Nature of
Sound" ("Sheng-wu-ai-lo lun" 聲無哀樂論).[9] The discourse takes the form
of a catechism, in which an unnamed guest confronts Hsi K'ang with Han-
vintage correlative schemes that define the emotional correlates for vari-
ous sounds. Hsi K'ang attempts to differentiate between qualities of sound,
which he acknowledges exist, and emotional content, which he denies. He
argues that the connection between sound and feeling is indirect and vari-
able, and that the same music will elicit different feelings under different
circumstances. Hsi K'ang's point is essentially the same as Susanne
Langer's argument, quoted in Chapter I, that music does not represent
feelings in particular but represents the morphology of feeling, "the way
feelings go."

For his argument, Hsi K'ang proposes an analogy between listening to
music and drinking wine. Music may incline one toward a general, emo-
tional state of mind, but the response may be very personal.

> In fact, one's halls may be filled with guests. After much drinking
> of wine, when the *ch'in* is performed, some feel a happy elation and
> others sob with deep-felt sorrow. It is not that sorrow is promoted
> with one song and joy with another. In actuality, the notes are un-
> changed, but both extremes of feeling emerge together.[10]

[8] In a chapter entitled "Cheng-wei" 正緯 [Correcting the apocrypha] in
the *Wen-hsin tiao-lung*, Liu Hsieh concludes an unrelenting attack on
early Han apocryphal writing with the statement: "During the two Han
dynasties, the Red and Purple were one boiling mixture." The remark
alludes to Confucius' attack on the music of Cheng. *Wen-hsin tiao-lung*,
pp. 29-33.

[9] Other important examples include Wang Pi, "Discourse on Music"
("Yüeh-lun" 樂論); Juan Chi, "Yüeh-lun"; and Hsia-hou Hsüan's
夏侯玄 "Discourse on Musical Disputation" ("Pien-yüeh-lun"
辯樂論). On the sage and feelings, there are essays by Ho Yen, Chung
Hui 鍾會, Wang Pi, and Hsia-hou Hsüan.

[10] Yen K'o-chün, comp., *Ch'üan Shang-ku wen*, p. 1332.

In the late Han, the field over which discussions of music ranged began to narrow. More was said about music down to earth, either as a part of friendship or a part of nature appreciation. Ying Shao records this story, which is found with only minor variations in a number of late Han texts:

> When Po Ya played the *ch'in* and Chung Tzu-ch'i listened, Tzu-ch'i's thoughts were transported to towering mountains. He exclaimed to Po Ya, "How marvelous, with majesty akin to Mount T'ai!" But in a moment his thoughts were carried to flowing waterways. "How marvelous," he said, "bubbling and flowing like our mightiest rivers."
>
> Tzu-ch'i died, and Po Ya thereupon smashed his *ch'in* and broke its strings. Never again did he play the *ch'in,* for he felt no one in the world was adequate to appreciate its voice.[11]

This story is a cornerstone of *ch'in* lore, introducing many of the themes that became subjects of longer narratives, *ch'in* songs, and theoretical discussions. Music provides a means of communion between like minds. There is genius in the art of performing, yet also in the art of listening. The affective process of music resembles the affective process of nature, and images of the two intermingle.[12]

The process of correlation had become, by Ying Shao's time, a process of communion. By Hsi K'ang's time it had evolved into a process of communion more with nature than with other men. In his *Rhyme-prose on the Ch'in (Ch'in-fu* 琴賦), Hsi K'ang deftly recast venerable old utterances into an eloquent statement of his new understanding.

> When I was young, I loved music, and as I grew up, I delighted in practicing it. My belief is that things have their flowering and decay; only music is without change. Flavors can satiate the palate; only music does not exhaust my interest. Nothing approaches music in a life of deep and solitary reclusion. Therefore, if simple repetition is not enough, I chant words in order to express what I intend. If

[11] *Feng-su t'ung-i,* p. 1442.

[12] For a more sustained discussion of this passage and the evolution of these ideas, see my article "Early Chinese Music."

> chanting is not enough, I set words [to song] in order to open fully my inner thoughts [i = intent].[13]

Music is addressed in a personal context. In a world of flux, felt poignantly in human mortality, music is seen as unchanging. Unlike carnal pleasures, it does not, in the process of one's enjoyment of it, dull the very capacity to enjoy it. It is the companion to the recluse, and it enlarges the expressive potential for language, even poetic language. The argument closes with a recitation of the familiar hierarchy of expressive means, which by Hsi K'ang's time were known not only in the *Book of Documents* and "Great Preface," but in the final lines of the "Book of Music" as well.

Although music and the other arts are still seen in the context of the cosmos, for the Six Dynasties aesthete the idea of the cosmos had become less the firmament with its starry lights and more the world of nature near at hand, the mountains and hillsides, the fishing streams and placid lakes, the pine forests and the bamboo groves. Music and the other arts are still treasured for their influential and expressive potentials, but such influence and expression are less for the benefit of state and society than for the individual, explicitly removed from society by his state of reclusion.

Ts'ao P'i's theory of literature, preserved in the fragmentary "Discourse on Literature" ("Lun-wen" 論文), emphasizes writing as a means of personal expression, an illustration of individual genius, and a means to individual renown and nominal immortality.[14] Ts'ao P'i's important comments, the artistic activities of the Ts'ao family and their artists-in-residence, and the remarkable writings and legends of the Seven Sages of the Bamboo Grove constitute the particular theory and practice of art associated with the Chien-an period (A.D. 196-219). The Chien-an period is often spoken of by scholars as the period in which Chinese theories of aesthetics were born and is, indeed, a period in which an awareness of art familiar to modern minds emerges and flowers.

An important part of the late Han and Chien-an preoccupation with individual talent was an interest in the rank-ordering and classifying of individuals according to their talents and achievements. The practice of "Pure Critiques" (Ch'ing-i 清議), discussions and criticisms of individuals in formal and informal contexts, was eventually reflected in the

[13] Hsi K'ang, *Ch'in-fu*, in *Wen-hsüan*, pp. 240-45.
[14] Liu, *Chinese Theories of Literature*, pp. 4, 12-13, 70-72.

identification and idealization of certain figures as models, the division of prominent people into a talent typology, and the ranking of artists and writers according to their specific artistic achievements.[15] As late as the Chin dynasty, the practice of Pure Critiques persisted as a concrete evaluation of people's talents. Concurrently, under the influence of philosophers who pursued Mysterious Learning, most notably Wang Pi and Ho Yen, Pure Critiques and Pure Conversations became increasingly associated with the abstract discussion of ontology and epistemology.[16]

The discussion of all arts in the Chien-an period invoked the concepts of ch'i as the energetic component in aesthetic endeavor. Ts'ao P'i wrote, "Literature must take ch'i as its mainstay. And the effective manifestations of ch'i have particular embodiments; they cannot simply be forced. In this, a comparison can be made to music."[17]

[15] For a study of Pure Critique and its relation to "Pure Conversation" (Ch'ing-t'an 清談), see T'ang Ch'ang-ju, "Ch'ing-t'an yü ch'ing-i," pp. 289-97. The practice of Pure Critiques is exemplified in Liu Shao's 劉邵 (ca. A.D. 190-265) Description of Human Talents (Jen-wu-chih 人物志). The most important example of what I have called a talent typology is the Shih-shuo hsin-yü 世説新語 of Liu I-ch'ing 劉義慶 (A.D. 403-44), translated by Richard Mather as A New Account of Tales of the World. The work divides hundreds of stories of eminent historical figures, mostly from the Chin dynasty, into chapters with such titles as "Virtuous Conduct," "Cultivated Tolerance," "Insight and Judgment," and "Technical Understanding." The most important example of the ranking of poets is the Classification of Poetry (Shih-p'in 詩品) of Chung Hung 鍾嶸 (A.D. 469-518), which divides poets into three classes and discusses their strengths and weaknesses.

[16] T'ang Ch'ang-ju, "Ch'ing-t'an yü ch'ing-i," p. 292. A considerable number of discourses on talent, nature, and fate were assembled during the Wei-Chin period, at least six of which were entitled "Discourse on Talent and Nature" ("Ts'ai-hsing lun" 才性論), written by Li Feng 李豐, Wang Kuang 王廣, Juan Wu 阮武, Yüan Chun 袁準, Fu Chia 傅嘏, and Chung Hui. A number of these were collected in a single volume by Chung Hui, which, in characteristic Pure Conversation style, explored all of the possible positions on talent and nature: that they were connected or not connected, the same thing or divergent things. Most of the writings are lost, but a brief description of them is in Mather, New Account of Tales of the World, pp. 94-95.

[17] Ts'ao P'i, "Lun-wen," from the Classical Discussions (Tien-lun 典論), in Wen-hsüan, p. 714.

From the restoration of the Han on, interest in music and *ch'i* in the cosmological and numerological context declined markedly. Music and poetry as pursuits in the literati's life became the greatest concerns. With these, as with other subjects, there were highly abstract discussions on the ultimate mystery of musical and poetic process and the significance of *ch'i*. But they were balanced with discussions of music and poetry in a concrete and particular vein. The focus of the latter was not only on the artists, musicians, and poets, but on critical standards for the objects and performances themselves.

Apropos of critical standards, not only *ch'i*, but other terminology was borrowed from earlier musical theory and description by the Ts'aos and their successors to provide a critical vocabulary for the evaluation of literature. Of greatest importance was a set of five qualities of music borrowed by Lu Chi 陸機 for use in his *Rhyme-prose on Literature (Wen-fu* 文賦*)* to explain the strengths and defects of poetry.[18] The five qualities are "correspondence," or "response" *(ying* 應 *)*, "harmony" *(ho* 和 *)*, "gravity of feeling" *(pei* 悲 *)*, "restraint" *(ya* 雅 *)*, and "artful appeal" *(yen* 艷 *)*. The five operate in an interrelated way, much like the five phases. Each is born of another, controlled by another, or balanced by another. What appear at first sight to be contradictory requirements, e.g., for "restraint" in expression as opposed to "artful appeal," are actually a prescription for the maintenance of artistic tension between competing demands in composition and performance. The need for restraint checks the need for artful appeal. At the same time, if restraint reigns, as it apparently did for Marquis Wen of Wei when he listened to the ritual music, it will engender interest in artful appeal. Although the terms differ, this vocabulary is structurally similar to that used by Duke Cha, in which a virtue of the songs is always mentioned in conjunction with a particular vice, that vice being the excess of the virtue. The formula is: "A," but not "B." Art should be "grave, but not unrestrained"; "restrained, but not lacking artful appeal"; "winding about, but not bending over"; "moving afar, but not drifting away"; or "vast, but not shouting."

[18] This is treated in detail with translations of the relevant sections in my article "Early Chinese Music." For earlier studies, see Jao Tsung-i, "Lu Chi *Wen-fu* li-lun"; and "Literary Criticism and Music," pp. 22-37.

The five qualities that Lu Chi chose to discuss were of recognized importance in the period, and they were musically best exemplifed by the *ch'in* zither. The *ch'in* had long been associated with restraint. The *Tso Commentary* has, "It is for decorum and restraint that the superior man abides by his *ch'in* or *se*."[19] The binome *ya-ch'in* 雅琴 was in common use no later than the early Han: "In the expression *ya-ch'in*, the character *ch'in* means 'restraint' (*chin* 禁) and the character *ya* means 'correct' (*cheng* 正). The superior man holds to what is correct in order to restrain himself."[20] The three manuals of *ch'in* schools listed in the bibliography of the *History of the Han* are all of the *ya-ch'in*, the schools of Master Lung, Master Chao, and Master Shih.

By the early Six Dynasties, *ya* was still part of *ch'in* discussions, but the concept of *ya* had evolved away from its original association with ritual toward an association with simplicity and primitivism. The ideal of music was no longer the imposing bell set and the massive stone chimes. Even the large *se* zither had vanished as a solo instrument by the early Six Dynasties, giving way to the light and portable *ch'in*. Juan Chi wrote in his "Discourse on Music":

> The male and the female principles of the universe move easily and simply; refined music, too, is uncomplicated; the Way and its Virtue are level and plain: the five notes [= five tones] of music, too, are insipid. Refined music is uncomplicated, and so the *yin* and *yang* communicate naturally; it is insipid, and so all beings are naturally joyous. Daily they grow in unconscious goodness and achieve their moral transformation; their customs and habits change and alter, and they are all united in the same joy-music. This is the natural way; this was music at its beginnings.[21]

The *ch'in* is also associated early on with gravity of sentiment. In the *Garden of Explanations (Shuo-yüan)*, Lord Meng-ch'ang 孟嘗君 receives as a guest the musician-scholar Yung-men Tzu-chou 雍門子周. The lord

[19] *Tso-chuan*, Chao 昭 , year 1.

[20] Li Shan quoting the *Ch'i-lüeh chih* 七略志 [Outline of seven categories] of Liu Hsiang. See his commentary to the *Ch'ang-men-fu* 長門賦 [Rhyme-prose on the Ch'ang-men Palace] , in *Wen-hsüan*, p. 213. The bibliography in the *Han-shu* is based on the *Ch'i-lüeh chih*, but the extant text does not include the lines Li Shan quoted.

[21] Translated in Holzman, *Poetry and Politics*, p. 89.

asks Yung-men to play his *ch'in* and try to elicit grave sentiments from him. Yung-men Tzu-chou denies that the instrument has such power. Instead, he counsels Lord Meng-ch'ang to look about and note the precarious state of his territory and his people. If that does not make the lord heavy of heart, argues Yung-men, his *ch'in* certainly cannot. Lord Meng-ch'ang then begins to weep over the state of his affairs, at which point Yung-men begins strumming his *ch'in*, reducing the lord to uncontrolled sobbing.[22]

Characteristic of the changes we have noted already, during the Chien-an period the emphasis changed to the expression of grave sentiments with the *ch'in* rather than the influencing of such sentiments. Ts'ao Chih 曹植 wrote,

> Turning my face to the clear wind, that I might breathe and sigh,
> I place my thoughts in my *ch'in*'s sad strings.[23]

Though the association between the *ch'in* and the superior man is projected back at least to Confucius, and though the mythological accounts place the *ch'in* in the hands of the sage-rulers of high antiquity, it is during the early Six Dynasties that *ch'in* lore begins to take shape as a corpus and the instrument starts to assume the significant place in the life of the literati and aesthete that it occupied throughout premodern culture. Because the *ch'in* was a literati instrument, no effort was spared in the recording of every detail of its history, the extolling of its virtues, and the appreciation of its physical qualities and its mystique. Poems and essays about it date from the Han; larger collections of materials appeared during the T'ang and Sung; and by the Ming, extensive handbooks were compiled that combined instructions for playing, large assortments of pieces to be played, exercises for spiritual preparation prior to performance, and sundry philosophical and anecdotal materials in which the *ch'in* devotee obviously took great pleasure. But precisely because these are compilations by and for devotees, there was a certain abandon with which materials were gathered and forged into quasihistorical accounts or cast as the collected

[22] *Shuo-yüan*, chap. 11: "Shan-shui" 善說, [Skilled persuaders], pp. 946-47. A translation of a nearly identical story from P'ei Sung-chih's 裴松之 commentary on the *San-kuo chih* is found in Pokora, *Hsin-lun*, p. 186.

[23] Ts'ao Chih, *Yu-ssu-fu* 幽思賦 [Rhyme-prose on abstruse thoughts], in Yen K'o-chün, comp., *Ch'üan Shang-ku wen*, p. 1124.

sayings of one or another *ch'in*-culture hero. The written lore of the *ch'in* is diverse and appealing. At the same time, it is extremely difficult to date, even approximately, much of the material and virtually impossible to determine the authorship of the narratives, the discourses, or the songs. It is often the case that something with an attribution in the classical or Han periods cannot be traced back further than the Ming handbook that is materially extant. The literati's uninterrupted interest in the *ch'in* argues for the antiquity of received materials. It is quite obvious that the Ming collections were not assembled *de novo* by their compiler-publishers. We can easily imagine that old handbooks became obsolete and vanished as newer and larger handbooks, with newer music and more lore, replaced them and won favor. It is a typical defect of highly specialized textual traditions (which tend to have isolated and self-contained canons) that little of their contents can be corroborated with texts either transmitted or mentioned outside their own mainstream collectanea. *Ch'in* lore is similar to the Taoist Patrology in this respect.

Probable attributions of important *ch'in* materials do not ordinarily go back to before the late Han, with the notable exception of some one- or two-line utterances and some distinguished songs that are attributed to Confucius. Ts'ai Yung, active during the late second century A.D., has been credited with the oldest extant collection of *ch'in* songs, several dozen anecdotes, and numerous aphorisms. The *Ch'in-ts'ao* 琴操 [*Ch'in* practices], as his major collection is called, is probably dated correctly to within a century, but there has long been skepticism about the attribution of this work to Ts'ai Yung, and no conclusive evidence is likely to be found. One later handbook that I have found most interesting, the *Lingering Tones of Great Antiquity (T'ai-ku i-yin)*, records the following passage, which is attributed to Ts'ai Yung:

> The tone of the *ch'in* is the true tone of heaven and earth. If the right materials are found, they will provide a true instrument for harmonizing heaven and earth. If the right person is found, it can provide him the correct Way for harmonizing heaven and earth. If the exact pitch is found, it will make correct tones for harmonizing heaven and earth. Fu Hsi made the *ch'in* in order to make perceptible the systems of heaven and earth and to harmonize the powers of the spiritual forces.[24]

Though it may be doubted that the statement is Ts'ai Yung's, there is no

[24] T'ien Chih-weng, *T'ai-ku i-yin*, p. 35.

doubt that a singular preference for the *ch'in* had been expressed at least as early. Huan T'an wrote in his *New Discourses (Hsin-lun* 新論), "Among the eight sounds, that of silk is the finest, and [among silk instruments], the *ch'in* is supreme."[25] The supremacy of the *ch'in* in aesthetics is little disputed, and there are many factors contributing to its recognized superiority. It is an instrument of great antiquity and untainted pedigree. Frequently mentioned in the *Book of Odes* and the *Book of Documents,* it was thought to be one of the oldest instruments, shared the prestige of all strings from their role as tuners, and may well be directly descended from the chordophone that appears to be the object of the primitive *yüeh* pictograph. If Mizuhara Ikō's argument is valid, the *ch'in,* being of silk, may well have been sanctified by ritual use in connection with sericulture.[26]

Furthermore, the *ch'in* possesses physical properties and qualities of sound that fit expressed aesthetic preferences very well. Van Gulik points out that the *ch'in* enjoyed a completely unique identification as the exemplar of classical musical orthodoxy. As such, reverence for it was enhanced, and its ideology was enlarged and enriched, especially in periods of broad exposure to popular or foreign musical influences.[27] The *ch'in* was widely studied and discussed in all periods of premodern history. It dominates early musical lore as the obvious instrument of choice. In the mythologies it is the companion of Shen Nung, Fu Hsi, Confucius, Lieh-tzu, and Sun Teng 孫登 , to name but a few of its eminent patrons. Many of the cosmological texts from the early Han make frequent reference to it, and many aphoristic philosophies from the late Han, e.g., Huan T'an's *New Discourses* and Ying Shao's *Penetrating Popular Ways,* devote chapters to it. It is celebrated in poems and prose-poems, including Yang Hsiung's *The Ch'in's Pure Bloom (Ch'in-ch'ing-ying* 琴清英*),* Ma Jung's 馬融 *Rhyme-prose on the Ch'in (Ch'in-fu* 琴賦 *),* and two works entitled *Rhyme-prose on the Ya-ch'in (Ya-ch'in-fu* 雅琴賦*),* one attributed to Liu Hsiang and one to Fu I 傅毅 . After numerous rhyme-prose treatments of the *ch'in,* the tradition culminated in Hsi K'ang's magnificent *Rhyme-prose on the Ch'in (Ch'in-fu* 琴賦 *),* included in the *Wen-hsüan.*[28] The lengthier texts dealing with the *ch'in* become less narrative and more descriptive, increasingly in

[25] Pokora, *Hsin-lun,* p. 182.
[26] Mizuhara Ikō, "Chūgoku kodai ongaku shisō kenkyū," pp. 2-4.
[27] Van Gulik, *Lore of the Chinese Lute,* p. 42.
[28] Translated by van Gulik, *Hsi K'ang's Poetical Essay on the Lute.*

the vein of appreciations. By the advent of the *lei-shu* encyclopedia in the T'ang and Sung dynasties, more than enough material could be collected to fill complete chapters of works like the *Imperial Digest of the T'ai-p'ing Era.* Eventually, general collectanea, e.g., the *Shuo-fu* 説郛, reprinted complete *ch'in* handbooks, and in this century, collectanea devoted totally to *ch'in* materials have appeared, e.g., Yang Tsung-chi's 楊宗稷 *Collectanea for Ch'in Study (Ch'in-hsüeh ts'ung-shu* 琴學叢書*)*, T'ang Chien-yüan's *Compendium of Ch'in Texts (Ch'in-fu)*, and the *Complete Collection of Ch'in Music (Ch'in-ch'ü chi-ch'eng)*, compiled by the Central Academy of Music in Peking in 1963. This accumulation of literature had already been identified as a body of lore by the fourth century A.D., and the *ch'in* itself had become the nucleus of a "Way," the Ch'in-tao 琴道 . As such, it was the symbol of the aesthete, relating to his need for self-cultivation, to his need for communion with friends and with nature, and ultimately to his potential for triumph over the limitations of ordinary men.

The *ch'in* and its Way are best known to Western scholars of Chinese humanities through van Gulik's sweeping, sensitive, and romantic *Lore of the Chinese Lute* and his accompanying translation of the Hsi K'ang prose-poem. Recently, a book-length study by David Ming-yüeh Liang has added some historical and much technical information to the available Western-language sources.[29] One delves into primary sources only with trepidation because of the considerable demands they make in terms of language and technical knowledge. Given the staggering amount of primary material that is available, the difficulty in ascertaining its historicity, and the central involvement of *ch'in* lore with Chinese concepts of art, several more volumes on the *ch'in* are needed to carry us past the pioneering stage. My brief comments below seek to illustrate from the body of *ch'in* lore various points raised in the previous chapters, primarily concerning theories of sound and particular qualities that are esteemed in music and art. Historically, embracing the *ch'in* symbolized one's interest in and sympathy with prevailing views on life and art. Our recourse to concrete examples of *ch'in* stories and practice will serve to bring together much of the diverse theory on sound and art inherited by the Six Dynasties writers.

[29] Liang, *Chinese Ch'in*, pp. 132-33.

Fig. 1. String Correlations.*

	Phase	Interval	Bureau	Color	Virtue	Season	Asterism
String #1	土 earth	宮 kung	君 lord	黄 yellow	信 faith	分旺四季 "divider"	土星 Saturn
String #2	金 metal	商 shang	臣 minister	白 white	義 righteousness	秋 autumn	金星 Venus
String #3	木 wood	角 chiao	民 people	青 green-blue	仁 benevolence	春 spring	木星 Jupiter
String #4	火 fire	徵 chih	事 affairs	赤 red	禮 rites	夏 summer	火星 Mars
String #5	水 water	羽 yü	物 things	黑 black	智 knowledge	冬 winter	水星 Mercury
String #6	文 culture	少宮 kung'			文德 cultured virtue		文星 Wen-hsing
String #7	武 martial	少商 shang'			武功 martial merit		武星 Wu-hsing

*Adapted from materials in the *T'ai-ku i-yin*, p. 34.

Huan T'an appears to have coined the term "Way of the Ch'in" in the title of his lost essay, "Ch'in-tao." A fragment that is still extant describes the dimensional correlates that he perceived in the instrument.

Shen Nung succeeded Fu Hsi as ruler of the empire. He made a *ch'in* from the wood of the *t'ung* tree. It was three *ch'ih*, six *ts'un*, and six *fen* long [3 feet, 6.6 inches], representing the number (of days) in a full year. It was one eight-(tenths) *ts'un* [1.8 inches] thick, symbolizing the multiple of three and six. Above it was circular and gathered in, following the model of Heaven; below it was square and flat, following the model of earth. Above, it was broad, while below, it was narrow, following the model of the rituals between superiors and inferiors. *Ch'in* means "to restrain." The sages and worthies of the ancient past played the zither to cultivate their hearts.[30]

Shen Nung's primordial *ch'in* is often described as having five strings, which, according to remarks credited to Ts'ai Yung, corresponded to the five phases. Ts'ai Yung also observed that the width, said to be six inches, correlated with the six cardinal points.[31] The philosophical convenience of the five-string zither was abandoned for seven strings on the working model as it emerged in the late Han, but it still proved possible to establish a matrix of correlations (see fig. 1).[32] The parts of the zither are named after highly evocative things and places, which they ostensibly resembled in shape: Mount Yüeh, which is the sacred Mount T'ai in Shantung, "Dragon's Gums," "Phoenix Forehead," and "Immortal's Shoulders," to name a few.[33] Similarly, the tones, fingerings, strumming techniques, melodies, and antique instruments are all suggestively named to evoke associations with immortals, rare and wondrous creatures, and remote places dear to the practicing and aspiring sage. Among the closest symbolic attachments were the crane and the sword, the plum and the pine tree. The former are said to be reminiscent of the feather plume and sword that were the civil and military regalia in early ritual dance.

The taxonomies of physical and acoustical correlates are an essential part of *ch'in* handbooks, but little is said about them, which suggests that

30 Pokora, *Hsin-lun*, p. 181.

31 The text used here is in T'ang Chien-yüan, *Ch'in-fu*, pp. 740ff.

32 T'ien Chih-weng, *T'ai-ku i-yin*, p. 34.

33 Van Gulik, *Lore of the Chinese Lute*, pp. 98-99.

the interest in them was more conventional than vital. The pursuit of *ch'in* correlates involves the same issues as the general correlative discussions of music, although the regimentation of items is somewhat vaguer, even in the earlier examples. Issues of morality and leadership are often the ends of such discussions, just as they are in the discussions of pitches. The narratives are more interesting because they are more developed as stories and because they are about the immoral rather than the moral.

A traveler appeared in Chao carrying a *ch'in* from which *ch'i* issued forth. When its sounds entered the ears of listeners, their feet and hands would fly and flap about, and they would lose all normal sense. Those with a bent toward bravura became criminal, while the licentiously inclined turned away from their dear ones. Criminal acts lead to rebellion against one's lord and ministers, and turning away from dear ones means distorting the paternal relationship. Such distortion and rebellion further exacerbate one another; turmoil is born, and disaster arises.[34]

The *Han-fei-tzu, Records of the Grand Historian, Huai-nan-tzu,* and *Balancing Discourses* all tell the story of Duke Ling of Wei and his visit to Duke P'ing of Chin. The two dukes forced their music masters to play *ch'in* tunes that were composed under the influence of morally reproachable lords or that were spiritually too potent for the unperfected virtues of the dukes themselves. As the performance went on, dark cranes appeared, an early warning of the cosmic disorder brought on by the playing. But the dukes persisted. There followed a torrent of rain and then a three-year drought that scorched the earth of Chin.[35] In the *Han-fei-tzu* chapter "Ten Faults" ("Shih-fei" 十非), this story is told in a longer version, in which Music Master K'uang defines a hierarchy of musical potency, from the "Clear *Shang*" (Ch'ing-shang 清商) mode, to the "Clear *Chih*" (Ch'ing-chih 清徵) mode, to the ultimate "Clear *Chiao*" (Ch'ing-chiao 清角) mode.[36] Unlike most tales of music, morality, and heavenly response, in which the ruler or his people are seen in a state of gradual moral decline

[34] Juan Chi, "Yüeh-lun," in Yen K'o-chün, comp., *Ch'üan Shang-ku wen,* p. 1313.

[35] The story is translated below in connection with another argument.

[36] More will be said about the Clear *Chiao* mode below. For a translation of the incident as told by Han-fei-tzu, see Watson, *Han-fei-tzu,* pp. 54-55.

and inevitable extinction, in this particular episode, a very powerful performance on the *ch'in* brings immediate reaction and specific retribution.

Arguments by Hsi K'ang, Juan Chi, and others at the end of the Han dynasty disavowed the precise correlation between the *ch'in* and external phenomena and disavowed vulgar claims of magical qualities, just as they denied that a precise association could be made between particular music and particular feelings. In the same way that the unpredictability of the future appealed to the temperament of the early Six Dynasties aesthete, so, too, did the impenetrable shroud of mystery that was cast about the *ch'in*, its body parts, strings, tones, tunes, and techniques. The ability to play or even to appreciate the *ch'in* becomes esoteric, and the significance of the instrument and its music becomes ineffable. Whereas the early Han thinker demonstrated a Confucian confidence in the precise, unambiguous, and durable significance of language, in its ability to communicate, and in the intertranslatability of all systems of signification, in the early Six Dynasties, thinkers are committed to the idea that language is uncertain, ambiguous, evocative rather than definitive, and that other systems of order and meaning are discrete, distinct, and in no sense fungible or intertranslatable. It is in this light that Hsi K'ang's *Rhyme-prose on the Ch'in* epitomizes the third-century view of the instrument. The rhyme-prose creates a tremendous sense of mystery, not by denying the wide-ranging involvement of the instrument in the cosmos, but by describing its powers as mystical rather than magical. The precise nature of the powers of the *ch'in* is beyond the grasp of ordinary understanding and beyond expression by ordinary words. In the rhyme-prose as well as in other writings, Hsi K'ang denies that music has specific and definable content as either an expression of feeling or a stimulus to feeling, but he expands on the idea that it articulates forms that language cannot set forth. In this capacity, argues Hsi K'ang, music reveals patterns of mind and nature with a quality and depth unmatched by other media. Freed from the weight of Han musical theory and Confucian notions of signification to such an extent, the *ch'in* becomes more portable for the Six Dynasties aesthete.

A variety of ghost stories and marvel stories testify to the prepotent influence of the *ch'in*. In some tales, mostly of popular origin or associated with popular diviners or magicians, the instrument has precise talismanic or magical powers that are used to summon or control spirits, regulate weather, open magical doors, communicate over great distances, or cure disorders of the body and mind. In others, mostly of more elite origin,

attention is focused on purely artistic achievement and the enhancement of the reputation of historical figures who were mythologized as *ch'in* geniuses. In some there is a curious combination of popular and elite interests, which is characteristic of the best Six Dynasties narratives. *Ch'in* stories that reflect this combination suggest that the veneration for the instrument extended beyond elite circles. The redaction of the Six Dynasties collection *Records of the Light and the Dark (Yu-ming-lu* 幽明錄*)* has the following:

> Ho Ssu-ling of K'uai-chi was skillful at strumming the *ch'in*. One night as he sat stroking his zither under the moonlight, with the breeze blowing in his face, a man appeared. The visitor, of towering build, was fettered in chains and had a depressed look on his face. Walking right into the center of the courtyard, he said, "Good!" and began to converse with Ho. The visitor said that he was Hsi Chung-shan[37] and he told Ho, "Sir, you move your hands very adroitly, but your technique does not accord with that of the ancients." So he taught Ho the "Kuang-ling Song," which Ho mastered and which has been transmitted ever since.[38]

Conversations between literati and ghosts were not uncommon in Six Dynasties narratives. A ghost can always out-debate even the best of living scholars, and among the more popular, humorous, and ironic themes is that of a ghost in human disguise arguing for the existence of ghosts with a skeptic. In this tale, the specialty of the ghost is *ch'in* music, and his appearance before Ho provides the continuity between the current performer and the ancient technique that was always highly prized in *ch'in* ideology. The invocation of Hsi K'ang illustrates the extent to which his image was intertwined with the *ch'in* as early as the fourth century.

A survey of *ch'in* collectanea seems to indicate that the volume of tales, rhyme-prose, and poems that contribute to *ch'in* ideology is rather more substantial than any descriptive, technical, or instructional material of the sort that would contribute directly to mastery of the instrument.

[37] Another name for Hsi K'ang of the Seven Sages of the Bamboo Grove.

[38] The *Yu-ming-lu* is redacted in Lu Hsün's 魯迅 *Ku-hsiao-shuo kou-ch'en* 古小說鈎沉 [Redaction of ancient fiction], 3d ed. (Hong Kong: Hsin-i, 1967), pp. 302-3. A peculiar variant of this story, in which Hsi K'ang is visited by a ghost and instructed in the *ch'in*, is translated from a later source by van Gulik, *Lore of the Chinese Lute*, p. 152, no. 12.

Ch'in manuals are explicit and insistent in claiming that such materials contribute to the spiritual preparation necessary for mastery of the instrument. The underlying claim is that mastery of the instrument does not necessarily entail playing it but rather involves mastery of its ideology, its Way. Exemplary stories of the ch'in were collected when story telling was in its infancy, the eras of Liu Hsiang, Huan T'an, Ts'ai Yung, and Ying Shao, all of whom are credited with compiling modest collections. The description of music in most stories falls somewhere between the vague magical powers of the instrument, as illustrated in the story of Dukes Ling and P'ing, and the extravagant mystical excursions in Hsi K'ang's rhyme-prose. Whereas stories about the ch'in rarely include any specific descriptions of the music, much less any notation, ch'in music virtually always includes an evocative title, a short story, or narrative inserts; in short, some sort of programmatic content. The tunes we have received through the Ming collections, which we might fairly assume to represent much older traditions, are highly programmatic and provide their own explicit ch'in-lore context. Many tunes, especially those in the Ming collections, have a "mode significance" (tiao-i 調意) appended, a musical prelude that prepares the atmosphere, the hands, and the mind for the performance of the tune itself.[39] In the Lingering Tones of Great Antiquity, terse descriptions are added to the mode significance, descriptions that through association and evocation place the mode-key in a cosmological framework. Subtitles (t'i-mu 題目), pithy phrases that allude to well-known myths, historical accounts, and paradisiacal scenarios, punctuate the scores, guiding the mind of the musician through a number of programmatic themes as he follows the score. Like the other components of ch'in lore, the scores of the music present a mosaic of vaguely magical and mystical elements. Van Gulik discusses the example of "Lieh-tzu Riding the Wind."[40] In telling the tale of Lieh-tzu's celebrated ride through space, a story line that would hardly need explanation to any ch'in devotee, the song exemplifies what ch'in discipline might do for any aspirant. Predictably, many of the songs

[39] For a detailed discussion of the tiao-i, see Liang, Chinese Ch'in, pp. 185-207; and van Gulik, Lore of the Chinese Lute, pp. 85-87. The use of "mode" here differs from "mode-key" used earlier. A tiao : mode includes not only the mode-key system of tones, but further structure toward a melody or melody type. See Powers, "Mode," pp. 376-77.

[40] Van Gulik, Lore of the Chinese Lute, pp. 88-89.

are about ancient immortals, aged fishermen, tranquil firewood collectors, and other lyric and eremetic types, who themselves are often devotees of the *ch'in* and beneficiaries of its powers. The program content of the tunes, then, supplies a model with whom the performer might identify in his performance of the piece, making the performance an explicit reenactment. The performance of such a piece not only tells the story, it draws the performer closer to the very character and life the piece describes. This is an important dimension of the pursuit of the *ch'in* as an instrument of self-discipline and cultivation. Before considering a specific example and its implications for the art, I will first attempt to describe the instrument and ideals of its performance in more general terms.

From the variety of materials we have about the *ch'in*, it is possible to characterize an ideal performance, one that optimizes the many potentials of the instrument. Given its emblematic role in the aesthete's life and its functional role in his discipline and refinement, what we can say about an ideal moment of *ch'in* performance will additionally reveal ideals in the life of the aesthete and foster understanding of underlying aesthetic notions in medieval China. We can begin where most *ch'in* manuals begin, with a description of the physical properties of the instrument in the context of its ideology and lore.

The body of the *ch'in* is a hollow supporting chamber made of a curved upper surface and a flat lower surface, which are compared to the heavenly firmament and the face of the earth. The standard size is approximately four feet in length and six inches wide, with two concave waists at either end. The strings stretch nearly the entire length of the body, beginning at widely spaced loops atop the bridge at the square end and coming gradually together, then curving under the end of the body at the narrow, rounded end. Prior to standardization during the Han, strings numbered from five to twenty-seven.[41] The standard *ch'in* has seven strings, graduated from thick to thin, with a precisely prescribed number of filaments. The strings are individually tensioned, but all have an equal effective vibrating length. The top surface of the instrument is unfretted, with thirteen decorative points, *hui* 徽 , marking fractions of the string lengths. Although van Gulik calls the instrument a lute, in order to

[41] A comparison is made between classical and early Han zithers in Huang Hsiang-p'eng, "Tseng Hou-i mu ti ku yüeh-ch'i," pp. 33-34.

associate it with the lute of the medieval courtier, it is technically a zither, by virtue of its construction and playing method. Major decorative touches, inscriptions of names and dates, fastening pegs, and two rectangular ports are concealed on the bottom of the instrument, generally out of sight. The instrument should be finely lacquered, with a dark metallic color of muted translucency. It is extremely light, comfortable to the touch, and of an easily embraceable shape. Hence, it is readily portable. The strings are relatively soft and not tightly drawn, making the voice low in pitch and the volume low in amplitude.

As the chart of correlations above (fig. 1, p. 114) demonstrates, the seven strings are named according to the classic five tones plus *wen* 文 and *wu* 武 . Wen and Wu were sage-kings to whom the addition of the sixth and seventh strings is credited. With the bridge positioned to the right, the thickest string, *kung*, is farthest from the player. The number of filaments in the strings range from one hundred eight to forty-eight, decreasing by ratios equal to the intervallic ratios of adjacent strings. As in the five tones themselves, the ratios and thus the pitch relations of the strings are prescribed, but the exact pitch level itself is not. The filament and pitch ratios from *kung* to *wu*, i.e., from string one to string seven, are 9:4, defining a thirteenth.

The thirteen *hui* markers combine the advantages of accurately marked intervals while not restricting the string length by frets. This provides not only considerable freedom in the pitch, *vibrati*, and *glissandi*, but special potentials in shaping timbre as well. The left hand may stop a string fully by pressing it to the sounding board and thereby reducing its vibrating length, just as a violin string is controlled. But it may also touch the string lightly at a *hui* mark, establishing a node point which divides the string into two harmonics of the open-string pitch. This is similar to the sounding of harmonics in the higher registers of the violin, but on the *ch'in* it is used for high and low pitch. Given the choice between a light touch or a full touch at any *hui*, the performer has dual-pitch capability without changing position, a capability analogous to the dual pitches of the MT bells. There is both a divisive and a harmonic sequence of pitches associated with the *hui*. If the left hand is moved from *hui* to *hui* toward the right, full stops create an ascending scale that reaches the octave at the seventh *hui*, another octave at the fourth, and a third octave at the first *hui*, counting from the bridge. In contrast to this straightforward ascent of pitch, the same movement with light touches will sound the third

octave at the thirteenth *hui*, descend to a second octave at the tenth, continue descending to the first octave at the seventh, and ascend again to the third octave at the first *hui*. Light touches will cause a symmetrical ascent and descent with the same *hui* sequence that causes a regular ascent with full stops. Without the addition of any other variations in touch or strumming technique, twenty-seven tones are playable on each string, a total of one hundred eighty-nine per tuning for all seven strings, if one takes into account the timbre distinctions for the same pitch sounded on different strings. The *ch'in* is thus comparable to the MT bells also in terms of the great number of tones available. The *hui* on the board are not the finest distinction recognized in the notational system, though they are the finest marked on the instrument. For notational purposes, each *hui* is further divided into ten *fen* 分.

In spite of the great number of tones available, the number of pitches is still very limited on the *ch'in*. The aesthetic virtue of "artful appeal" demands diversity; in the case of the *ch'in*, that diversity is realized in timbre, not pitch. With light touches, only the tonic, third, and fifth can be sounded for each octave. Full stops add a second and a sixth, filling out the basic pentatonic series, 1-2-3-5-6. David Liang has conducted a statistical analysis of the most venerable of early compositions, "Secluded Orchid" ("Yu-lan" 幽蘭).[42] He demonstrated that most sections used only seven or eight pitches and that those of the pentatonic series were preponderant. On the basis of further correlations with data describing resolution and duration of notes, Liang concluded that the most important pitches are the tonic and fifth.[43] In its utilization of pitch, the *ch'in* is a model of "restraint."

There appears to be no comparable exploitation of timbre for variety in Western music. As a result, Western studies of the *ch'in* and of Chinese literati music often note that musical composition focuses on timbre rather than pitch. Needham remarks that early European travelers to China were unaccustomed and, we might assume, unresponsive to this dimension of the music they heard in China.[44] Given the constraints on pitch variations in

[42] The manuscript of "Yu-lan" dates to the T'ang, which Liang says makes it the oldest known piece of *ch'in* music. Liang, *Chinese Ch'in*, p. 208.

[43] Ibid., pp. 233-38.

[44] Needham, *Science and Civilisation in China*, vol. 4, pt. 1, p. 142; see also van Gulik, *Lore of the Chinese Lute*, pp. 1-2.

classical moral philosophy as they were finally crystallized in the concepts of *ya* : restraint, *ho* : harmony, and *ying* : resonance, we can appreciate the particular advantages of the *ch'in*, with its capacity for prolific timbre variation of a single pitch. Making timbre the highest order in distinctive tonal features made possible the enrichment of the performed music by means of tonal variation within the confines of an even more parsimonious use of pitch variation than the orthodoxy required. As a model of correct music, "Secluded Orchid" achieves extreme restraint by relying on only two pitches primarily and achieves artful appeal in its exploitation of timbre variation.

There are moments in a *ch'in* performance when the left (stopping) hand is apparently still and a number of subtly distinct tones are played. There are other moments when the performer's hands dance through a series of complex shapes and motions, rendering nothing audible, especially to the ears of the noninitiate. In *ch'in* music, which is, at its most expansive, a parlor music and more typically for only one or two, there is particular interest in the interplay of visible hand movements and sound. A highly developed choreography of hand movements is expressed in the traditional *ch'in* notation system and is elaborated in the *ch'in* manuals. Reliance on timbre variation permits a quietness in the player's arms and hands. Even with a change of stop technique at the same *hui* mark, changing pitch involves a repositioning of the hands. In contrast, subtle variations in timbre are performed with invisibly minute motions of the hands. They are something to which eyes and ears must be carefully attuned. One *ch'in* manual offers the following description of a fingering method:

> *Yin* 吟 : *vibrato*. A finger of the left hand quickly moves up and down over the spot indicated. "A cold cicada bemoans the coming of autumn." The plaintive, rocking drone of the cicadas . . . should be imitated. Of this *yin* there exists more than ten varieties. There is the *ch'ang-yin* 長吟, a drawn out vibrato, that should recall "the cry of a dove announcing rain"; . . . the *yu-yin* 遊吟 , swinging vibrato, that should evoke the image of "fallen blossoms floating down the stream," etc. Remarkable is the *ting-yin* 定吟 ; the vacillating movement of the finger should be so subtle as to be hardly noticeable. Some handbooks say, that one should not move the finger at all, but let the

timbre be influenced by the pulsation of blood in the fingertip, pressing the string down on the board a little more fully and heavily than usual.[45]

The sound continues to be articulated in motionless moments, when the performer seems inactive and his hands quiet.

The overall effect in performance is a disconnection of the visible and the audible. Complex hand movements cause no audible change and invisible hand movements subtly alter the timbre. The importance of the interplay between the visible and the audible is reflected in both the notation system, throughout its historical development, and the accumulated lore that defines the ideals of *ch'in* performance.

[45] Van Gulik, *Lore of the Chinese Lute*, p. 125.

CHAPTER VIII
Critical Terminology, Notation, and Ideology

There were attempts to classify the varieties of timbre in the *ch'in* repertoire that were in essence descendants of the *pa-yin*, the "eight voices." With regard to the *ch'in*, the terminology was either descriptive of the sound or referential to moral or mystical values. Some terms describe the touch—"light," "loose," "crisp," "quick," and "gliding." On the other hand are such terms as "clear," "empty," "profound," "ancient," and "balanced." Sixteen distinct tones are described by van Gulik.[1] Just as in the word "touch," the terminology pertains to both the motion of the hands and the qualities of the sound. It is useful to remember that descriptions of sound are often metaphoric, and metaphoric descriptions are likely to be culturally particular. That is, we describe pitches of faster vibrating frequency as "high" and slower ones as "low." There is nothing universal about this choice of metaphors; we could as easily have adopted "short" and "long" (descriptions of wave-length if there is in fact a reference to frequency in "high" and "low"). The same is true of other descriptions of tone: "sharp," "grave," "light," and so forth. Perhaps the most basic description of tone in Chinese is found in the terms *ch'ing* 清 and *cho* 濁, literally translated as "clear" and "turgid." These are variously explained as "high" and "low" when referring to pitch, "unvoiced" and "voiced" when referring to speech, and "pure" and "resonant" when referring to timbre. Scholars have speculated that the terms *ch'ing* and *cho* were derived from the experience of tossing rocks into water and observing the wave patterns. Smaller rocks make smaller waves of shorter period and do not stir up the bottom silt. Larger rocks make larger waves of longer period and do stir the silt.[2] What can be said with certainty is that the terms are a pair, defined in relation to each other and metaphoric in their origins. Because

[1] Van Gulik, *Lore of the Chinese Lute*, pp. 105-13.
[2] Needham, *Science and Civilisation in China*, vol. 4, pt. 1, p. 157.

the *ch'in* lore abounds in description and literary allusion, it provides keys to the origin of its critical terminology. This area of inquiry has yet to be developed by scholars, but as it becomes understood it should provide keys to understanding critical terminology in other arts as well.

The critical terminology that describes the tones and the music is in most ways parallel to the notation system of the music itself. I would venture the generalization that within a culture or musical tradition, all systems of critical terminology and notation will focus on those qualities considered to be definitive of the music and will reflect in their own structure what is definitive in the structure of the music. In the *ch'in* tradition, both critical terminology and notation strive to be comprehensive with respect to the tones. That is, they strive to define the tone wholly, not merely one or another quality of it. In contemporary Western notation, instructions like *forte* and *pianissimo* define volume. The position of notes on the Western musical staff defines pitch level. The form of the note defines its duration. Diacritics define variables of articulation. A different facet of the notation is dedicated to each of the important qualities of the tones. The sum of these constraints is the tone as it must be produced at that moment for that particular piece of music. The notational system is distinctly linear, reflecting the linear nature of music organized around melodic line.[3]

[3] The structure of a notational system reveals the perceived structure of the music in that it seeks to define, with minimal ambiguity, all choices that are essential to the identity of the piece being recorded or composed. Anything not described by the notational system must be externally transmitted (as from teacher to student) or it is not essential to the identity of the composition in question. One advantage to studying music as a key to other arts is that music is unique in having a dedicated notational system; that is, another semantic system into which it is essentially translatable. Langer observes that music notation systems, while not readily reducible to meanings or concepts (as is ordinary language), are similar to language as systems of articulated forms with a remarkable tendency to modify each other's characters in combination. (Langer, *Philosophy in a New Key*, p. 228.) This is not to argue that a piece of music and its score are the same thing. However, comparatively speaking, a symphony is more fully described in an orchestral score than a play in its script or a painting in a verbal description. Consider reproducing a symphonic performance from its score, a play from its

The literary language which prevailed in China for some two millenia is self-consciously reflective of its own past in the preservation of historically sanctioned formats and genres, the constant use of allusion, and the constant use of the commentary approach for structure in philosophical discourse. The literary tradition is imbued with a sense of nostalgia, and its refinement was motivated by a desire to preserve the knowledge and virtues of the past.[4] A similar sense of nostalgia and a similar desire to preserve the music and virtues of the past are evident in the *ch'in* notation. Virtually all of the *tiao-i* mode-key significance and *t'i-mu* subtitles affixed to the notation are historical and allusive. Some scholars have claimed that the *tiao-i* are simply preserved primitive tunes that are the font for that particular mode.

Historical records of as early as the sixth century B.C. tell of *ch'in* tunes being written down, but it has so far been impossible to document the existence, prior to the T'ang, of the standard traditional *ch'in* notation system, called "abbreviated graph notation" *(chien-tzu-p'u 簡字譜)*. A score of "Secluded Orchid" is extant from the sixth century A.D., expressed in written descriptions of the hand movements. A similar written notation of hand movements *(wen-tzu-p'u 文字譜)* is described in a number of Han accounts and may well have roots earlier than the Han.[5] Resembling ordinary literary Chinese writing, the *ch'in* notation is holistic, attempting to achieve a single, integrated definition of a sound within a single, integrated "graph." The notation is comparable to medieval tablature in the West, describing not the sound (i.e., its pitch, duration, or volume), but the

script, a painting from a description. It is said that even those less gifted and less beleaguered than Beethoven in his deafness can, through practice, derive aesthetic pleasure from reading a musical score that rivals hearing a performance.

[4] For a discussion of early views on writing and record-keeping, see my article "The Six Dynasties *Chih-kuai* and the Birth of Fiction," in *Chinese Narrative: Critical and Theoretical Essays*, ed. Andrew H. Plaks (Princeton: Princeton University Press, 1977), pp. 21-52.

[5] The evolution of the notation systems for *ch'in* music is reviewed briefly by Liang, *Chinese Ch'in*, pp. 208-13. The early manuscript of the "Yu-lan" is reproduced in the *Ku-i ts'ung-shu 古逸叢書 ,* discussed in Paul Pelliot's "Notes de Bibliographie chinoise," *Bulletin de l'École Française d'Extrême-Orient* 2 (1902): 315. The putative date of the text is A.D. 590.

way the sound is made, the fingering, the hand position, the nature of the strum, and so forth. According to performance ideals, the exact pitch and duration are, in fact, at the discretion of the *ch'in* player. The contrast between Western notation describing the sound and the *ch'in* graphs describing the movement of the performer is suggestive of what *ch'in* masters thought was important to record, and hence what they felt was essential to the performance.

In the earliest collections of *ch'in* music, the pieces are called *ts'ao* 操 , which refers to the performer's composure rather than the music's composition.[6] Huan T'an wrote, "The sages and worthies of the ancient past played the zither to cultivate their hearts. In adversity, they would devote themselves to perfecting their own persons and would not lose their principles; therefore, a composition [for the zither] was called a *ts'ao* ['principle']."[7] In the *Ch'in-ts'ao*, virtually nothing is written about the sound of the fifty-odd classic songs collected; only the physical and emotional contexts of their composition are described.

The holistic nature of the notation is reflected in its visible structure. Like ordinary characters, each tone is represented with a bidimensional combination of basic forms (= radicals), fitted into equidimensional quadrates irrespective of graphic complexity. The basic forms are derived from ordinary writing, and the arrangement of the graphs is columnar and sinistrorse.[8] Facets of the tone defined by the graphs include timbre, relative pitch, attack, relative duration, and embellishments, e.g., *glissandi* and *vibrati*. Pauses and general pace are noted interlinearly. The core of each graph is called a *chien-tzu* 簡 字, an abbreviation of an ordinary

[6] *Ts'ao* is described as the ability to remain composed in the face of potentially aggravating circumstances. See the *Feng-su t'ung-i*, p. 1442, and the *Lü-shih ch'un-ch'iu* 5.7b-10b. Van Gulik reviews the problems of dating and authorship of the *Ch'in-ts'ao* in *Lore of the Chinese Lute*, p. 167.

[7] Pokora, *Hsin-lun*, p. 181.

[8] The descriptive terms for the Chinese written character are from Peter A. Boodberg, "The Chinese Script: An Essay on Nomenclature (The First Hecaton)," *Bulletin of the Institute of History and Philology* 29 (1957): 113-20.

Fig. 2. *Ch'in* Notation.

From the Ming dynasty collection *Shen-ch'i pi-p'u*
神奇秘譜 [Secret collection of marvelous songs],
reprinted in the *Ch'in-fu,* pp. 124-25.
The song is the popular "Liu-shui" [Flowing waters].

character that defines a *chih-fa* 指法 , "fingering."[9] Van Gulik writes
that a handbook will typically have from one hundred fifty to two hundred
such fingerings,[10] which we might note is close to the number of *pu-shou*
郭首 ("radicals") in the lexical tradition. The most important of the
chien-tzu are described with particular attention to *shou-shih* 手勢 ,
"hand postures," and may be seen as representing hand postures and move-
ments. Enclosed in the *chien-tzu* is a number, written larger than any
other number in the quadrate, that indicates the string on which to perform
the movement. Above it is an abbreviated sign that describes the fingering
of the left hand used to stop the string and a number, written small, indi-
cating the *hui* and *fen* where the stop is to be executed. Each graph pre-
scribes a moment in the music. As in literary Chinese, the molecular,
isolated, and isometric appearance of the graphs conveys a sense of suc-
cessive and complete moments, rather than a sense of linear continuity.
This, I believe, reflects the essential sense of time in *ch'in* performance. A
percussive burst of sound will be expressed in a single graph, and a long
glide will be expressed in a single graph.[11] Thus, whereas the graphs are
spatially fungible, the corresponding performance is not so in terms of
movement or sound.

From the *Ch'in-ts'ao* to the sixth century to the standardized notation
known to have existed since the T'ang, the recording of *ch'in* music always
attended primarily to the hand movements. The proper execution of hand
movements is the immediate means of proper performance, with the result
that much of the elaboration of performance instruction is concerned with
hand movements. Not only are the hand movements prescribed for the
particular pieces, but an auxiliary body of materials describes the hand
movements generally in richly imagistic language. At least as early as the
Ming, *ch'in* handbooks included long, illustrated sections in which line
drawings of hand postures were placed alongside corresponding natural
scenes.[12] The use of the term *shou-shih* dates back at least to the *History*

[9] Pian reviews all the forms of notation found in Sung dynasty musical
references. See *Sonq Dynasty Musical Sources*, pp. 59-98, esp. pp. 76-
92, which include a detailed introduction to *ch'in* tablature.

[10] Van Gulik, *Lore of the Chinese Lute*, p. 114.

[11] See, for example, *ta-yuan* and *so-ling* in ibid., pp. 122-23.

[12] The oldest known example, according to van Gulik, is the *Wen-hui-t'ang*
文會堂 [Hall of literary gatherings] , a *ch'in* handbook with a preface

of the Northern States (Pei-shih 北史 *),* compiled in the late seventh century. The idea in association with the *ch'in* probably dates back at least to the late Han.

Other arts in early China used similar imagistic approaches to the teaching of mental preparation and physical technique. Ts'ai Yung uses the term "posture" *(shih* 勢 *)* to describe the significant patterning of calligraphy brushing after bird and animal markings and tracks.[13] The association between calligraphy and animal tracks and markings was made in the earliest classical texts and was recited again and again in discussions of the writing system. While this association has often been seen by scholars as a static relationship between the written characters and animal markings and tracks, nothing in the primary texts excludes the possibility that the association was more dynamic; that is, the movements of the hands in making calligraphy were seen as correlative to the movements of animals in the making of their visible traces.[14] In an early T'ang manual of calligraphy technique, the *Plan of Strategies for the Brush (Pi-chen-t'u* 筆陣圖 *),* the basic eight strokes of calligraphy are explained in images comparable to

dated 1596. See ibid., p. 115. For my discussion, I have used the *T'ai-ku i-yin,* which was originally printed within a decade of the *Wen-hui-t'ang.* The original date and circumstances of the *T'ai-ku i-yin* are uncertain, with some editions making reference to Sung authorship. At this point it is impossible to identify the extent to which the work is the result of individual authorship as opposed to gradual accretion, but its encyclopedic nature, very much like a *lei-shu,* suggests that whenever it took its present form, its contents derived largely from earlier sources.

[13] Ts'ai Yung, *Chüan-shih* 篆 勢 [The postures of the seal script], in *Ch'üan Shang-ku wen,* comp. Yen K'o-chün, p. 900. The most popular myth describing the invention of writing credits that important step in the emergence of culture to Ts'ang Chieh 倉頡 , who was inspired by and imitated bird and animal tracks. For a brief review of the myth, see Jonathon Chaves, "The Legacy of Ts'ang Chieh: The Written Word as Magic," *Oriental Art Magazine* 23, no. 2 (Summer 1977): 200-215.

[14] The imitation of animal movements is the underlying principle of Taoist calisthenics, *tao-yin* 導引 , by means of which one improves one's integration with natural process and prolongs life. See Holmes Welch, *Taoism: The Parting of the Way* (Boston: Beacon Paperbacks, 1966), p. 108; and Needham, *Science and Civilisation in China,* 2:145-46.

those used to inform the *ch'in* hand postures, e.g., "a stone tumbles from a high peak," "waves crash and thunder roars," "the earth breaks off an elephant tusk," and the like.[15] Often related to the Ts'ang Chieh myth are accounts of calligraphic geese, and even calligraphic incense smoke, in which a flock of geese or a trail of smoke nonpurposefully and unaffectedly write against the sky.[16]

Several pages of hand-posture illustrations from the *Lingering Tones of Great Antiquity* have been included here. Correlates to particular postures may be ordinary birds and beasts, mythical birds and beasts, natural scenes or formations, and, on rare occasions, people. The correlates are not simply things, but things in motion or in motionlessness. It is motion on which the hand movement is to be modeled. The freezing blackbird pecks at snow, the divine turtle crawls out of the water, the leaping fish splashes with its tail, fallen petals ride the wave crests, dragonflies dapple the still water, and the swallow darts after a flying insect--all provide evocative analogies for the movements of the hands over the *ch'in* strings. Ideally, the hands and the instrument are transformed in performance to achieve perfection of the correspondence and perfection of the execution of the posture. Beneath the sketch of the hand is a detailed description of the posture, indicating which strings are strummed, the nature of the attack, and the number of strums. Beneath the sketch of the correlative scene or creature is a *hsing*, a poetic and metaphoric invocation of the essence of the posture. For example, beneath the illustration of a figure facing an empty valley (fig. 3), there is a poem entitled "Sending a Sound Through the Empty Valley":

> Long whistle, just one sound
> Rattles the trees and the mountains.
> Following the sound, echoes return,
> In the void of the valley, between here and there.

[15] Richard Barnhart, "Wei Fu-jen's *Pi-chen-t'u* and Early Texts on Calligraphy," *Archives of the Chinese Art Society of America* 18 (1964): 16. Barnhart dates the text to the early T'ang on the basis of its contents, in spite of earlier attributions in the native tradition. The manuals will be of considerable use in dating technical manuals for other arts as well, including the playing of the *ch'in*.

[16] James I. Crump, "Calligraphic Geese and the Scent of Time," chap. 8 in *Songs from Xanadu* (Ann Arbor: The University of Michigan Center for Chinese Studies, forthcoming).

Fig. 3. Illustrations of Hand Postures.

The top is entitled "Sending a Sound Through the Empty Valley";
the bottom is entitled "A Secluded Bird Pecks at the Trees."
From the *T'ai-ku i-yin,* in *Ch'in-fu,* p. 66.

Overall, then, there is a three-part relationship among the hand posture, the sketch of its emulation object, and the poetic description of the essence of the correspondence. Because of this association, an explicit metaphoric value is provided the various executions on the instrument. For example, light touches on the strings to sound harmonics are floating postures—butterflies float across the flower petals. *Legato* executions are flowing postures—the water of the creek babbling through its intricate course. *Pizzicato* executions are dappling postures—the dragonfly dipping the tips of his wings in still water. Water, especially various scenes of it flowing, falling, reflecting, and rippling, is a favored image.

It is probable that the significance of the hand postures was elaborated in the transmission of playing technique and lore from master to student. As in most correlative schemes, the emphasis is always on the internal essential nature of the things compared, irrespective of the extent to which external illustration is used. For example, the *ta-yüan* 打 圜 posture requires a straightening of the little finger, with a relaxed claw shape made by the other four. The hand resembles the four crooked legs and outstretched neck of the turtle crawling from the water. But what is sought is the *ch'i* of the creature. Van Gulik writes, "One should try to imitate the crawling movement of the legs of the tortoise: short but determined touches in absolutely the same rhythm."[17] As is the case in Taoist gymnastics, the goal is achievement of the inner qualities of the animal being imitated. The implicit claim of the hand-posture approach is that there is musical patterning in the natural world, a patterning which may or may not involve sound and which man can emulate.

In the great wealth of *ch'in* writings, certain apologues embodying salient points of *ch'in* ideology are repeated time and again. Generally, these are compact narratives or lyrics that describe a performer or performance which illustrates a particular ideal of the Way. Van Gulik has translated twenty-two items from a Ming and a Ch'ing collection of *ch'in* lore. Many of the stories were canonized by the end of the Han dynasty and are standard fare in any of the comprehensive collections on the *ch'in*. Using Han sources wherever possible, I will attempt to illustrate some of the points that relate significantly to early music theory and thought.

[17] Van Gulik, *Lore of the Chinese Lute*, p. 122.

Fig. 4. Illustrations of Hand Postures.

The top is entitled "A Flying Dragon Holds to the Clouds";
the bottom is entitled "A Praying Mantis Captures a Cicada."
From the *T'ai-ku i-yin,* in *Ch'in-fu,* p. 59.

Fig. 5. Illustrations of Hand Postures.

The top is entitled "The Shang-yang's Drum Dance";
the bottom is entitled "The Spirit Turtle Exits the Water."
From the *T'ai-ku i-yin*, in *Ch'in-fu*, p. 63.

A dominant theme is the influential power of the *ch'in*, which can ostensibly stimulate the forces of nature, individuals, or society. These subdivide into the witting, and often magical, use of the instrument by a sage-musician and the improper or ill-advised use of it by a weak or degenerate ruler. I have mentioned above the incident recorded in the *Records of the Grand Historian* in which Duke Ling travels to visit Duke P'ing in Chin. During a feast there, the dukes forced Music Master K'uang to play to their whims.

> As soon as he began to play, billowing clouds gathered in the northwest. When he played again, great winds blew up and rain soon followed, so fierce that tiles were dislodged from the portico. All those in attendance rushed away, and Duke P'ing was so terrified he crawled into a sheltered waiting room. Chin was then beset by a fierce drought that baked the earth red for three years.[18]

The Yellow Emperor could draw cranes near, make them line up, and move them to dance with his *ch'in*, a capability that Music Master K'uang was also reported to have. According to the *Lieh-tzu*, when Hu Pa strummed his *ch'in* the birds danced and the fish leaped.[19]

An instructive incident begins the account of Duke Ling's travels.

> Duke Ling of Wei, on a trip to Chin, camped one evening over the P'u River. In the middle of the night he heard the sounds of *ch'in* playing, but when he asked his attendants, they all replied they could not hear it. So he summoned Music Master Chüan and said, "I heard the notes of a *ch'in* being played, but none around me could hear it. The composition seemed other-worldly. Please listen for me and transcribe it."
>
> Music Master Chüan assented. He sat very straight, holding on to his own *ch'in* and wrote. The next day he reported, "Your servant has gotten it down, but it is not yet precise. Permit me to refine it for another night."[20] The duke agreed, and after one more night, Music Master Chüan reported, "It is refined!"[21]

[18] *Shih-chi*, p. 1236.

[19] *T'ai-p'ing yü-lan*, p. 2735.

[20] *Hsi* 析 refers to the process of refinement, first getting the notes down, later refining apprehension of timbre and other qualities.

[21] *Shih-chi*, p. 1235.

The song is subsequently performed in Chin, where Duke P'ing's music master, K'uang, is able to identify it as the "Mulberry Grove" music of the tyrant ruler Chou.[22] He warns that the music is not to be played.

Nowhere in the story is it mentioned that Music Master Chüan played his *ch'in* when transcribing the mysterious music. In fact, the import of the story resides in his merely holding the *ch'in*, and possibly listening to it, as he wrote. He may have strummed responsively to the airborne tones as they came to him; more likely, however, his *ch'in* resonated responsively to the sounds as they came, or perhaps the sounds were realized on his *ch'in* and were otherwise inaudible. The *ch'in* serves the same role as the *chün* tuner, that of a sympathetic resonator, and Music Master Chüan was able to refine his apprehension of the piece by listening to it resonate. It was a kind of hearing aid rather than a performing instrument.

The "nonsounding" of the *ch'in* is as important a part of the lore as the playing of the instrument. If minimalization of surface is an aesthetic ideal, nonsounding performance is the ultimate in musical performance. Soundless music is discussed throughout the classical and Han periods. In the *Book of Rites*, the following exchange is credited to Confucius and his disciple Tzu-hsia:

> "Now that I have asked and received instruction in the Five Attainments, I would be so bold as to inquire what is meant by the Three Withouts."
>
> Confucius replied, "Music without sound, rites without embodiment, and mourning without garb. These are the Three Withouts."[23]

The three disciplines (music, rites, mourning), practiced without any external evidence of their being practiced, achieve their ultimate realizations. The external trappings compromise the inner realization. Inaudible music is the ultimate music. In cosmogonic theory, it was noted that sound in its primal state was inaudible. "The formless is the grand ancestor of all things. The inaudible is the great progenitor of all sound."[24] In his general

[22] See p. 93, n. 17 above. The reader will recall that Chou's Music Master Yen drowned himself in the P'u River after being forced to compose the "Mulberry Grove."

[23] *Li-chi*, chap. 30: "K'ung-tzu hsien-chü" 孔子閒居 [Confucius in repose], v. 2.

[24] *Huai-nan-tzu* 1.11a.

discussions of music, Lü Pu-wei wrote, "The greatest tones are sparing of sound."[25] I have quoted above the "Book of Music" description of ritual music at its zenith: "Sometimes the tones are inaudible."[26] The admiration of soundless music is a reasonable extension of claims we have noted before.

Superior sounds, like the call of the phoenix, can be heard only by such superior people as the Su family, for example. Lü Pu-wei tells the story of Tung-kuo Ya, who read the mind—more accurately, listened to the mind—of Duke Huan's 桓 公 strategist Kuan Chung 管仲. Kuan Chung was planning a military attack on an unruly vassal state. When Tung-kuo Ya reveals foreknowledge of Kuan Chung's intent, an intent which Kuan had never explained in words, Kuan invites him to explain how the plans were discovered. By listening carefully to what Kuan Chung had said and by careful observation of his composure, explains Ya. Lü Pu-wei concludes, "Tung-kuo Ya heard about something without using his ears. . . . The sage listens to the soundless and observes the formless."[27] The very finest sounds are heard by no one. Sound is the grosser part of music. "The sound that has sound cannot go beyond a hundred li. The sound without sound reaches to the Four Seas."[28]

Music with sound is likened to a shadow of the ultimate music, or music with sound stands to the ultimate music as an echo does to the original sound: "Musical tones have their origins in the human mind, being that which ultimately connects man and the cosmos, just as a shadow derives the plane from a three-dimensional object or an echo answers responsively to an issued sound."[29] This eloquent explanation, recorded by Ssu-ma Ch'ien, describes how tones, as a derivative of the order of the mind and the cosmos, are inferior to it. The metaphor is a provocative one, reminiscent of the seventeenth-century Christian image of sunlight as the shadow of God. The sun is an image, a pretender, dark by comparison to the true light. Sir Thomas Browne explained it as follows:

[25] Lü-shih ch'un-ch'iu 16.10a.
[26] See p. 95 above.
[27] Lü-shih ch'un-ch'iu 18.4b-5a.
[28] Han Ying, Han-shih wai-chuan, Han Wei ts'ung-shu ed., p. 74.
[29] Shih-chi, p. 1235.

Light that makes things seen, makes some things invisible; were
it not for darkness and the shadow of the earth, the noblest part of
the Creation had remained unseen, and the stars in heaven as invisible
as on the fourth day, when they were created above the Horizon, with
the Sun, or there was not an eye to behold them. . . . Life it self is
but the shadow of death, and souls departed but the shadows of the
living: All things fall under this name. The Sunne it self is but the
dark *simulachrum*, and light but the shadow of God.[30]

Ssu-ma Ch'ien's description also provides a picture of how the aes-
thetic processes of soundless music were conceived. Sound is a medium, a
configured medium to be sure, but it is not the essential thing. The essen-
tial thing is the order represented by the music, in the mind or in nature.
Music without sound was not problematic at all in the context of Han
thought on the pitches and *ch'i*. And in the early Six Dynasties, the idea of
an art without a medium had strong appeal. In communication, the medium
may be discarded when the idea is apprehended. Wang Pi took up this
argument in his discussion of language. He stated that symbols aim at
ideas and words aim at symbols. Once the idea is grasped, the words and
symbols may be forgotten. The ability to forget the external trappings,
which might be misconstrued by others as the essential idea, is a sign of the
sage.[31] These arguments find their inspiration in the *Chuang-tzu:*

The fish-trap exists because of the fish; once you've gotten the
fish, you can forget the trap. The rabbit snare exists because of the
rabbit; once you've gotten the rabbit, you can forget the snare.
Words exist because of meaning; once you've gotten the meaning, you
can forget the words. Where can I find a man who has forgotten
words so I can have a word with him?[32]

[30] Sir Thomas Browne, *The Garden of Cyprus*, in *The Prose of Sir Thomas Browne*, ed. Norman J. Endicott (New York: Doubleday and Co., 1967), p. 335. The full title of Browne's essay is *The Garden of Cyprus, or, The Quincunciall Lozenge, or Network Plantations of the Ancients, Artificially, Naturally, and Mystically Considered.* It is a search for the "fundamentall figure" of the five-point "X" and cross, realized in forms from the Garden of Eden to the cross of Christ. As a numerological and topographical tract, *The Garden of Cyprus* shares a number of traits with early Han works.

[31] Fung, *Chinese Philosophy*, 2:184.

[32] Watson, *Chuang-tzu*, p. 302.

Ch'in aesthetes would search for the ch'in player who performed without sound so that they might listen to him. This is one perspective from which to see the sage-musician, often pictured in landscape painting alone with his instrument, not playing and without an audience.

The conspicuous nonsounding of the ch'in was popular as a meditational or mystical discipline, a scholarly affectation, or the rationalization of a nonplaying collector. Many ideals of the aesthete converged in the art of nonsounding, whether achieved through stillness or through performance on stringless instruments. The ch'in player demonstrates that his concern is with the effort and not the outcome. The mystic ideal of soundless music is achieved. The sense of loneliness that comes from the lack of a tone-wise companion who can understand his music (chih-yin-che 知音者) is achieved with the appropriate gravity of feeling.[33] The aesthetic preference for minimalization of surface is taken to its limit. Even in actual performance, moments without sound are still informed moments; that is, the silence is significant. They are not nonplaying moments. The hands may or may not move, but soundless moments are not in any sense "rests." Physiologically, in the absence of sensory stimulation, qualities are perceived depending on the nature and intensity of the preceding stimulation. We experience the retention of the physiological complement of a strong visual stimulation, e.g., a blue flashbulb followed by a yellow "after-image." The musical tradition speaks about the "after-tones" in much the same way that wine-tasters speak about an aftertaste. The term yü-yin 餘音 , "after-tone," appears in Han poetry: "End the lyrics, finish the song, there still remains the tone"; and "Su-nü stroked the ch'in and the after-tones lingered on."[34] A modern Korean master of the Korean

[33] The Po Ya story was the focus of this reference. Po Ya explained the smashing of his ch'in upon Chung Tzu-ch'i's death as due to the loss of his chih-yin-che.

[34] Wang Pao 王褒 , Rhyme-prose on the Straight Bamboo Flute (Tung-hsiao fu 洞簫賦), in Wen-hsüan, p. 232; and Chang Heng, Rhyme-prose about Meditations on the Mystery (Ssu-hsüan fu 思玄賦), in Hou Han-shu, chüan 59: "Chang Heng chuan" 張衡傳 [Biography of Chang Heng], p. 1933. Su-nü 素女 was a goddess associated with music, first mentioned in the Songs of the South and subsequently identified as a woman of magical powers who lived during the time of the Yellow Emperor. See David Hawkes, trans., Ch'u-tz'u: The Songs of the South (London: Oxford University Press, 1959), pp. 144-45.

equivalent of the *ch'in* makes the following observation:

> After hearing a beautiful performance, musicians—and non-musicians—may speak of the beautiful after-tones rather than the beautiful melody. Similar concepts exist in other Korean arts. *Yeobaek* (*yeo* = remaining, *baek* = vacant space) or unpainted parts are highly valued in traditional Oriental painting. After seeing a fine picture, a viewer is more apt to speak of its beautiful *yeobaek* than of its beautiful mountains or trees, since the latter may be taken for granted in a good painting; but where the design is such that even the unpainted parts add beauty and significance, the work is more highly esteemed.[35]

Nonsounding is the most dramatic, but not the only, reductionist theme in *ch'in* lore. One of three components of the ordinary performance, the sound, the performer himself, or his audience may be removed from the scene to exemplify the classical theory and illustrate aesthetic ideals. In the many graphic portrayals of the *ch'in* or a particular *ch'in* master, ordinary performance was not the primary theme. For example, in the drawings of Sun Teng (fig. 6), as in many portrayals of *ch'in* sages, Sun is pictured holding the *ch'in* loosely on his lap. In other pictures, the *ch'in* sage clutches the instrument to his bosom. Performing on the *ch'in* actually requires a steady table adjusted to a convenient height before the player because both hands require freedom for the careful manipulation of the strings. Little, if anything, can be done with the instrument held to the bosom or rested across the lap. To the *cognoscente*, the pose with *ch'in* in lap is suggestive not of serious playing of the instrument, but simply of its presence. Without the touch of the performer's fingers, the *ch'in* is either a silent comforter or left to resonate on its own to the sounds around. The instrument mediates with the outside world not only in the expressive or emotive act, from within to without, but in the receptive act or responsive act, from without to within. As Po Ya demonstrated in his smashing of the *ch'in* upon Chung Tzu-ch'i's death, the instrument belonged as much to Chung Tzu-ch'i, the genius listener, as it did to Po Ya, the genius player. Simply put, the sage hears as well as communicates with the *ch'in*.

[35] Byongki Hwang, "Instruments and Aesthetics in Korean and Western Music," in "Notes to Music from Korea, Vol. 1: The Kayakeum" (Honolulu: East-West Center Press, 1965), p. 8.

Fig. 6. The Sage Sun Teng.

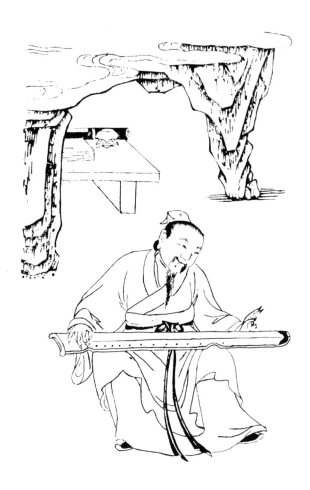

From the *San-ts'ai t'u-hui* 三才圖會
[Assembled illustrations of the three realms].

The extreme statements on nonsounding instruments are in stories of instruments without the means to sound. Five-string ch'in were revived periodically even after the seven-string ch'in had become standardized, apparently an effort at meaningful reduction of the ch'in's voice.[36] Sun Teng, a sage intimately associated with the ch'in, refuses to speak with or even acknowledge the presence of a young aspirant who comes to study the Way with him. Sun's biography notes that he "loved to read the Changes and play the one-string ch'in" and would only play the one-string ch'in as his guest looked on.[37] In his portraits, the single string of the ch'in is carefully illustrated. The best-known example of a sage who played a nonsounding ch'in is T'ao Yüan-ming, who is reported to have said, "Knowing the significance of what is in the ch'in, why labor to bring sound up from its strings?" By the time of his biography among the collected biographies of recluses in the History of the [Liu] Sung (Sung-shu 宋書), T'ao is described as "owning one very plain ch'in, without any strings at all, which he would hold and stroke to express his feelings whenever he became drunk."[38] The stringless ch'in (wu-hsien-ch'in 無弦琴) became coined as a symbol of the ideal of silence in ch'in performance.

The ch'in is by nature a quiet instrument, and we have seen in its ancestry the boiled-string zither of the ancestral sacrifice. While it is emphasized that listeners be capable, that is, "tone-wise," listeners are very often not to be found in portrayals and discussion of ch'in performances. As early as Ts'ai Yung, discussion of the harmonies in music included a concern for the audience. The excellence of music depends on the quality of the reception, and the ch'in player is warned not to perform before the barbaric or the vulgar. The story of Yang Ping 楊秉, attributed to Ts'ai Yung, illustrates this point:

Yang Ping played the ch'in. A monk would often come to listen to him play. Once, Ping suddenly, and obviously with intent, broke his

[36] Van Gulik, Lore of the Chinese Lute, p. 150, no. 2.

[37] Shen-hsien-chuan 神仙傳 [Biographies of spirit immortals], Lung-wei pi-shu ed., 6.7b. A similar account is found in his biography in the Chin-shu, p. 2426.

[38] The biography was written by Shen Yo 沈約. Reprinted in T'ao Yüan-ming yen-chiu tzu-liao hui-pien 陶淵明研究資料彙編 [Collected materials for the study of T'ao Yüan-ming] (Taipei: Ming-lun Publishers, 1972), p. 4.

strings in order to make a point. If there is no one around who really understands the tones, he would rather play to the clear winds, shining moon, dark pines, and aging boulders.[39]

It is impossible to ascertain when this story was written, but it was probably about the same time that the Po Ya and Chung Tzu-ch'i story was popular. Yang Ping's reaction to the loss of a tone-wise listener differed from Po Ya's. Lacking a friend with whom he could establish a close bond of sympathy, he turned to nature. By the T'ang, the idea of playing to nature is a stock image in the ch'in literature:

> Sitting alone in the dense bamboo groves,
> I strum my ch'in and accompany with long whistles;
> No one to see this deep in the trees,
> Only the bright moon appears to shine.[40]

Along with the ch'in, whistling is explored as a theme of communion between man and nature in the Six Dynasties and T'ang, a point to which we will return later. The ch'in is often embraced as one's only friend and is often an emblem of a lonely life, if not an intentionally antisocial one. By the time of Hsi K'ang, the ch'in and music had gone through a period of humanization in which emphasis shifted from communication with superior forces, namely, the ancestors and powers of heaven, to communication of a more mundane sort, with people. But during the early Six Dynasties, listeners lost the importance they had enjoyed during the late Han. The ch'in and its music were often considered a harmonizing influence between the individual, cultivating his inner nature, and the outside natural world in which he circulated. Accordingly, the aesthetics of the ch'in came to be discussed increasingly in the context of the natural order rather than the social, moral, or ritual order, as was the case in classical Confucian thought. Minimalization of real performance features facilitated the elaboration of the playing from and playing to nature themes.

The ch'in was viewed as the ultimate instrument for man to commune with nature because its material parts were so carefully drawn from the natural world. Only whistling was a headier musical pursuit for the

[39] *T'ai-ku i-yin*, p. 35.

[40] Wang Wei 王維, "Chu-li kuan" 竹裡館 [Hut among bamboos], in *Ch'üan T'ang-shih* 全唐詩 [Complete poetry of the T'ang], 12 vols. (Peking: Chung-hua shu-chü, 1961), 2:1301.

aesthete, due to the fact that it involved no materials at all. Being fashioned into a *ch'in* is the destiny of the most suitable materials. In keeping his *ch'in* with him on the mountain top, by the side of the gentle rill, or in the cool shadow of the bamboo grove, the sage avoids disruptive removal of the instrument from the nexus of relations in which it was born, nurtured, and selected. In the mythologies, Fu Hsi makes the first *ch'in* of T'ung wood, and, seeing a phoenix resting atop the tree, he shapes the instrument to resemble the phoenix. The voice of the T'ung never changes because the *ch'in* speaks in the pitches that Ling Lun modeled on the phoenix calls. In an apocryphal story explaining the etymology of *ch'in* anatomical nomenclature, a piece of wood literally "calls" to Ts'ai Yung, telling him it is to be made into a *ch'in*. Ts'ai Yung, slandered at court, has escaped south to the Wu regions:

> When he arrived in Wu, he found the people there burned T'ung wood [= Wu-t'ung 梧桐, Chinese Parasol Tree] to cook their food. When Yung heard a piece crackling in the fire, he said, "That's a piece of good stock!" He asked for it and carved it into a *ch'in*. It had, in fact, a beautiful tone, but its tail was scorched, so it was called the "Scorched Tail *Ch'in*."[41]

The left extremity of the *ch'in* was traditionally referred to as the "scorched tail,"[42] the term explained in this story. Almost one-third of Hsi K'ang's *Rhyme-prose on the Ch'in* describes the materials for the *ch'in*, where they grow, the special features of the climate and the landscape, their spiritual potency, and the ecstacy of gathering them. There is a distinct "*ch'in*-ness" to the trees waiting to be recognized, gathered, and shaped into zithers.

[41] Kan Pao, *Sou-shen-chi* 13.338, *Shih-chieh shu-chü* ed., p. 100. The following story in the collection tells of Ts'ai Yung's discovering a fine piece of bamboo from which he fashioned a flute.

[42] Van Gulik, *Lore of the Chinese Lute*, pp. 99–100. In reviewing names of *ch'in* parts, including "dragon pond," "phoenix pool," "phoenix tongue," and "phoenix wings," van Gulik explains their connection with *ch'in* lore. He argues that fabulous animals occupy a central position in Chinese music generally, a point that has recently been confirmed by the animal motifs on the instruments excavated from the Marquis Yi of Tseng tomb and other sites.

The attention to the material aspects of the *ch'in* is part of the effort to explain its potency, an effort which illustrates traditional principles of magic. The metaphoric relation to nature is manifest in the imitation of the phoenix's voice, the instrument's structural parallels to heaven and earth, and the correlative nature of the pitches and tones. A further potent relation is the metonymic one, manifest in the use of special materials in the *ch'in,* materials that are the very stuff with which nature and heaven sound.[43] The efficacy of the alchemist's furnace derived from a balance of metaphoric and metonymic connections to the cosmic processes it sought to reenact. Its proportions were those of the cosmos, and its placement, temperatures, and times of processing were calculated accordingly. "The adept was not directly concerned with exploring chemical reactions, but with designing laboratory (or psychophysiological) models of cosmic process."[44] Its materials were the actual materials with which the crucible of past eons made the same product the alchemist sought to achieve. Similarly, if sounds are to be sympathetic to nature, there must be both correspondence of pattern and congeniality of material. *Ch'in* manuals often contain pictures of what are alleged to be antique instruments in which the idea of physical imitation is taken to its logical, if musically impractical, extreme.

Stringless *ch'in,* voiceless *ch'in,* and moon-shaped *ch'in* are extreme examples of a musical instrument's domination by an ideology that grew around it, an ideology composed of extramusical considerations in the performance sense, but germane to the concept of art. Such ideological considerations bear on the development of the *ch'in* tradition in much the

[43] Sir James George Frazer, *The Golden Bough,* abridged ed. (New York: Macmillan, 1950), chap. 1: "Principles of Magic," pp. 12-52. Frazer's influential formulation divides the associative principles of magic into the principles of similarity and the principles of contagion. I have followed Roman Jakobson's reformulation of this division according to the more generalized semiotic principles of metaphor and metonomy, elaborated in "The Metaphoric and Metonymic Poles," in *Fundamentals of Language,* with Morris Halle (The Hague: Mouton, 1956), pp. 77-82.

[44] Sivin describes one metaphoric relation perceived in alchemical procedures as a "telescoped scale of time," in which one year of alchemical process is equivalent to 4320 cosmic years. The underlying idea in connection with alchemy is reviewed in Sivin and Nakayama, *Chinese Science,* pp. xxi-xxii.

same way they bore on bell-tuning during the Han. The enthusiasm with which the *ch'in* was embraced as an emblem of a particular life-style and the subtlety with which its traditions were expanded and enriched are part of the emerging consciousness of fine art during the Six Dynasties. At the foundation of *ch'in* ideology is a concept of life in which aesthetic constraints are substituted for what were traditionally social, political, and moral constraints. Whatever their ostensible medium, artists take their own lives as the subject of expression, and eventually their daily behavior itself becomes a medium of art. Ideals of conduct are the aesthetic ideals of the *ch'in* lore. Hsi K'ang, Juan Chi, and Liu Ling, as portrayed in *A New Account of Tales of the World*, follow *tzu-jan* : self-so-ness in their choices and actions. This is best understood not as "spontaneity," as it is commonly translated, but as sympathetic resonance, an analogy to the process by which Music Master Chüan's *ch'in* sounds on the banks of the P'u River. There is no apparent reason and no plausible explanation for action which does not follow in an orderly and comprehensible sequence. Rather, it is "self-so," apparently beyond the control of the person and therefore describable only as a momentary action in an isolated moment of time.

Wang Hui-chih was living in Shan-yin. One night he awoke in the midst of a heavy snowfall. He threw the windows open and ordered wine to be poured while he looked around at the gleaming brightness that surrounded him. Wang got up and ambled about the room, reciting Tso Ssu's poem, "A Call to Recluses," when the memory of his friend Tai An-tao came to mind. At that time, Tai was living some distance away in Shan. Wang immediately set off in the night, riding a small boat toward Tai's place. He traveled the whole night before arriving. Just as he approached the door, he stopped, then returned home.

Someone asked him why he had done this. Wang replied, "I originally set off aboard an impulse of the moment, and when that impulse passed, I returned. What necessity was there to [follow through] and visit Tai?"[45]

[45] *Shih-shuo hsin-yü, Shih-chieh shu-chü* ed., *chüan* 23, no. 47. I have translated this passage to maintain the consistency of my terminology. For Mather's version, see *New Account of Tales of the World*, p. 389.

Wang's behavior seems far less bizarre if one thinks of the story as the program for a *ch'in* piece, a series of vignettes not necessarily obligated to the exposition of a linear melody. The coming and going of impulses is beyond Wang's control. If he seeks accord with nature, he responds sympathetically to the piping about him. The removal of a sense of purpose from his action is analogous to the removal of strings from the *ch'in*.

Natural patterning provides a deterministic element in behavior and in art in the same way that correlative thinking provided a deterministic element in the referential aspects of artistic media. In the native traditions, however, it is recognized not as a restrictive element, but rather as a source of value in art and a source of value in life. Whether one sees traditions, conventions, correlative schemes, or any other established constraints on art and life as a source of frustration or a source of individual freedom is apparently a matter of emphasis and choice. Increasingly, scholars of intellectual and cultural history can discuss traditions and constraints as a precondition for individual expression and freedom.[46] For the Six Dynasties aesthete, submission to the world around him, expressed in self-so behavior, was the source of satisfaction and joy, an escape from the fetters of conventional ways of living inherited from the lost Han world.

The new consciousness of art and the new self-consciousness of aesthetic life that developed during the Six Dynasties period are inseparable from the profound tensions and conflicts that gripped the best minds from the fall of the Han to the Chin. In philosophy, the conflict was expressed in complex debates between "School of Names" advocates (*ming-chiao* 名教) and advocates of "self-so-ness." In life, the debate was expressed in the choice between being politically involved—and ostensibly conventional—and being nominally independent—and eccentric and natural. Pure Conversation mentality ultimately saw identity in both positions, as it saw identity in all perfect opposites. The point is artfully made in a delicately ambiguous conversation, variously attributed to Juan Chan 阮瞻 and Wang Jung 王戎 .

When Juan Chan saw Minister of the Interior Wang Jung, the latter asked him, "The Sage [Confucius] valued morals and

46 For example, see Edward Shils, "Tradition and Liberty: Antimony and Interdependence," *Ethics* 68 (April 1958): 153-65.

institutions *(ming-chiao)*, whereas Lao-tzu and Chuang-tzu threw light on the natural *(tzu-jan)*. Are they the same or different in their underlying meaning?" To which question the reply was made, "Can they be without similarity?"[47]

We have already noted that the practice of Pure Conversation was intimately related to the bureaucratic practice of Pure Critique. Ch'en Yin-k'o and others have argued that even the Pure Conversationalists were ultimately more of the Confucian persuasion than the Taoist one. In fact, he writes, the name "Seven Sages of the Bamboo Grove" was originally simply "Seven Sages," and the name was selected from the *Analects*, very much in the spirit of Han numerology.[48] The debate between *ming-chiao* and *tzu-jan* was cast in comparisons between Confucius on the one hand and Lao-tzu and Chuang-tzu on the other. Though the early Six Dynasties is routinely characterized as a period of Neo-Taoism, Wang Pi himself placed Confucius above Lao-tzu and Chuang-tzu, arguing that he understood the subtle points of nonbeing so thoroughly that he did not even have to mention them.[49] In the philosophical discourse, an accommodation was reached between conflicting positions that was not so easily realized in life, one result of which were the extreme statements on art and emphasis on eccentricity in life that we have witnessed.

Holzman has recently demonstrated the great complexity of Juan Chi's political and antipolitical life and poetry.[50] Ch'en Yin-k'o has made a similar point about the lives of Hsi K'ang and T'ao Yüan-ming. All three of these figures are exemplars in the lore of self-so-ness and naturalness. The potential for resolution of the tension in their lives came, according to Ch'en, in advocating the underlying unity of the two philosophical positions, and that advocacy implied an obligation both to serve their society and to pursue a life of self-so-ness.[51]

But it is a philosophical nicety to embrace diverse philosophical positions and declare their underlying unity. The volatile political atmosphere of the Seven Sages era and the following decades forced choices basic to

[47] Fung, *Chinese Philosophy*, 2:170.

[48] Ch'en Yin-k'o, "T'ao Yüan-ming ssu-hsiang," p. 1012.

[49] Fung, *Chinese Philosophy*, 2:170-71.

[50] Holzman, *Poetry and Politics*.

[51] Ch'en Yin-k'o, "T'ao Yüan-ming ssu-hsiang," pp. 1013-20.

survival—choices that meant accepting or rejecting official posts, alliances, marriages, and other political involvements. The appearance of *ch'in* ideology and aestheticism could only have occurred during a period of intense political uncertainty, intellectual complexity, and personal insecurity. The insistence on apolitical living, mental composure, and personal comfort in the natural world had roots in a real life of opposite qualities. The extremity of the life described in *ch'in* ideology balanced well the extremity of life experienced in the post-Han world. The intense concentration of "art" in the *ch'in* and its ideology is a mixture of escapism and affectation. With a *ch'in* in hand, the aesthetic life with its attendant comforts and joys could be worn as an emblem even if it were never to be fully realized inside or out. Political involvement was tainted by its sheer complexity, stirring an appetite for simplicity and withdrawal. Political involvement was recognized for its danger and impermanence. Involvement with the arts identified one, for others and oneself as well, as part of the enduring order and motion of nature and created at least the semblance of shelter from the hazards and transience of political life. The literatus, enmeshed in worldly affairs of the court, could take hold of his *ch'in* and in it find momentary reclusion. Just as in the ideal of *ch'in* music the inner discipline, and not the external manifestation, was the essence, so, too, in the ideal of the aesthetic life of the early Six Dynasties did the inner aspect become divorced from the outer.

> I build my humble shelter here in the world of men,
> But live without the racket of their horses and their carts.
> How is it possible that this be so?
> When the mind's put at a distance, the place becomes remote.[52]

The larger context in which music is discussed changed dramatically from the early Han to the Six Dynasties. Once considered the ultimate means of social influence and control--"For influencing airs and changing ways, nothing is better than music"--it had become for the Six Dynasties *ch'in* master the ultimate means of removing himself from a social involvement that was at once both painful and precarious.

[52] T'ao Yüan-ming, "Yin-chiu-shih" 飲酒詩 [On drinking wine], in *T'ao Yüan-ming shih-wen hui-p'ing* 陶淵明詩文會評 [Collected commentaries on the poems of T'ao Yüan-ming] (Taipei: Ming-lun Publishers, 1976), p. 151, no. 5.

I play the lute and sing:
 As the north wind hurries on,
 the battlements freeze.
 They tower over the plain,
 where there are neither roads nor field paths.
 For a thousand years and a myriad generations,
 I shall watch you to the end in silence.

Pao Chao 鮑照 , "The Ruined City," in *Poems of Solitude*, trans. Jerome Ch'en and Michael Bullock (London: Abelard and Schuman, 1960), p. 42.

CHAPTER IX

The Concept of Art

A survey of the history of theories and legend about music indicates striking elements of continuity and striking elements of change. Classics are treated by commentaries to reinterpretation and renewal, a cultural habit that was the revitalizing force in the longevity of the classics. Though music lacked a legitimate classic, as a tradition its textual embodiments were nevertheless treated in the same way. Bits and pieces of texts were quoted, studied, and explained, again and again, according to the interests and intellectual styles of whatever period one examines. This essay has produced a de facto periodization of the subject into four distinct eras—classical, early Han, late Han, and early Six Dynasties. Drawing on what the subsequent native scholarship determined to be the most significant philosophical works of preceding periods, one can articulate a history of views on music that takes the form of theme and variation. The themes are the legacy of the classical age, the writings of which established the range of discourse and the underlying metaphors that would be studied, contemplated, and addressed by thinkers in later ages. The variations are significant selections of materials from the classics, treated in the distinct styles of the various periods.

Major trends in Chinese literati thinking can be outlined with reference to the thought on music and art. For comparisons at a very general level, four issues might be considered, involving the selection of subjects that interested thinkers and the nature of the treatment accorded those subjects. Expressed as four questions, they are: (1) What are the major realms or matters of inquiry? (2) What are the structural features of the texts in which ideas were argued? (3) What are the features of the logic of the arguments? (4) To what tests of validity are the objects, the data, and the examples used in argument subject?

In the early Han, the expressed subject of philosophical inquiry was cosmology as moral and political philosophy and science. Scholars explored

cosmic processes at every level with the goal of legitimizing and perpetu-
ating rule. Of particular interest was the place of mankind in the overall
cosmic scheme, especially as exemplified in the historical record. The
texts were anecdotal or taxonomic: correlative for nature and society,
bibliographic for the written records. Many of the major texts purported to
be sequels or commentaries to the classics. They were primarily what
Karlgren described as "systematizing texts."[1] Discussions in the cosmolog-
ical texts were numerological, establishing parallel and ordered sets of two,
three, five, eight, ten, and twelve members, the completeness of which
sustained the putative significance of the correlations between one set and
another. Material for discussion came from classical texts, contempora-
neous observation and experimentation, and mathematical manipulation.

By the late Han, the expressed subject was the deficiency of early
thought on almost every issue—in a word, skepticism. Scholars explored
the claims of earlier thinkers, especially those claims considered to be
under the influence of popular culture. The structure of texts was aphoris-
tic, with brief examinations of earlier texts and orally transmitted mate-
rials followed by brief disclaimers and rejoinders. Ideas were presented as
debatable, lore as ahistorical, and musical instruments as palpable things.
Discussions were methodological, arguing point-counterpoint in an effort to
sort valid from invalid arguments and claims. Objects were measured,
weighed, and described, historical sources were assessed for reliability, and
tales and ideas were tested for plausibility.

By the early Six Dynasties, the expressed subject was aestheticism
and mysticism. Scholars explored the nature of art, approaches to evalua-
tion, the psychology of human response and expression, and the nature of
the ineffable, the "Mystery." Discussions were belletristic, employing
symbological references to nature and allusive references to ancient sages,
classical mystic texts, and historic exemplars of spontaneity and eccentri-
city. Tenets of validity were literary and aesthetic, derived from the
credibility of accepted textual precedents and accord with respected
ideals, e.g., artistry, self-so-ness, genius, eccentricity, and so forth.

[1] Karlgren, "Legends and Cults in Ancient China," pp. 201ff.

The foregoing paragraphs describe at a very general level the variation in the intellectual background to discussions of sound and music. The continuity was substantial because in all the periods commentary writing remained a favored mode of argumentation. Commentaries were written on the classics, e.g., the *Spring and Autumn Annals* or the *Chuang-tzu,* and on previous commentaries as well, e.g., the *Tso Commentary.* Selection varied, depending on the interests and tastes of the period. The early Han showed a preference for chronicles and for schematic texts. Commentaries and apocryphal texts were written most often on the *Spring and Autumn Annals* and *Book of Changes.* By the late Han and early Six Dynasties, the *Chuang-tzu* had become a work of major interest. The *Book of Changes* continued to be a popular text for commentators, but approaches to the materials changed dramatically.

Within each period and each major text that discusses music is a theory of music and a theory of art. But the theories of the early Six Dynasties are most readily recognizable as "aesthetic theories" to us. I have taken the early Six Dynasties as the terminus in the discussion of both theories and terminology. My reasons for doing so have primarily to do with the nature of Six Dynasties thought and our own expectations of theories of the arts. In the classical and Han periods, very little, if any, of the discussion of sound and music is completely divorced from concern with aesthetic value. However, until the Six Dynasties, aesthetic values themselves were not fundamental to thinking. Moral, cosmic, and political values were the collateral for aesthetic ones. The discussions of the Six Dynasties appear to be more genuine, more sophisticated, or more compelling as theories of art to contemporary readers. That is not because "aesthetics" did not previously exist; rather, it is due to the fact that in classical and Han thought, discussions of aesthetic values referred to other values of underlying concern. During the Six Dynasties, discussions of art were earnest, urgent, and immediate. They had become consciously distanced from political and moral issues because the pursuit of art offered escape from political and moral problems in life.

Throughout the Six Dynasties, theories of art and aesthetic terminology sought to sustain and explain the art of the past and also to shape the art of the future. What were once primarily musical theories and terms were broadened to include all arts worthy of discussion. A sense emerges that art is something more than the sum of the various recognized genres, but also something less than all the achievements of civilization. Art

requires definition as art for the first time and, with that definition, a new context and new justifications. The superior men of classical times were masters of the Six Arts--the rites, music, archery, riding, writing, and computation. The aesthetes of the early Six Dynasties were masters of the *ch'in*, poets, painters, calligraphers, and conversationalists.

Critical Terminology and Value

During the Six Dynasties, terminology once closely tied to experimentation and experience was elevated to a level of abstraction. "Resonance," "harmony," "restraint," "gravity," and "artful appeal" formed only one set of terms among many. Others in common use included *ch'i*, "wind" *(feng* 風*)*, "bones" *(ku* 骨 *)*, and "blood" *(hsüeh* 血 *)*, terms that became the coin of descriptive and critical discussions of the arts and nature. The abstraction is in part related to the level of generalization required of musical and other genre-specific terms before they can speak to other arts. Generalization of terminology required detachment from the particular concrete source. The idea of "resonance" as applied to poetry was detached from the demonstration of resonance in music. "Harmony" as applied to poetry is detached from the experience of harmony in music. The generalization of terms like "harmony," "resonance," "gravity," "restraint," and "artful appeal" does not imply a comparison of surface features among music, poetry, and painting. They are, in their surface features, incomparable. But they relate to the specifics of each form within the matrix of its own possibilities, that is, to the relationships of formal elements. Thus, in music, harmony is the agreeable relationship between different sounds, in contrast to resonance, the relationship between identical sounds. But in poetry, harmony is the agreeable relationship between different sounds, contrasted to rhyme, the relationship between identical sounds.[2] In English, no immediate comparison of surface features is implied in the use of "loudness" for music and "loudness" for color, or "discordance" for music and "discordance" for poetic composition. The multigeneric uses of such terms relate, through their formal referents, to the possibilities of art and ultimately to the apprehension of art; that is, they relate to the feelings, the emotions, the movements of the mind that are the inner correspondents of manifest art.

[2] Jao, "Literary Criticism and Music," p. 4.

Before looking more closely at questions of music, art, mind, and nature, it will be useful to consider the formal features of terminology used to discuss and evaluate art. In summarizing the evaluative comments of Duke Cha, Lu Chi, and others, I have noted that the terminology and its usage adhere to a distinct pattern. Every positive value in art has a corresponding failure or defect, sometimes expressed with a single term, as with *yen* : artful appeal and *yen* : lack of restraint, and sometimes expressed in paired terms, as in *chih* : straightforward, but not *chü* : overbearing. In fact, within the materials surveyed in this study, it is difficult to identify an explicitly desirable quality of art—a virtue of art—for which more is always better. Defects in art are excesses of virtues. The formal structure of the critical terminology and the systems of value it expresses are either dualistic, a balanced and dynamic interaction of two parts (e.g., *ch'ing* : clear and *cho* : turgid), or phasic, a cyclical and self-regulating sequence of parts (e.g., the five qualities discussed above). The ultimate excellence of any art is discussed, therefore, with a metacritical vocabulary that addresses the relationship among basic critical values. The basic critical values, "gravity" and the like, must themselves be in "balance" (*p'ing* 平) and must among themselves manifest "harmony."

As is the case with the basic critical terms, metacritical terms had discernible roots in experience and experimentation. *Ho* : harmony may have originally referred to an interval of a fourth, one of the first harmonic expansions of the basic five tones. The blending and balancing of the desirable qualities of music and art were likened to the blending and balancing of spices. Spices are virtuous additions to the "stuff" of food; they are not the food itself, but they are indispensable to it. The excellence of spices resides in their apportionment. The blending of spices was an ancient metaphor for harmony and cosmic balance:

Sing praise to fervent ancestors;
This benefaction, orderly and complete,
Extends offerings to them, without bounds,
That their presence may grace this place.
We bring clear sacrificial wine,
That their thoughts of favor toward us may bear fruit.
We have as well a soup of harmony,
With flavor both restrained and well balanced.[3]

[3] *Shih-ching*, Mao edition, no. 302. Compare this to no. 301, in which the virtues of harmony and balance are praised in the sacrificial music.

Balance in art, like balance in human feelings, is a matter of restraint and minimalization. The sacrificial soup is a thin soup; ritual music is restrained. Low volume in music is treasured because it minimizes stimulation and is conducive to quietness of mind. In the ritual zither, the strings are boiled to make them soft and quiet. Slowness in tempo is valued for the same reasons. The typical tempo of a *ch'in* piece is slow to quickening to slow again.[4] Practical criticism of later ages reflects the same inclinations, employing terms like "flatness" (*p'ing*), "blandness" (*tan* 淡), and "quietness" (*ching* 靜).

These aesthetic qualities are reflected in the ideals of performance. In performance, emphasizing the effort more than the outcome, the "mere going through the motions," is an ultimate achievement. Zithers without strings and soundless music are most highly venerated. As the mind advances, aural skill improves. The mind is more responsive to subtle stimuli, which, like those that dislodge the ash from the cosmic *ch'i* tubes, may be inaudible. Lore emphasizing minimalization of performance features illustrates that self-cultivation or social regulation attained through the effort of the performance rivals in importance the quality of the music and its influence. Early mythology associates rhythm with social regulation and the ritual dance with the movement of individuals within the constraints of social organization. Music unites socially in the same way that the drums assure concord among the moving dancers. Ritual dance music is an image comparable to the darting of minnows or the precision formation of flying geese for discussions of the individual in an orderly society.[5] When the rules are fully internalized, all parties move in accord, requiring no visible restraints, demarcations, or sign-posts. In the ideal society, all members have the aural perspicacity to be aware always of the regulating drums.

It is in this regard that the *ch'in* was associated paronomastically with *chin* : restraint. Numerous comments describe the salutary effects of quietude and peace of mind attained through *ch'in* practice, through the exercise of restraint. The attainment of social, spiritual, or emotional tranquility is often expressed as an end of music in discussions of

[4] Liang, *Chinese Ch'in*, p. 229.

[5] Minnows are invoked as an image of effortless societal harmony by Chuang-tzu in his conversation with Hui-tzu while the two philosophers stood over the Hao River and mused about the pleasures of the fish. See Watson, *Chuang-tzu*, pp. 188–89.

performance discipline and affective power, but the prescription to bring about this result varies from culture to culture and is not always through a process of restraint.

In his essay "Style, Grace, and Information in Primitive Art," Bateson describes art as "corrective" in nature, noting that it "has a positive function in maintaining what I call 'wisdom,' i.e., in correcting a too-purposive view of life and making the view more systemic."[6] The description of an ideal performance is a statement on the dynamics of this corrective process. Without notable exception in early China, the dynamics of the corrective process are seen as direct and active, not contrary and reactive. That is, an integrated state of mind is achieved by communion with an integrated and tranquilizing art, rather than by exposure to excitation and catharsis. No premium is attached to the experience of "fear and pity"; there is no view of art as a surrogate for the painful experiences of life. Whereas historical narrative does include the record of the cruel, unjust, and immoral as contrary examples, there is nothing to be gained from listening to the music of Cheng, which in intricacy had gone "too far," and listening to the "Mulberry Grove" could bring on immediate disaster.[7] This is not to argue that, in practice, music is not varied and does not command a full range of emotions and responses. But in theory, the ideal state of mind is achieved by inducing its activity level below normal or ambient levels, not by exciting it to higher levels of activity and then permitting it to return to the normal or ambient after a performance "climax." The voice of the ch'in is literally below ambient sound levels; one must be unusually quiet and attentive to hear it and engage in appreciation of its music. The history of keyboard instruments in the West is one of technical advances toward greater volume, from the panteleon and clavichord to the "forte-piano" of Mozart's day to the electric piano of today. In the history of the ch'in, the opposite seems to have occurred, with large, multiple-string instruments evolving toward an ideal of small, sparsely stringed, and even stringless ones.

Byongki Hwang has noted that although both plucked and bowed string instruments exist in the West and in East Asia, they are accorded opposite status. He argues that the preference for bowed strings in the West is related to the desire to control the length and volume of tone and achieve a larger voice. About plucked strings, he writes:

[6] Bateson, *An Ecology of Mind*, p. 147.
[7] See pp. 22, 88, 93, 137-38.

In a plucked string instrument, on the other hand, only the original production of tone is determined by the player, after which the tone exists relatively independent of the performer (much as a child, who, at birth, achieves an existence independent of its mother). The tone gradually becomes softer, and the performer cannot extend it or control its rate of diminution except by modern electronic devices. There is no definite perceptible boundary between the end of sound and the beginning of silence—in essence, the tone becomes silence, and those with keen ears, situated close to the sound and in otherwise quiet surroundings, can follow this process longer than those with average or dull ears or who are in less favorable circumstances for listening.[8]

Hwang's comparison of string instrument preferences and his remarks on the skills of listening provide a contemporary context for the Po Ya and Chung Tzu-ch'i theme. Skillful listening involves following a tone from audibility to inaudibility, and the most critical moment, the climactic moment, is that point in time which hangs between sound and silence. Ideally, the listener's mind (and the listener may be both the performer and the audience) is brought to tranquility at that point. Skills for listening are no less essential than skills for performing. The act of listening has as great—perhaps greater—a potential for genius as does performing. Music masters Chüan and K'uang are heroes of tales in which they only listen. A comparable notion was adapted for other theories of art. Writing early in the sixth century, Liu Hsieh composed a section on "tone-worthiness" as the penultimate chapter in *The Literary Mind and the Carving of Dragons* (chap. 48). Liu Hsieh alludes to the Po Ya and Chung Tzu-ch'i story in arguing that the person worthy of appreciating art is rare, that the appreciation of art is difficult, and that the virtue of art is realized only in its appreciation. "For it is said that the orchid, which is the most fragrant thing in the country, will give forth its full scent only when worn."[9]

Early Chinese lore about whistling illustrates the great power of minimal music and the potential effects of the subtlest effort.[10] Whistling

[8] Byongki Hwang, "Instruments and Aesthetics in Korean and Western Music," in "Notes to Music from Korea, Vol. 1: The Kayakeum" (Honolulu: East-West Center Press, 1965), p. 7.

[9] *Wen-hsin tiao-lung*, p. 373.

[10] For reflections on whistling and a review of the etymology of the word, see Holzman, *Poetry and Politics*, pp. 150–52. An exact translation for

is a minimal performance act. It requires no instrument. It involves no words or thoughts; it does not use the larynx. Thus, it is *ch'ing* : clear/unvoiced, not *cho* : turgid/voiced. It is *ch'ing* : high, not *cho* : low. The earliest sustained discussion of whistling, Chin writer Ch'eng-kung Sui's 成 公 綏 "Rhyme-prose on Whistling" ("Hsiao-fu" 嘯賦), says:

> [Whistling] harmonizes *kung* and the yellow-bell pitch in the Clear *Chiao* mode.[11] It elaborates the *shang* and *yü* tones with the flowing *chih* tone. It blows the wandering clouds about the clear heavens and assembles sustaining winds for a distance of ten thousand *li*. Even when the song is over and the echoes have died away, lingering tones continue their play. This is truly the ultimate in self-so-ness. Not in imitation of the silk strings or the bamboo pipes, the sounds of whistling are not substitutes for other things and they employ no material aids. They come directly from the body, near at hand.[12] Relying on the mind, riding upon the *ch'i*, the lips themselves become a round,[13] and from the mouth, the tones issue forth. Things are touched and moved according to their class.[14]

whistling has been a problem for translators, in part because the word was used rather broadly in traditional China and in part because it is difficult to imagine exemplary Chinese aesthetes, e.g., Su Tung-p'o, expressing their profound appreciation for nature by standing on a hill and whistling. According to the "Hsiao-chih," the word *hsiao* refers to any highly articulated, but unvoiced human sound. This definition would not exclude what we call "whispering," but there is no indication that whispering was included in the Chinese sense.

[11] The Clear *Chiao* is a tone and a mode. According to Han-fei-tzu, Music Master K'uang declared it to be the ultimate mode in gravity of feeling (see Watson, *Han-fei-tzu*, p. 55; Watson translates it as "pure *chüeh*"). Lieh-tzu reiterates this association with Music Master K'uang ("T'ang-wen" 湯 問). It is described in the *Huai-nan-tzu* as the "sound of white snow" (2.4a, 6.1a), and the "Lü-li-chih" of the *Chin-shu* describes it as a performance system with *kung* at the *ku-hsi* pitch. The "Clear *Chiao*" is also a name given to the *ch'in* of the Yellow Emperor.

[12] A reference to Fu Hsi's discovery of the hexagrams, reported in the *I-ching*, "Ta-chuan," *chüan* 2, v. 2. See p. 53.

[13] In descriptions of whistling, the pun between *ch'ü* 曲 : winding/round and *ch'ü* 曲 : song is widespread.

[14] *T'u-shu chi-ch'eng*, "Hsiao-fu," 73.46a.

A more extensive range of whistling lore is collected in the "Hsiao-chih," a manual assembled during the T'ang by Sun Kuang 孫廣 . In the preface, Sun writes:

> When *ch'i* stirs in the throat and is voiced, we call it "speech." When it stirs about the tongue, and is unvoiced, we call it "whistling." The voiced act of speech is appropriate for human affairs and can reach our nature and feelings. The unvoiced act of whistling can move ghosts, reach spirits, and is undying. Speech issued forth skillfully will have response for one thousand *li*. Whistling issued forth skillfully will marshal the attention of the ten thousand spirits.[15]

Whistling lore resembles *ch'in* lore in its particulars. The technique is described and the pieces notated by reference to the movements of the throat and mouth, not the sounds per se.[16] There are twelve such movements, related, naturally, to the twelve pitches. There are five "greatnesses," *t'ai* 太 , synonymous with the five tones and related to the five virtues.[17] The tunes themselves are entitled as nature vignettes: "Fleeting Cloud," "Tiger in a Deep Ravine," "Cicada on a Tall Willow," "Night Demon in a Lonely Wood," "Dragon Droning," and so forth.[18] The images include the audible and the soundless, and the verbal descriptions that form the bulk of the notation make reference to movements in nature suggested by the piece.

The power of whistled music derives directly from natural powers. An earthquake song attests to the potential for terrestrial movement. It does not necessarily cause the earth to move, but it embodies the *ch'i* of

[15] The "Hsiao-chih" is found in the same *chüan* (73) of the *T'u-shu chi-ch'eng* as the "Hsiao-fu." The quotation is p. 45a; for another translation, see Edwards, "Principles of Whistling," p. 218.

[16] The "Hsiao-chih" defines a set of distinct articulatory means for producing whistling sounds in a straightforward and reproducible manner. These include apico-palatal, apico-alveolar, apico-dental, and both rounded and advanced bilabial postures. Combinations are also included, e.g., apico-palatal and advanced bilabial for the production of an intensely "swirling" sound.

[17] The five "greatnesses," also called the five "colorings," *wu-se* 五色 , are contrasted to the five "slightnesses," *shao* 少 , the former having *yang* attributes, the latter *yin*. "Hsiao-chih," p. 46a.

[18] Edwards, "Principles of Whistling," pp. 222-25.

the earth and congeals the *yin*, the very events that occur during the natural process.[19] Apropos of this congruence, the "Hsiao-chih" takes note of the importance of inner cultivation:

Confucius "transmitted and did not create."[20] That is to say, the immortal transmits the music of Kuang Ch'eng[-tzu] 廣成子 and Wu Kuang[21] in order to refine his nature and spirit and to expand upon the Way. It is not to achieve some standard in the producing of sounds and tones! For effectiveness in the movement and response of the myriad things, each according to its own, nothing approaches the musical tones. As for the tones, [with whistling] the sages have achieved the ultimate. Be it flying or running, the birds or the beasts, whistling is the final need.[22]

Juan Chi was renowned for his whistling as well as his *ch'in* playing. The "Hsiao-chih" relates the details of a widely known story about him.

Juan Chi was a skilled whistler and heard about the immortal of Su-men Mountain. Thinking himself of comparable skill to the immortal, Juan Chi went off for a visit to the mountain. The immortal just sat quietly, with dishevelled hair tossed about his shoulders, while Juan Chi bowed repeatedly and made polite inquiries about the immortal's well-being. He repeated his salutations again, and repeated them again. The immortal's expression remained completely unchanged, and he made no response to Juan Chi at all.

So Juan Chi whistled several dozen long notes and departed. Guessing when Chi had not traveled too far off, the immortal began to whistle in the Clear *Chiao* mode. He issued four or five tones. Chi only sensed that all of the trees and plants of the forests and mountains had a different sound about them. But in a very short while, powerful winds blew up and a fierce thunderstorm burst forth. When this ended, phoenixes and peacocks flew forth from every direction in greater numbers than could be counted. Chi was at first frightened;

19 Edwards, "Principles of Whistling," p. 225; and "Hsiao-chih," p. 45b.
20 *Analects*, chap. 7: "Shu-erh" 述而, v. 1.
21 Two figures from high antiquity who are ranked among the great whistlers of all times. Wu Kuang was noted above for having extraordinary ears (p. 35).
22 "Hsiao-chih," p. 45b.

then he was delighted. After he returned, he tried to write it down, managing to get perhaps two of ten parts.[23]
In the whistling lore, the sage performs the minimal music by whistling. His whistling issues no sound, but by it he conducts the sounds of nature, the musical powers of nature. It exemplifies the principle of nonpurposeful action, by which all things can be done.

Correlation and Signification

The extent to which systems and theories of correlation were involved in discussions of art profoundly influenced the nature of aesthetic theory. To what degree it influenced art and music itself is a complex, yet important question. The contributions of correlative thinking to aesthetic theory were most explicit in the classical and early Han periods. The correlative schemes were thought to be comprehensive. In their temporal configurations, they correlated to cosmogonic, historical, and calendric processes, past, present, and future. In their spatial configurations, they correlated to the center and all directions, the three tiers of heaven, earth, and man, the near at hand and the grand ultimate. Hence, to all synchronic and diachronic limits, the correlations sought to explain natural phenomena; human institutions; individual fates, emotions, and sensual experience; and purely intellectual renderings of cosmic structure, i.e., the numbers, graphs, phases, counters, and so forth. Correlations of sensual experiences were highly articulated and included the five tones, colors, flavors, smells, and shapes, and the sense organs, the ears, eyes, mouth, and nose. The proposed relation between cosmic and mundane entities gave rise to an idea of cosmically sanctioned value in mundane entities. That in turn gave rise to an idea of cosmic absolutes. In the case of sound, there were absolutely true pitches and intervals and absolute significances attributed to them. Unchanging elements were combined with ever-changing elements, insuring both continuity and constant change. The harmony of music depended completely on achievement of the absolute pitches.

[23] "Hsiao-chih," pp. 45b-46a. The same passage is translated in Edwards, "Principles of Whistling," p. 226. A similar story is translated in Mather, *New Account of Tales of the World*, pp. 331-32; and Holzman, *Poetry and Politics*, pp. 150-51.

The correlative themes constrained human action, which in actuality was guided by particulars of the systems. Effort was consumed in testing and verifying correspondences on the one hand and in the exploitation of correlations for particular purposes on the other. Choices which we might otherwise regard as individual in art, a musical mode, a poetic theme, or the subject of a painting or sculpture were potentially constrained by immediate and remote correlative concerns. A ritual musical performance around the winter solstice would employ modes positioned at the yellow-bell pitch in order to facilitate the passage from yin to yang and initiate a new cycle of life.[24] The various arts had, in effect, extensive external conventions governing content.

Correlative thinking potentially exerted a more subtle influence on signification and the perception of the nature of signification. The correlative schemes encompassed both the media of arts and all possible external referents. A particular pitch had associated with it a length, numbers, volume, a season and hour, a direction, a flavor, a color, smell, shape, and feel, a sensory system, an internal physiological system, a star—in short, one of the five phases and all its correspondents. By virtue of the correlations, the affective value of a pitch was instantiated in several broad areas, most of which were not obviously related to music. Kung was the minister; the yellow bell represented New Year's time; yellow was the color of the earth. Ritual music was program music. Its content was highly constrained by explicit rules and its referential significance was apparent to all parties to the performance. Modes at the yellow-bell meant the New Year; presumably, when played out of season they recalled the New Year.

Between arts, the correlations established explicit synaesthetic pairs. The shang tone was the color white, yü the color black, and chih the color red. These associations would have been internalized by those who subscribed intellectually to the correlative schemes. The extent to which such correlates can be perceived as structural bases for works of art has been demonstrated; for example, studies of the Dream of the Red Chamber have described the structure of the novel in terms of the five phases and

[24] Derk Bodde, Festivals of Classical China (Hong Kong: Chinese University of Hong Kong and Princeton University Press, 1975), p. 178.

yin and *yang*.[25] Certain *ch'in* tunes reveal a similar informing presence of correlations.

Not only did correlative thinking define the particular relata in various systems, but what was believed to be the basis for correlative relationships served as well to explain the basis for aesthetic response. By recourse to experimentation in sympathetic resonance and the like, subscribers to correlative thinking sought to explain how the media of the arts related to natural and human phenomena and acted upon them. These explorations of the referential and influential relationship between art and life involved personal feeling, social order, ritual events, and cosmic phenomena. The conception of a demonstrable connection between art and life, expressed in metaphors about *ying* : correspondence, canalisation of *ch'i*, and congruence of mental and cosmic order, inclined the conception of art itself toward one of an invariably programmatic nature.

Contemporary discussions of aesthetic experience speak of it as a process of emergence, a coming into focus, the apprehension of resemblance and order discovered from apparent dissimilarity and disorder. In definitions of art based on consideration of formal criteria, both the creative act and the act of appreciation involve apprehension of pattern and order. The object itself is patterned; its coherence derives from a level of redundancy. Irrespective of what vocabulary is used to describe the interaction of the object and the mind, be it "inspiration," "insight," "discovery," or "revelation," theories in the psychology of art address the process by which the pattern or redundancy is apprehended. The claim for "emergence" is predicated on a belief that apprehension in the aesthetic act is, in part, an apprehension of the potential for resemblance, pattern, and order. As crucial as what is known is what is unknown. The potential for aesthetic effect exists when there is something as yet unrealized or unknown. Borges stated this observation concisely:

> Music, states of happiness, mythology, faces belabored by time, certain twilights and certain places try to tell us something, or have

[25] See Andrew Plaks, *Archetype and Allegory in Dream of the Red Chamber* (Princeton: Princeton University Press, 1976). Plaks coins the terms "multiple periodicity" and "bipolar complementarity" to describe the five phases and *yin* and *yang* when generalized as structural elements in the novel.

said something we should not have missed, or are about to say something; this imminence of a revelation which does not occur is, perhaps, the aesthetic phenomenon.[26]

Exploring the concept of art in early China, the question arises as to the nature of the aesthetic act when, in theory, resemblances between all things in the world, be they apparent or not, and the overall order into which they fit are explicitly revealed in a comprehensive scheme of correspondences that is prior to and independent of the aesthetic act. For a concrete example, consider Wallace Stevens's description of the aesthetic process in his "Anecdote of the Jar":

I placed a jar in Tennessee,
And round it was, upon a hill.
It made the slovenly wilderness
Surround that hill.

The wilderness rose up to it,
And sprawled around, no longer wild.[27]

The jar, the hill, the view, and whatever is "around" are revealed to have a common quality of "roundness" and "aroundness." The poetry is the discovery of that resemblance, that orderliness, and the pleasure of that discovery.[28] What alteration of that poetic process would be caused if both the poet and the reader had within their minds a chart of "roundness" correlates including jars, hills, and views? There are a number of extraordinary examples of highly correlative literary works in early China. For example, Chang Heng's *Rhyme-prose about Meditations on the Mystery* makes use of images that correlate to the hexagrams and commentaries of the *Book of Changes*; and it requires reference to the *Book of Changes* for explication not only of the images themselves, but of the sequence of images in the poems as well. That is, the poetic syntax correlates to the

[26] Quoted from a brief note on the Ch'in emperor Shih-huang's wall, entitled "The Wall and the Books," in *Labyrinths: Selected Stories and Other Writings*, ed. Donald A. Yates and James E. Irby (New York: New Directions, 1962), pp. 186-88.

[27] Wallace Stevens, *Collected Poems* (New York: Alfred A. Knopf, 1954), p. 76.

[28] Stevens writes, "The eye does not beget in resemblance. It sees. But the mind begets in resemblance, as the painter begets in representation." *The Necessary Angel*, p. 76.

transformations from hexagram to hexagram as defined by the *Book of Changes*.[29]

Whether or not the explicit articulation of correlations in any sense altered the potential for "discovery" in aesthetic experience, the awareness of and interest in correlative process provided a basis for discussing key and definitive issues in the nature of art. Without embarking on a general discussion of epistemology that would exceed the bounds of this essay, I would like to raise an epistemological issue that is essential for interpreting much of the theory and metaphor that the Chinese used for aesthetic discussion. There are many dualistic themes in early Chinese civilization, by which I mean the various ramifications of *yin* and *yang* or similar formal constructs.[30] Some are obvious to any student of China, e.g., the use of *yin* and *yang* in cosmological speculation, in *Book of Changes* divination, or in the interpretation of meteorological portents. Others are less obvious, e.g., the validation of oracle bones in divination by the scribing of complementary and symmetrical positive and negative charges. Dualism is a pervasive feature in early Chinese comprehension of the cosmos, of cosmic process, of the mind, and of mental process. I have already noted the dualistic structure of evaluative terminology. The importance of dualistic thinking is also illustrated in the linked definitions of ritual and music, which were best defined as a pair. The mental activities suggested by ritual and music, separation (distinction and selection) on the one hand and union (association and integration) on the other, together describe the totality of thought processes, i.e., "splitting" and "lumping."

In the discourse and lore about art and culture there is a persistent *topos* of diplopia, a doubleness of vision in which pairs of things are simultaneously seen, their parallels perceived, their structural similarities apprehended. Ts'ang Chieh is said to have had four eyes; one set looks up, the other looks down, permitting him to apprehend simultaneously the correlations of heaven and earth.[31] Fu Hsi looks up and then looks down

[29] *Hou Han-shu*, pp. 1914–39.

[30] Needham, *Science and Civilisation in China*, 2:273–78; and Fung, *Chinese Philosophy*, 2:7–32.

[31] Jonathon Chaves, "The Legacy of Ts'ang Chieh: The Written Word as Magic," *Oriental Art Magazine* 23, no. 2 (Summer 1977): 202–3. Note especially the representation of Ts'ang Chieh from the I-nan tombs in Shantung. A number of ceramic images of Ts'ang Chieh illustrating his "quadrocular" capacity have been found and dated to the early Han.

Fig. 7. The Sage Ts'ang Chieh.

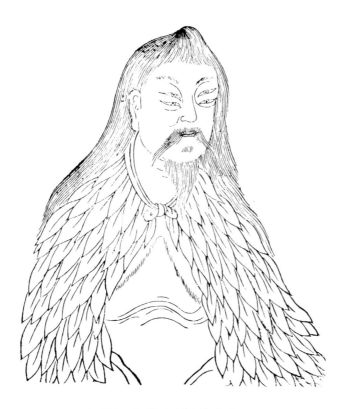

From the *San-ts'ai t'u-hui.*

before he transcribes the trigrams with which he schematized the relations among all things. Writing, trigrams, calendars, and other systems of meaning and order are discovered, according to the mythologies, by those who look two ways. Looking two ways means not focusing on things per se, that is, on their visible attributes, their essences, or their ideals, but rather on the relationship between things, their resemblances and distinctions.[32]

Bateson stresses the centrality of relations in nonrational psychological processes: "It is probably an error to think of dreams, myths, and art as being about any one matter other than relations."[33] Wallace Stevens places the issue of resemblance at the center of poetic process: "The study of the activity of resemblance is an approach to the understanding of poetry. Poetry is a satisfying of the desire for resemblance."[34] "Relations" and "resemblance" are more palatable words for us in the discussion of art than "correspondence" and certainly more palatable than "correlation." They speak to less predetermination of the relata, less definition of their similarities, and more potential for discovery. These are differences in degree, however, and all four terms address the integrating nature of the aesthetic act, the uniting of two things into one that is the pleasure of art.

This feature of aesthetic process, relating, resembling, corresponding, or correlating, narrowed to the compass of a "device" and used to describe the affective potentials of art, is called "synaesthesia." Given the epistemological background of early Chinese thinking on art, I would argue that such thinking was characteristically synaesthetic, the term taken in a broad and fundamental sense (Greek *sun* : together + *aisthanesthai* : to perceive). In their study *The Foundations of Aesthetics*, a book in part inspired by a reading of the Confucian *Doctrine of the Mean*, Ogden, Richards, and Wood list synaesthesia as a basic principle of art.[35] Described broadly, a synaesthetic theory of art focuses on the commutability

[32] The classical exorcist, *fang-hsiang-shih* 方相氏 , is described in the *Chou-li* as having four eyes and is portrayed with four eyes in a number of Han figurines. See Bodde, *Festivals*, pp. 77-80, 116-20; and Berthold Laufer, *Chinese Clay Figures* (Chicago: Field Museum of Natural History, 1914), p. 199, pls. xv-xvii.

[33] Bateson, *An Ecology of Mind*, p. 150.

[34] Stevens, *The Necessary Angel*, p. 37.

[35] Ogden, Richards, and Wood, *Foundations of Aesthetics*, p. 21. Synaesthesia is rule 16 in their classification of "The Senses of Beauty."

of sensations, the exchangeability of objects and images, the intertranslatability of meaning from genre to genre, and, finally, the natural interpenetration of art and life.[36] A synaesthetic theory of art describes as the end of art a sense of harmony, equilibrium, and integration, attended by the pleasure that Stevens described.

A synaesthetic notion of art is evident in a synoptic review of Chinese theories and lore. The idea of ch'i is as ubiquitous in the texts as ch'i was alleged to be in the cosmos. Being configured, ch'i either created or reflected similarity in what were apparently unconnected or dissimilar entities and events. The result of this similarity, which had both temporal and spatial dimensions, was cosmic accord. Ch'i was the means by which a moment of cosmos, mind, and art were interrelated. In early China, one finds evidence of this perception of ch'i in discussions of art, of dreams,[37] and of life.[38]

The role of ch'i in all arts allows for a degree of intertranslatability and the potential for harmonious admixture: words and music, calligraphy and poetry, poetry on paintings, paintings on zithers, inscriptions on bells, animal sculpture on chime stands, and the like. Mythologies of the writing and divinational systems emphasize that such systems embody patterns of

[36] Bateson, using psychoanalytic terminology, writes:

"In primary process the things or persons are usually not identified, and the focus of the discourse is upon the *relationships* which are asserted to obtain between them. This is only another way of saying that the discourse of primary process is metaphoric. A metaphor retains unchanged the relationship which it 'illustrates' while substituting other things or persons for the relata." *An Ecology of Mind*, pp. 139-40.

[37] The late Han skeptic-philosopher Wang Fu made the following observation about dreaming: "Dreams of hazy, rainy days make one bored and stupified. Dreams of sunny, baked-dry days make one confused and vague. Dreams of bitter cold make one bitter and grave. Dreams of great winds make one breezy and flighty. These are called 'ch'i-moved dreams.' " *Ch'ien-fu lun*, "Meng-lieh" 夢列 [Varieties of dreams], 7.1b.

[38] See, for example, the role of music and dance in the keen-edged butchery of Cook Ting. Watson, *Chuang-tzu*, pp. 50-51. What Watson translates as "perfect rhythm" is *chung-yin* 中音, to be "right on the tone."

nature. They are, therefore, considered iconic, not arbitrary or merely conventional systems of signs. Writing about music embodies musical qualities, making it an incipient multimedia presentation, rather than a singular textual-semantic representation. For example, musical discussions in the *Huai-nan-tzu* are rich in onomatopoeia and reduplicated terms; in the *Spring and Autumn Annals of Mr. Lü*, technical arguments are marked with long cadences of three- and four-character phrases. The five musical voices described in the "Book of Music" are expressed with onomatopoeia that mimics the instruments themselves: *k'ɛng/chien* 鏗 (*GSR* 1252) for bells, *k'ieng/ch'ing* 磬 (*GSR* 832) for stones, *ər/ai* 哀 (*GSR* 550) for zithers, *glam/lan* 濫 (*GSR* 609) for flutes, and *χwan/huan* 讙 (*GSR* 158) for drums.[39] The rhyme-prose pieces written in profusion during the Han and early Six Dynasties were filled with onomatopoeia and showed a marked preference for musical subjects, subjects that included not only instruments and performances, but noisy insects, like the cicada, and noisy things, like waterfalls, as well. The texts strove to provide a measure of the sensual experience of hearing the sounds about which they wrote. The proclivity of an artful text to be "presentational" as well as "representa- tional" becomes a normal feature in later writing, found, for example, in theories of poetry written in poetry.

The satisfaction of the desire for resemblance is expressed in the *yüeh* : music and *lo* : pleasure homographic pun. The pun, which itself conjoins the senses of music and pleasure throughout early discussions, invites a retranslation of the key utterance on music in the "Book of Music," viz., *yüeh-t'ung*, "music unites," as *lo-t'ung*, "take pleasure in resemblances."

Music and Ritual

The dialectic tension between the definitions of music and ritual found throughout early Han texts calls attention to both similarities and differences perceived in their natures and functions. "Music unites that which is the same; ritual distinguishes that which is different." Discussions of ritual are parallel to those of music and are in no sense external to the concept of art. There are shared values. Both music and ritual prize

[39] Needham, *Science and Civilisation in China*, vol. 4, pt. 1, p. 153.

minimalization and prize restraint, and both emphasize the importance of the effort rather than the outcome. Both music and ritual address the twin concerns of self-cultivation and social order, appropriately contextualized in the prevailing cosmic order. Discussions of music resort to analogy with other elements in the rites, e.g., the sacrificial soup; and music was itself an instrument in the proper and effective conduct of the rites--the controlling drums and the rhythm of the dancers. In the concept of ya, proprieties of both ritual and music were closely associated, and from that association the aesthetic ideal of ya in regard to music emerged.

In a variety of formulations, music and the rites played coordinated roles in the achievement of the ideal life and the ideal state of mind. When issues of individual mind are brought to the surface in discussions of art, the restraint and cultivation of emotion is the expressed goal, just as it was in connection with the rites when social concerns dominated the discussions. Music and rites are principal issues in the investigation of human emotions. Particularly in the Six Dynasties, emotion itself was widely discussed. In the prevalent line of debate, the question was raised whether the sage had emotions, the sage being pursued as a model of how ordinary men might deal with their emotions. The emotional content or potential of art was then raised in this context. Ho Yen argued that the sage was devoid of feelings, but Wang Pi differed.[40] Wang Pi expressed confidence that emotions could be communicated, but Yin Jung 殷融 differed.[41] The issues were combined in discussions of music and the arts to which the best thinkers put their minds. The Shih-shuo hsin-yü describes a journey of the powerful Chin minister Wang Tao, who, when crossing the Yangtze River, deigned to discuss only three subjects, one of which was the joyless and sorrowless nature of sound.[42]

Even after the discussion of music was removed from a social context, music retained a ritual dimension. After the fall of the Han, ya no longer referred directly to the orthodox performance of a sacrificial rite, but the achievement of ya in music was still via ritual reenactment. Ch'in tunes were not pieces of music but were prescriptions for movement,

[40] Their positions in this debate were recorded by P'ei Sung-chih in his commentary on the San-kuo chih and are redacted in Ch'üan Shang-ku wen, comp. Yen K'o-chün, p. 1301.

[41] Fung, Chinese Philosophy, 2:185-86.

[42] Mather, New Account of Tales of the World, p. 102.

176

fitting closely the Han definition of *li* : ritual, which the dictionary *Explaining the Graphs and Explicating Their Combinations* defines as "[pre-scribed] steps or paces." Performance of *ch'in* pieces, by virtue of the expressed content of the tune, was often a reiterative act, portraying the performance act of a previous *ch'in* master, the movement of a dragon in the clouds, or the movement of a tortoise crawling from the water. "Alas! The Orchid" ("I-lan" 猗蘭) is said to have been performed by Confucius upon his return to Lu after being rejected for employment. Traveling through a secluded valley, he happened upon a single orchid flourishing in its loneliness. When performing the piece, there should prevail a sense of reenacting the disciplined response of Confucius, through a reenactment of his tuning, his fingerings, and his appreciation of the orchid. The skilled player relives the emotional processes of the sage. The tune embodies the model for its own appreciation. In the *Ch'in-ts'ao*, all the "scores" are verbal descriptions of how the tune was composed, or, in actuality, first performed. Each score begins with the title, which is followed by a brief introduction of the composer. The body of the score then describes the circumstances of the tune's composition, usually a situation of some duress for the composer.[43] It is what Lu Chi described when he wrote, "In making an axe handle by cutting wood with an axe, the model is indeed near at hand."[44] A remarkable tune entitled "Wine Madness" ("Chiu-k'uang" 酒狂), associated with Juan Chi, includes a coda subtitled "The Sound of an Immortal Vomiting Wine" ("Hsien-jen t'u-chiu sheng" 仙人吐酒聲), which has been described by a contemporary *ch'in* player and scholar as a "humoristically stylized imitation of the sound of a person vomiting, ob-tained through an appropriate use of *glissandi* and *tremoli*."[45]

[43] *Ch'in-ch'ü chi-ch'eng*, pp. 740-75. The score for "I-lan" is found on p. 741.

[44] Lu Chi, *Wen-fu*, trans. Ch'en Shih-hsiang, in *Anthology of Chinese Literature*, ed. Cyril Birch (New York: Grove Press, 1965; Evergreen Paperbacks, 1967), p. 204.

[45] Liang, "Neo-Taoist Implications," pp. 26-27. Liang notes that the earliest known edition of the piece is in the Ming *ch'in* collection, the *Shen-ch'i pi-p'u* of Chu Ch'üan 朱權 (A.D. 1376-1448). See *Ch'in-fu*, pp. 109-219. This song is found on pp. 129-30. The introduction to "Wine Madness" illustrates the extent to which Juan Chi's memory was simplified and idealized in subsequent centuries of *ch'in* lore:

There is a pronounced tendency for discussions of music to draw attention away from the objects and audible events and to seek definitive qualities in the act. The highly regarded aesthetic act, like the highly regarded ritual act, is one that is properly performed, though not necessarily intellectually understood. Both the ritual aspect of a musical performance and the musical facet of ritual are aids to proper performance. Classical Chinese thinkers of various persuasions made a distinction between knowing how to do something and knowing about doing something. The former was always considered superior to the latter. Interest in the latter could, in fact, impede success with regard to the former.[46]

Art and Cosmos

The analogy between musical harmony and cosmic harmony is the most central association found in the theory and lore. Harmony is a pervasive theme throughout the classical texts. The *Book of Odes* says that eating medicinal plantain creates "harmony and balance permitting the lady to joyfully bear her child."[47] A central and recurrent metaphor in the *Book of Documents* for the virtues of the Chou kings was their ability to harmonize "above and below." The *Tales of the States* describes the mutually generative feature of harmony, "the process by which the notes bring about

"This tune was composed by Juan Chi. Chi sighed that the Way was not widely practiced and he was out of accord with his times. Therefore he forgot the world of men and indulged his thoughts outside material form, trusting to the spirits in the wine cup with joyful drinking to the end of his days. Is this really a case of uncontrolled addiction to wine? No, the Way was found therein."

[46] Chuang-tzu provides the best examples of this argument. For example, see the stories of Wheelwright Pien, Cook Ting, and Woodworker Ch'ing; Watson, *Chuang-tzu*, pp. 152-53, 50-51, 205-6. Gilbert Ryle differentiates between "knowing how" and "knowing that," writing that it is an "intellectualist fallacy" to argue that an act effectively and successfully done requires "regress" into a prior intellectual operation. See *The Concept of Mind* (London: Hutchinson and Co., 1949), pp. 25-61, esp. pp. 27-35.

[47] *Shih-ching*, Mao edition, no. 8; for Waley's translation, see *Book of Songs*, no. 99, p. 91.

one another is called 'harmony.' "[48] Harmony is contrasted to isolation in the *Analects*: "Harmony [means to be] without isolation."[49] In the *Book of Rites*, the concept of harmony represents ultimate virtue in society, governance, and music. In association with harmony, music continued to be the most versatile *problèmatique* in which the early speculator indulged his curiosity about cosmic processes. Discussions of harmony again recall what Pater sought in a "principle" to link the diverse impulses of the cosmos. Music was the superior art for this undertaking. Music permitted a demonstration of the one giving birth to the many through the division of strings. It permitted a demonstration of the many, remaining distinct unto themselves, yet melding back into a harmonious whole. The high and the low blend, innocent of the contradiction that besets verbal arts. In music, correctness of timing, tonal quality, and placement were the requisites of harmony; in human action, harmony obtained from doing things in the proper time, in the proper place, and in the proper way. Over the centuries there were differing prescriptions for achieving harmony, ranging from the researching of detailed lists of correlations (used to compute the parameters of harmonious action) to the abandonment of purposeful thinking in order to permit nature to play upon one. The principles that applied to the making of music were the principles that applied to living generally, and, until the Six Dynasties, when art was identified as a particular and distinct undertaking, all disciplines that were geared to harmonious living were encompassed in the idea of what was aesthetic. Any endeavor, no matter how ordinary—butchering an ox, shaving wheel spokes, or succumbing to a fatal illness—if properly done achieved an aesthetic dimension and harmonized with the prevailing order. No "line" separated ordinary work from the making of art, another point that is made manifest in the paradigmatic images of harmony in early Chinese texts, the well-blended musical performance and the well-seasoned soup.

Early Chinese thinkers describe music as a reflection or a realization of nature's patterning in the human mind. The diversity of views on the nature of such patterning follows from a diversity of views on human nature. The patterning of mind invoked in discussions of musical harmony

[48] *Kuo-yü*, "Chou-yü," 3.18a. This entire section of the *Kuo-yü* (3.12a-18b) describes at length the dynamics of governance through stories of bell-making and the search for harmony.

[49] *Analects*, chap. 16: "Chi-shih" 季氏 , v. 1.

was felt to be innate, cultivable, and corruptible. The diversity of ideas about pattern and music notwithstanding, they were virtually never divorced from the enduring concern with the formal structure of the cosmos and the formal structure of the mind. In classical and early Han thinking, the emperor and society at large reside between the individual and the heavens. Patterning is exemplified by the ruler and is manifested in the harmonious society. The ruler and the society he oversees respond to what is projected down from the heavens and what emanates upward from the people. In later thinking, as interest in society recedes, the role of patterning is emphasized as a direct link between the individual mind and nature at large.

Embodiment of natural patterning is a definitive requirement of the aesthetic. As a result, there is a general inclination to differentiate between art (i.e., that which is aesthetic) and nonart (i.e., that which is not aesthetic) rather than between good art and bad art. In other words, in the early stages, discussions of aesthetics inclined toward the theoretical, not the critical or evaluative. Not until well into the Six Dynasties were efforts made to grade art or to establish a consensus of critical norms. Earlier discussions, for example, of the music of Cheng, disqualified this genre from consideration as art entirely because it did not partake of natural patterning, did not harmonize with nature or society, and was corrupting to the patterning of the individual mind. The other major genre discussed in the classical period, the poetry of the *Odes*, was without defect: "The *Odes* number three hundred yet may be covered with a single description—they are without depraved thoughts," Confucius argued.[50]

The early Chinese concept of natural pattern obviates an important issue in the Western discussion of aesthetics, namely, the symptom-emotive approach to art as opposed to the affective approach. The former describes the function of music, for example, as an expressive (and cathartic) act from the perspective of the composer or performer. The latter addresses music's communicative and influential significance vis-à-vis the listener. In the Chinese view, all parties to the aesthetic act are inherently participants in a validation of cosmic patterning. Their primary and inalienable relationship is to that prevailing order, not to the composer, performer, or audience and not to the art object or event. The later lore

[50] *Analects*, chap. 2: "Wei-cheng," v. 2.

tends to diminish the active-passive disparity between the creative and receptive roles, emphasizing the ideal of passivity in performance and the skillful involvement in listening (e.g., Chung Tzu-ch'i). Cosmic order is omnipresent, and, when the mind is there as well, any of the common components of the aesthetic event can be eliminated—the performer, the sound, the instrument, the audience—as long as formal correspondence between the mind and nature is achieved. Vastly reduced in importance is the responsibility of the performer to "express," the burden of the music to "affect," and the need for a listener to "respond." Above all, the aesthete is engaged in a process of communion between his mind and nature.

> The clouds sculpture in colors, with a genius surpassing any painter. The plants and trees burst forth in blossoms, without waiting on the ingenuity of the embroiderer. Could it be but external embellishments? No, it is simply self-so.

> When the sounds of the forest's piping intertwine, they are as melodic as the reed flutes and zithers. In the rhyme of spring waters gushing over rocks is harmony the like of jade chimes and bronze bells.

> When forms took shape, formal order came to be. When sounds issued forth, the patterns were born. Now, if things without consciousness are so marked in variety, how could a thing with the mind of man be without such pattern as well?[51]

The claim that the aesthetic embodies natural patterning, a revelation of order common to the mind and the cosmos, led to explorations of the relationship between art and nature. Ch'in lore, in particular, emphasizes this relationship through elaborate metaphors for hand postures, a performance regimen that requires visualization of natural images and an affinity for natural themes in its programmatic aspects. Nature itself, appreciations of nature by previous masters, or stories of mythic communions with nature are the nearly exclusive topics of ch'in songs.[52]

[51] See the Kai-ming edition of the Wen-hsin tiao-lung, 1.1a. For another version, see Shih's translation, pp. 9-10.

[52] Van Gulik classifies ch'in tunes into five thematic groups: (1) mystic journey; (2) semihistorical; (3) converted literary products; (4) descriptions of nature; (5) descriptions of literary life (Lore of the Chinese Lute, pp. 84ff.). A more careful analysis may be made by looking at the

Some explorations of the relationship between art and nature construe it in terms reminiscent of Aristotle, that is, art as an imitation of nature.[53] I have raised examples of a particular kind of scale-modeling, comparable to the alchemist's proportional reenactment of cosmic process. But elaborated expressions of the art-nature relationship view it as more subtle and complex, and less purposeful, than a coarse imitation of surface features—petal for petal—of nature by art. Any visible or audible resemblance may or may not exist between art and its correlates in nature. The ch'in hand postures are described in terms of the "character" of movement.

> K'un 滚 "welling-up": . . . A heron bathing in a whirlpool. One should think of a heron taking a bath in the small eddies of a stream in the shallow places along its banks: the whirling movement of the water, together with the flapping of the wings should suggest the character of the movement.[54]

The surface features are largely incomparable, hence the comparison exists at a more profound level.

> An ear is a small hollow, and a valley is a large hollow. Mountains and marshes are a "small valley" and Heaven and Earth was a "large valley." (Theoretically speaking, then,) if one hollow gives out sound ten thousand hollows will give out sound; if sound can be heard in one valley it should be heard in all ten thousand valleys.[55]

The patterning is inherent, not something that the aesthete willfully obtains or imitates from nature. Rather than strive to imitate an external order in the making of art, the aesthete or artist must avoid a purposefulness that would obscure the patterning within his mind. Bateson makes a

underlying content; virtually all of the pieces are descriptions of nature (a "classical inclination") or descriptions of supernature (a "romantic inclination"), either directly (1 and 4), through a borrowed text (3), or vicariously through the persona of a famous figure, literary or real (2 and 5).

[53] Croce takes up the theme of imitation of nature and explains its pitfalls when used as a concept in the discussion of art. See *Aesthetic*, pp. 27-29.

[54] Van Gulik, *Lore of the Chinese Lute*, p. 124. The character should be read as *kun*.

[55] Needham, *Science and Civilisation in China*, vol. 4, pt. 1, pp. 207-8.

similar claim for art, arguing that the corrective potential of art is precisely dependent upon its departure from "mere, purposive rationality."[56]

The extent to which the individual mind participates in a larger scheme of events and the extent to which the activities of the mind are revealed in music are illustrated in a story from Ts'ai Yung's biography:

When Ts'ai Yung was living in Ch'en-liu, a neighbor gave a large party and invited Yung. The guests seemed already well intoxicated by the time Yung arrived. As he approached the door, one guest was playing the *ch'in* behind a divider. Yung secretly listened, then exclaimed, "What is the meaning of this? I was drawn over by the music only to discover someone here with a mind bent on violence!" So he returned home immediately.

He sent a messenger to the host to convey this message: "Master Ts'ai came to your party, but he walked only as far as the door, and then he returned home." Now, Ts'ai Yung's family was long venerated throughout that area, so the host himself immediately rushed over to Yung's house to ask the reasons for this. Yung told the entire story, which left the host completely astonished.

Later, the guest who had been playing the *ch'in* offered this explanation: "As I was playing, I noticed a praying mantis about to pounce upon a singing cicada. The cicada was soon to take to flight, but had not yet flown away. The mantis moved tentatively, forward and then back. My heart skipped a beat as I watched, apprehensive that the mantis would lose his prey. Could this be the 'mind bent on violence' that took form in the sound?"

Yung laughed when he heard this explanation. "That does explain it all!"[57]

At least in the expression of ideals, the disciplines of art embodied an element of passivity that is quite contrary to the image of the artist locked in struggle to control or confine the forces of nature. The passivity of the

[56] In a discussion reminiscent of the self-so-ness ideal of the Six Dynasties thinker, Bateson writes, "Life depends upon interlocking *circuits* of contingency, while consciousness can see only such short arcs of such short circuits as human purpose may direct." *An Ecology of Mind*, p. 146.

[57] Note fig. 4 above (p. 135), which illustrates the hand posture for "A Praying Mantis Captures a Cicada." *Hou Han-shu*, p. 2004.

The polarity between art and nature which is explicit in many schools of Western aesthetics (revealed in the polysemy of the word *art* itself and its derivatives, e.g., "artifice," "artificial") is not in evidence in early Chinese theory. A functionally comparable polarity is that between order and disorder, with nature, art, and the correct state of mind associated with the former. Nature and natural patterning being at the hub of the arts, aesthetic endeavors of all kinds are part of human nature, not apart from it. In both the theory and practice of art, the early Chinese took pleasure in blurring the boundaries between extreme civility and cultivation and utter rusticity, in much the same way that Western pastoralists celebrate and affect primitivism in the midst of elegant and courtly culture. In early China, however, the habits of theory and practice allowed for the less contrived return of art to nature than seemed possible, for example, for Castiglione's courtiers. In the same way that a perceived consanguinity of all arts allowed easy admixture of media, the perceived congruence of artistic and natural patterning allowed an easy admixture of art and nature. The lore speaks of "piping" in the trees; the instruments made from those trees find their perfect voice only when returned to their native setting. Poems are written on stones or bamboo slats or banana leaves; zithers are played to the streams and trees, and songs are whistled to be heard by nature alone. Lest art be perceived as artifice, it is always returned to its natural context. Where poems are inscribed in stone along scenic trails, even the verbal arts are returned to the scene where Ts'ang Chieh first discovered writing in the tracks of birds and beasts. Such poems reveal the mental achievement of the poet in his appreciation of the spot. For those who come later, the poems are part of the nature there, an accumulation of the pattern of the place with which later visitors will find accord. The poem does not prescribe a proper response to the place; rather, it translates the scene's aesthetic significance into another art or medium. To see such inscriptions as artifice is to see them as defacements of the natural scene, a complaint unknown in the varieties of early works that collected and commented on them. As with all components of art, poems in stone derive in a spiritual and material way from the interaction of man and nature and are assembled in a natural process. Though the definition of *ya* : refinement varied from the classical period to the early Six Dynasties, whether it meant "elegant" or "rustic," it never meant "unnatural." The process of refinement, through the practice of the arts and the aesthetic pursuit of life, brought a return from a state of

separation to a state of closeness with nature. We can best understand this by resorting to music, as did the early Chinese thinkers who pondered the question of refinement. The ultimate refinement of the pitches was achieved in the discovery of the perfect pitches of the phoenix. The ultimate refinement of the pipes was achieved in perfect coincidence with the seasonal movements of *ch'i*. The ultimate refinement of music was achieved by resonation with the sound power by which nature moves the winds, the rains, and all things.

SELECT BIBLIOGRAPHY

I. Works in Chinese and Japanese

Ch'en Yin-k'o 陳寅恪 . "T'ao Yüan-ming ssu-hsiang yü ch'ing-t'an chih
kuan-hsi" 陶淵明思想與清談之關係 [The relationship between
the thought of T'ao Yüan-ming and pure conversation]. In *Ch'en Yin-
k'o hsien-sheng lun-chi* 陳寅恪先生論集 [Collected essays of Ch'en
Yin-k'o], 2:1012-36. Taipei: Chiu-ssu Publishers, 1971.

Ch'ien-fu lun 潛夫論 [Discourses of the hidden one]. Compiled by Wang
Fu 王符. *Han Wei ts'ung-shu* edition.

Ch'in-ch'ü chi-ch'eng 琴曲集成 [Compendium of *ch'in* music]. Compiled by
the Chung-yang yin-yüeh hsüeh-yüan 中央音樂學院 [Central Acad-
emy of Music] and the Ku-ch'in yen-chiu hui 古琴研究會 [Society
for Researches in the Ancient *Ch'in*]. Peking: Chung-hua shu-chü,
1963.

Chin-shu 晉書 [History of the Chin]. Compiled by Fang Hsüan-ling 房玄
齡. *Chung-hua shu-chü* (Peking) edition.

Ch'iu Hsi-kuei 裘錫圭. "T'an-t'an Sui-hsien Tseng Hou-i mu ti wen-tzu tzu-
liao" 談談隨縣曾侯乙墓的文字資料 [Notes on the written
documents found in the tomb of Tseng Hou-i in Sui County]. *Wenwu*,
no. 7 (1979), pp. 25-31.

Chiu T'ang-shu 舊唐書 [Old history of the T'ang]. Compiled by Liu Hsü
劉昫 . *Chung-hua shu-chü* (Peking) edition.

188

Chou Fa-kao 周法高 . *Chin-wen ku-lin* 金文詁林 [Forest of bronze inscriptions]. Hong Kong: Chinese University of Hong Kong, 1974.

Chu Ch'ien-chih 朱謙之 . *Chung-kuo yin-yüeh wen-hsüeh shih* 中國音樂 文學史 [History of Chinese musical literature]. Taipei: Commercial Press, 1965.

Ch'un-ch'iu fan-lu 春秋繁露 [Myriad dewdrop commentary on the spring and autumn annals]. *Han Wei ts'ung-shu* edition.

Feng-su t'ung-i 風俗通義 [Penetrating popular ways]. Compiled by Ying Shao 應劭 . *Han Wei ts'ung-shu* edition.

Han-shu 漢書 [History of the Han]. Compiled by Pan Ku 班固 . *Chunghua shu-chü* (Peking) edition.

Hou Han-shu 後漢書 [History of the later Han]. Compiled by Fan Yeh 范曄 . *Chung-hua shu-chü* (Peking) edition.

Huai-nan-tzu 淮南子 . Compiled by Liu An 劉安 . Commentary by Kao Yu 高誘 . *I-wen* edition.

Huang Hsiang-p'eng 黃翔鵬 . "Hsien Ch'in yin-yüeh wen-hua ti kuang-hui ch'uang-tsao Tseng Hou-i mu ti ku yüeh-ch'i" 先秦音樂文化的光輝創造曾侯乙墓的古樂器文物 [The ancient musical instruments unearthed from the tomb of Tseng Hou-i: Glorious creations of pre-Ch'in musical culture]. *Wenwu*, no. 7 (1979), pp. 32-39.

Jao Tsung-i 饒宗頤 . "Lu Chi *Wen-fu* li-lun yü yin-yüeh chih kuan-hsi" 陸機文賦理論與音樂之關係 [The relation between music and Lu Chi's theory in the *Wen-fu*]. *Chūgoku-bungakuhō* 14 (1961): 22-37.

Kuo-yü 國語 [Tales of the states]. Commentary by Wei Chao 韋昭 . *T'ien-sheng ming-tao* edition.

Lei-ku-tun i-hao mu k'ao-ku fa-chüeh-tui 擂鼓墩一号墓考古發掘隊 [Lei-ku-tun Excavation Team]. "Hu-pei Sui-hsien Tseng Hou-i mu fa-chüeh chien-pao" 湖北隨縣曾侯乙墓發掘簡報 [Brief report on

the excavation of the tomb of Tseng Hou-i in Sui County, Hupei Province]. *Wenwu*, no. 7 (1979), pp. 1-24.

Lü Chi 呂驥. "Ts'ung yüan-shih shih-tsu she-hui tao Yin-tai ti chi-chung t'ao-hsüan t'an-so wo-kuo wu-sheng yin-chieh ti hsing-ch'eng nien-tai" 從原姓民族社會到殷代的幾種陶塤探索我國五.聲音階的形成年代 [Researches into the formation of our country's five-tone scale based on examination of several types of ceramic *hsün* from primitive clan society to the Shang period]. *Wenwu*, no. 10 (1978), pp. 54-61.

Lü-shih ch'un-ch'iu 呂氏春秋 [The spring and autumn annals of Mr. Lü]. Compiled by Lü Pu-wei 呂不韋. *Ssu-pu pei-yao* edition.

Lun-heng 論衡 [Balancing discourses]. Compiled by Wang Ch'ung 王充. *Han Wei ts'ung-shu* edition.

Ma Kuo-han 馬國翰. *Yü-han shan-fang chi-i-shu* 玉函山房輯佚書 [Collected fragments of the Jade-Case Mountain Studio]. 6 vols. Taipei: Wen-hai, 1967.

Mizuhara Ikō 水原渭江. "Chūgoku kodai ongaku shisō kenkyū" 中國古代音樂思想研究 [A study of musical thought in ancient China]. *Tōyō ongaku kenkyū*, no. 10 (June 1965), pp. 207-31.

Naito Shigebunu 内藤戊申. "Kandai ongaku to ongaku riron" 漢代の音樂と音樂理論 [Han dynasty music and music theory]. *Tōhō gakuhō* 46 (1974): 127-60.

Pai-hu-t'ung te-lun 白虎通德論 [Comprehensive discussions of virtue in the White Tiger Hall]. Compiled by Pan Ku 班固. *Han Wei ts'ung-shu* edition.

San-kuo chih 三國志 [History of the three kingdoms]. Compiled by Ch'en Shou 陳壽. Commentary by P'ei Sung-chih 裴松之. *Chung-hua shu-chü* (Peking) edition.

Shih-chi 史記 [Records of the grand historian]. Compiled by Ssu-ma Ch'ien 司馬遷. *Chung-hua shu-chü* (Peking) edition.

Shuo-yüan 説苑 [Garden of explanations]. Compiled by Liu Hsiang 劉向. *Han Wei ts'ung-shu* edition.

T'ai-p'ing yü-lan 太平御覽 [Imperial digest of the T'ai-p'ing era]. Edited by Li Fang 李昉. *Ssu-pu ts'ung-k'an* edition.

T'ang Ch'ang-ju 唐長孺. "Ch'ing-t'an yü ch'ing-i" 清談與清議 [Pure conversation and pure critique]. In his *Wei Chin Nan-pei-ch'ao shih-lun-ts'ung* 魏晉南北朝史論叢 [Collected historical discourses on the Wei, Chin, and Northern and Southern dynasties], pp. 289-97. Peking: Hsin-hua shu-tien, 1955.

T'ang Chien-yüan 唐健垣, ed. *Ch'in-fu* 琴賦 [Compendium of *ch'in* texts]. Taipei: Lien-kuan Publishing Company, 1971.

T'ien Chih-weng 田芝翁. *T'ai-ku i-yin* 太古遺音 [Lingering tones of great antiquity]. In *Ch'in-fu*, edited by T'ang Chien-yüan, pp. 29-108. Taipei: Lien-kuan Publishing Company, 1971.

Tung-fang Ming 東方明. *Chung-kuo ku-tai yin-yüeh chia* 中國古代音樂家 [Musicians of ancient China]. Hong Kong: Shanghai Book Company, 1963.

Wen-hsin tiao-lung 文心雕龍 [The literary mind and the carving of dragons]. Compiled by Liu Hsieh 劉勰. Translated by Vincent Yu-chang Shih. Bilingual edition. Taipei: Chung-hua Book Company, 1975.

Wen-hsüan 文選 [Anthology of literature]. Edited by Hsiao T'ung 蕭統. Commentary by Li Shan 李善. Index edition. Tokyo: Chubun-shuppan sha, 1976.

Yasui Kōzan 安居香山, and Nakamura Shōhachi 中村璋八. *Isho no kiso-teki kenkyū* 緯書の基礎的研究 [Basic researches into the apocrypha]. Tokyo: Kangi bunka kenkyū-kai, 1966.

Yasui Kōzan, and Nakamura Shōhachi. *Isho-shūsei* 緯書集成 [Collected fragments of music apocrypha] . 6 vols. Tokyo: n.p., 1971.

Yen K'o-chün 嚴可均, comp. *Ch'üan Shang-ku, San-tai, Ch'in, Han, San-kuo, Liu-ch'ao-wen* 全上古三代秦漢三國六朝文 [Collected fragments from high antiquity to the Six Dynasties] . *Chung-hua shu-chü* (Peking) edition.

"Yüeh chi" 樂記 [Book of music] . In *Li-chi hsün-tsuan* 禮記訓纂, *chüan* 19. *Ssu-pu pei-yao* edition.

"Yüeh-ling" 月令 [Monthly ordinances] . In *Li-chi hsün-tsuan* 禮記訓纂, *chüan* 6. *Ssu-pu pei-yao* edition.

II. Works in Western Languages

Bateson, Gregory. *Steps to an Ecology of Mind.* New York: Ballantine Paperbacks, 1972.

Bodde, Derk. "The Chinese Cosmic Magic Known as 'Watching for the Ethers.' " In *Studia Serica Bernhard Karlgren Dedicata*, edited by E. Glahn, pp. 14-35. Copenhagen: E. Munkgaard Int., 1959.

Chow Tse-tsung. "Ancient Chinese Views on Literature, the Tao, and Their Relationship." *Chinese Literature: Essays, Articles, and Reviews* 1 (January 1979): 3-29.

Courant, M. "Essai historique sur la musique classique des Chinois, avec un appendice relatif à la musique coréenne." In *Encyclopédie de la Musique et Dictionnaire du Conservatoire*, pt. 1, vol. 1, pp. 77-241. Paris: Delagrave, 1924.

Croce, Benedetto. *Aesthetic: As Science of Expression and General Linguistic.* Translated by Douglas Ainslee. London: Macmillan and Co., 1909.

Davie, Donald. *Articulate Energy: An Inquiry into the Syntax of English Poetry.* London: Routledge and Paul, 1955.

DeWoskin, Kenneth J. "Early Chinese Music and the Origins of Aesthetic Terminology." In *Theories of the Arts in China,* edited by Susan Bush and Christian Murck. Princeton: Princeton University Press, forthcoming.

Eberhard, Wolfram. "Beiträge zur Kosmologischen Spekulation Chinas in der Han-Zeit." *Baessler-Archiv* 16, no. 1 (1933): 1-100.

Edwards, E. D. "Principles of Whistling--*Hsiao-chih*--Anonymous." *Bulletin of the School of Oriental and African Studies* 20 (1957): 217-29.

Fung, Yu-lan. *A History of Chinese Philosophy.* Translated by Derk Bodde. 2 vols. Princeton: Princeton University Press, 1953.

Gulik, Robert van, trans. *Hsi K'ang's Poetical Essay on the Lute.* Monumenta Nipponica, no. 4. Tokyo: Sophia University Press, 1941.

------. *The Lore of the Chinese Lute: An Essay in Ch'in Ideology.* Monumenta Nipponica, no. 3. Tokyo: Sophia University Press, 1940.

Holzman, Donald. *Poetry and Politics: The Life and Works of Juan Chi (A.D. 210-263).* Cambridge: Cambridge University Press, 1976.

Hsu, Wen Ying. *Origin of Music in China.* Los Angeles: Wen Ying Studio, 1973.

Jao, Tsung-i. "The Relation Between Principles of Literary Criticism of the Wei and Tsin Dynasties and Music." Paper read at the Eleventh Conference of Young Sinologues, 1958, Padua, Italy. Xeroxed.

Karlgren, Bernhard. "Legends and Cults in Ancient China." *Bulletin of the Museum of Far Eastern Antiquities* 18 (1946): 199-365.

------, trans. *The Book of Documents. Bulletin of the Museum of Far Eastern Antiquities* 22 (1950).

Kaufmann, Walter. *Musical References in the Chinese Classics.* Detroit: Information Coordinators, 1976.

Kuttner, Fritz A. "A Musicological Interpretation of the Twelve *Lü's* in China's Traditional Tone System." *Ethnomusicology* 6, no. 1 (1965): 22-38.

------. "The Musical Significance of Archaic Chinese Jades of the *Pi* Disk Type." *Artibus Asiae* 16 (September 1953): 25-50.

Laloy, L. *La Musique Chinoise.* Paris: Laurens, 1909.

Langer, Susanne K. *Philosophy in a New Key: A Study in the Symbolism of Reason, Rite, and Art.* Cambridge: Harvard University Press, 1959.

Legge, James. *The Chinese Classics.* 5 vols. 1872. Reprint (in 5 vols.). Taipei: Wen-hsing shu-tien, 1966.

Levis, J. H. *The Foundations of Chinese Musical Art.* 1936. Reprint. New York: Paragon, 1964.

Liang, David Ming-yüeh. *The Chinese Ch'in: Its History and Music.* Taipei: Chung-hua kuo-yüeh hui, 1969.

------. "Neo-Taoist Implications in a Melody for the Chinese Seven-Stringed Zither." *The World of Music* 17, no. 2 (1975): 19-28.

Lieberman, Fredric. *Chinese Music: An Annotated Bibliography.* New York: Society for Asian Music, 1970.

Liu, James J. Y. *Chinese Theories of Literature.* Stanford: Stanford University Press, 1975.

Liu, Tsun-yuan. "*Ch'in* Techniques of the Right Hand." *Selected Reports of the UCLA Institute of Ethnomusicology* 1, no. 1 (1966): 83-88.

------. "A Short Guide to *Ch'in*." *Selected Reports of the UCLA Institute of Ethnomusicology* 1, no. 2 (1968): 179-204.

Loewe, Michael. *Ways to Paradise: The Chinese Quest for Immortality.* London: George Allen and Unwin, Ltd., 1979.

Malm, William P. *Music Cultures of the Pacific, the Near East, and Asia.* Englewood Cliffs: Prentice Hall, 1967.

Mather, Richard, trans. *A New Account of Tales of the World: The Shih-shuo hsin-yü of Liu I-ch'ing.* Minneapolis: University of Minnesota Press, 1976.

Meyer, Leonard B. *Music, the Arts, and Ideas: Patterns and Predictions in Twentieth-Century Culture.* Chicago: University of Chicago Press, 1967.

Mote, Frederick. *Intellectual Foundations of China.* New York: Alfred A. Knopf, 1971.

Moule, A. C. "A List of Musical and Other Sound-Producing Instruments of the Chinese." *Journal of the Royal Asiatic Society, North China Branch* 39 (1908): 1-162.

Munro, Thomas. *Oriental Aesthetics.* Cleveland: Western Reserve University Press, 1965.

Nakaseko, Kazu. "Symbolism in Ancient Chinese Music Theory." *Journal of Music Theory* 1, no. 2 (November 1957): 147-80.

Needham, Joseph. *Science and Civilisation in China.* 5 vols. to date. Cambridge: Cambridge University Press, 1954-.

Ogden, C. K. "Sound and Colour: The Development of the Analogy." *The Cambridge Magazine* 11, no. 1 (1921): 9-19.

Ogden, C. K., Wood, James, and Richards, C. A. *The Foundations of Aesthetics.* London: George Allen and Unwin, Ltd., 1922.

Pater, Walter. *The Renaissance: Studies in Art and Poetry.* London and New York: Macmillan and Co., 1910.

Pian, Rulan Chao. *Sonq Dynasty Musical Sources and Their Interpretation.* Harvard-Yenching Institute Monograph Series, vol. 16. Cambridge: Harvard University Press, 1967.

Picken, Laurence E. R. "The Shapes of the *Shi Jing* Song-texts and Their Musical Implications." *Musica Asiatica* 1 (1977): 85-109.

Pokora, Timotheus, trans. *Hsin-lun (New Treatise) and Other Writings by Huan T'an (43 B.C.-28 A.D.).* Michigan Papers in Chinese Studies no. 20. Ann Arbor: The University of Michigan Center for Chinese Studies, 1975.

Porkert, Manfred. *The Theoretical Foundations of Chinese Medicine: Systems of Correspondence.* Cambridge: M. I. T. Press, 1974.

Powers, Harold. "Mode." In the *New Grove Dictionary of Music and Musicians,* edited by Stanley Sadir, 20 vols., 12:376-450. London: Macmillan, 1980.

Robinson, Kenneth G. "New Thoughts on Ancient Chinese Music." *Annual of the China Society of Singapore,* 1954, pp. 30-33.

Sivin, Nathan, and Nakayama, Shigeru. *Chinese Science: Exploration of an Ancient Tradition.* Cambridge: Cambridge University Press, 1973.

Stevens, Wallace. *The Necessary Angel: Essays on Reality and Imagination.* New York: Alfred A. Knopf, 1942.

Tjan, Tjoe Som, trans. *Po Hu T'ung: The Comprehensive Discussions in the White Tiger Hall.* 2 vols. 1949-52. Reprint. Westport, Conn.: Hyperion Press, 1973.

Waley, Arthur, trans. *The Book of Songs.* New York: Grove Press, 1960.

Watson, Burton, trans. *The Complete Works of Chuang-tzu.* New York: Columbia University Press, 1968.

Watson, Burton, trans. *Han-fei-tzu: Basic Writings.* New York: Columbia University Press, 1964.

------, trans. *Hsün-tzu: Basic Writings.* New York: Columbia University Press, 1963.

------, trans. *Mo-tzu: Basic Writings.* New York: Columbia University Press, 1963.

Wilhelm, Richard, trans. *The Book of Changes.* English translation by C. F. Baynes. New York: Bollingen-Pantheon, 1950.

------, ed. *Chinesische Musik.* Frankfurt: China Institut, 1927.

Wood, James. "Colour-Harmony: Some Applications of the Analogy." *The Cambridge Magazine* 11, no. 1 (1921): 20-28.

Zuckerkandl, Victor. *Sound and Symbol: Music and the External World.* Translated by Willard R. Trask. New York: Pantheon, 1956.

MICHIGAN PAPERS IN CHINESE STUDIES

No. 2. *The Cultural Revolution: 1967 in Review*, four essays by Michel Oksenberg, Carl Riskin, Robert Scalapino, and Ezra Vogel.

No. 3. *Two Studies in Chinese Literature*, by Li Chi and Dale Johnson.

No. 4. *Early Communist China: Two Studies*, by Ronald Suleski and Daniel Bays.

No. 5. *The Chinese Economy, ca. 1870-1911*, by Albert Feuerwerker.

No. 7. *The Treaty Ports and China's Early Modernization: What Went Wrong?* by Rhoads Murphey.

No. 8. *Two Twelfth Century Texts on Chinese Painting*, by Robert J. Maeda.

No. 9. *The Economy of Communist China, 1949-1969*, by Chu-yuan Cheng.

No. 10. *Educated Youth and the Cultural Revolution in China*, by Martin Singer.

No. 11. *Premodern China: A Bibliographical Introduction*, by Chun-shu Chang.

No. 12. *Two Studies on Ming History*, by Charles O. Hucker.

No. 13. *Nineteenth-Century China: Five Imperialist Perspectives*, selected by Dilip Basu, and edited by Rhoads Murphey.

No. 14. *Modern China, 1840-1972: An Introduction to Sources and Research Aids*, by Andrew J. Nathan.

No. 15. *Women in China: Studies in Social Change and Feminism*, edited by Marilyn B. Young.

No. 17. *China's Allocation of Fixed Capital Investment, 1952-1957*, by Chu-yuan Cheng.

No. 18. *Health, Conflict, and the Chinese Political System*, by David M. Lampton.

No. 19. *Chinese and Japanese Music-Dramas*, edited by J. I. Crump and William P. Malm.

No. 21. *Rebellion in Nineteenth-Century China*, by Albert Feuerwerker.

No. 22. *Between Two Plenums: China's Intraleadership Conflict, 1959-1962*, by Ellis Joffe.

No. 23. *"Proletarian Hegemony" in the Chinese Revolution and the Canton Commune of 1927*, by S. Bernard Thomas.

No. 24. *Chinese Communist Materials at the Bureau of Investigation Archives, Taiwan,* by Peter Donovan, Carl E. Dorris, and Lawrence R. Sullivan.

No. 25. *Shanghai's Old-Style Banks (Ch'ien-Chuang), 1800-1935,* by Andrea Lee McElderry.

No. 26. *The Sian Incident: A Pivotal Point in Modern Chinese History,* by Tien-wei Wu.

No. 27. *State and Society in Eighteenth-Century China: The Ch'ing Empire in Its Glory,* by Albert Feuerwerker.

No. 28. *Intellectual Ferment for Political Reforms in Taiwan, 1971-1973,* by Mab Huang.

No. 29. *The Foreign Establishment in China in the Early Twentieth Century,* by Albert Feuerwerker.

No. 31. *Economic Trends in the Republic of China, 1912-1949,* by Albert Feuerwerker.

No. 32. *Chang Ch'un-Ch'iao and Shanghai's January Revolution,* by Andrew G. Walder.

No. 33. *Central Documents and Politburo Politics in China,* by Kenneth Lieberthal with the assistance of James Tong and Sai-cheung Yeung.

No. 34. *The Ming Dynasty: Its Origins and Evolving Institutions,* by Charles O. Hucker.

No. 35. *Double Jeopardy: A Critique of Seven Yuan Courtroom Dramas,* by Ching-hsi Perng.

No. 36. *Chinese Domestic Politics and Foreign Policy in the 1970s,* by Allen S. Whiting.

No. 37. *Shanghai, 1925: Urban Nationalism and the Defense of Foreign Privilege,* by Nicholas R. Clifford.

No. 38. *Voices from Afar: Modern Chinese Writers on Oppressed Peoples and Their Literature,* by Irene Eber.

No. 39. *Mao Zedong's "Talks at the Yan'an Conference on Literature and Art": A Translation of the 1943 Text with Commentary,* by Bonnie S. McDougall.

No. 40. *Yuarn Music Dramas: Studies in Prosody and Structure and a Complete Catalogue of Northern Arias in the Dramatic Style,* by Dale R. Johnson.

No. 41. *Proclaiming Harmony,* translated by William O. Hennessey.

No. 42. *A Song for One or Two: Music and the Concept of Art in Early China,* by Kenneth J. DeWoskin.

MICHIGAN ABSTRACTS OF CHINESE AND JAPANESE WORKS ON CHINESE HISTORY

Michigan Papers and Abstracts available from:
Center for Chinese Studies
The University of Michigan
104 Lane Hall (Publications)
Ann Arbor, Michigan 48109 USA